This book is dedicated to *God*,
for his faithful love and constant friendship.

This book is also dedicated to my dad,
Everett Farmer. His love for reading is like
no other. He has read, and reread, all of *Louis
L'Amour* books, and a variety of books on the
military. He served in the United States Navy. He
has helped me through the years more than I could
share in a few books, much less this one page. The
Pony Express journeys are no different. He makes
sure we are safe by helping keep our truck and
trailer in travel ready condition.

Thank you *Pa*, especially for the mornings we share
about the old west, airplanes flying over (*he is also
a pilot*), "That's where we 'otta be," while hanging
out around the barn throwing the ball for *Rider*.

"A MAN'S HEART
plans his way,
BUT THE LORD
directs his steps."
Proverbs 16:9

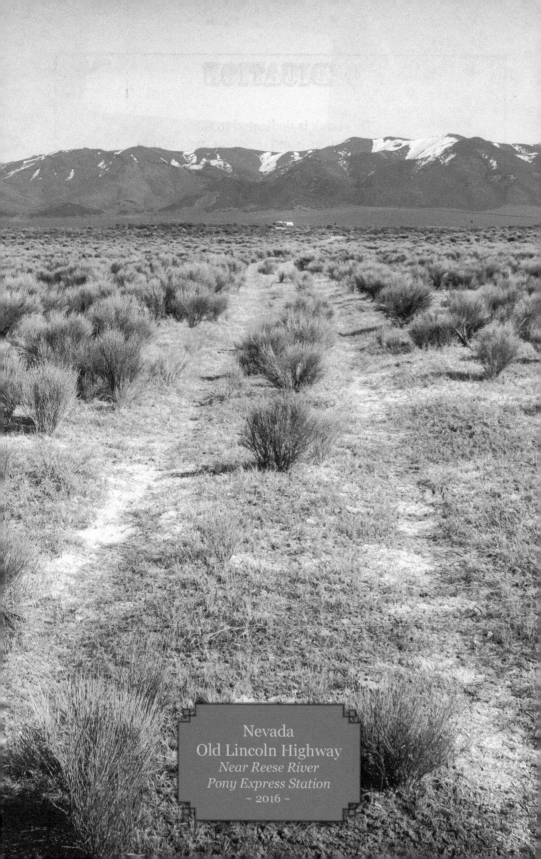

Nevada
Old Lincoln Highway
Near Reese River
Pony Express Station
~ 2016 ~

 Volume 1 2015-2016

Rider
on the
PONY EXPRESS TRAIL

Sacramento, California to Salt Lake City, Utah

CARLA E PHOTOGRAPHY

Sheridan, Wyoming 82801 USA

COPYRIGHT

Library of Congress Cataloging-in-Publication Data

Carla E Photography
After surviving great losses this is how one woman
found her way to live a passionate life with her camera and : Rider,
on the Pony Express Trail : Volume 1 : 2015-2016 :
Sacramento, California to Salt Lake City, Utah. / Carla E.
Editor: Wendy Martindale
ISBN-13: 978-1-7322638-0-2 (pbk)
ISBN-13: 978-1-7322638-1-9 (ebk)
1. Travel 2. Photography 3. History
LCCN: 2018905306

www.CarlaEPhotography.com

Sheridan, Wyoming
www.CowboyWest.net

TABLE OF CONTENTS

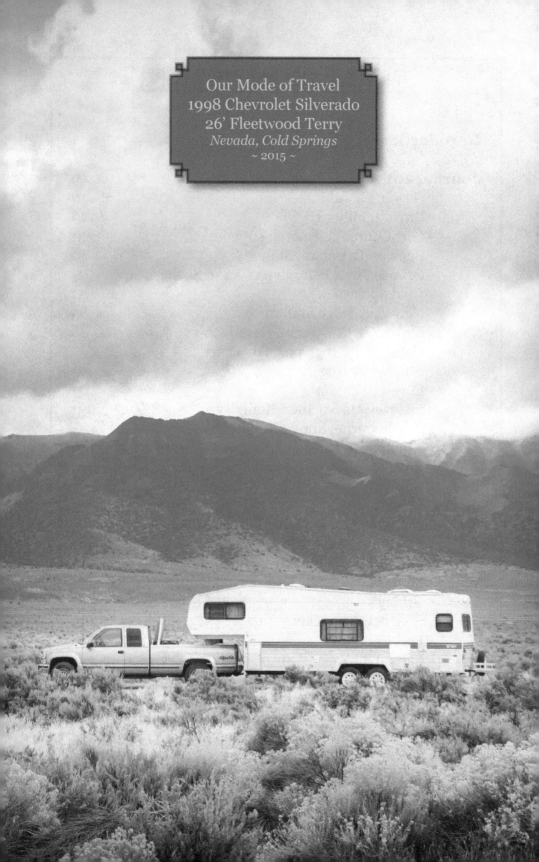

Our Mode of Travel
1998 Chevrolet Silverado
26' Fleetwood Terry
Nevada, Cold Springs
~ 2015 ~

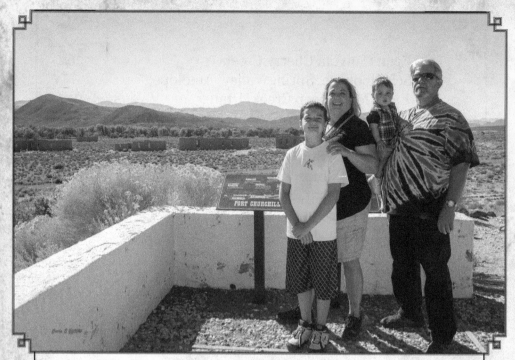

Cole, Suzanne, Bennett and Kent
~ 2014 ~
Fort Churchill, Silver Springs, Nevada

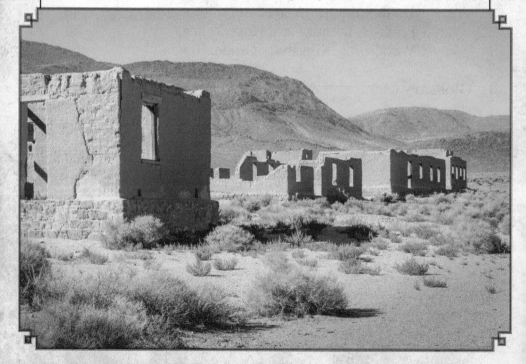

INTRODUCTION

Howdy, and Welcome!

My name is Carla, and I am a Western Lifestyle photographer. In recent years, I have traveled all over the western United States capturing the ranching way of life and loving it!

The journey we are about to share was inspired by a family outing on Saturday, October 4, 2014. My brother-in-law, Kent; my sister, Suzanne; their son, Cole; their grandson *(and my great-nephew)*, Bennett; and myself all headed out for a family day to visit Fort Churchill Historic State Park.

Fort Churchill is located just south of Silver Springs, Nevada. Kent had expressed to me that the ruins there were built in the mid 1800s...loving the old west, I grabbed my camera and we set out. When we got there, I was in AWE! I could not believe that there were such large adobe ruins out in the middle of what appeared to be the middle of nowhere. There was also a museum that shared the history of the area. My camera was hot from all the snaps I was shooting! Not really—but it should have been!

Several monuments in front of the museum captured my attention. I stopped to read them, and this is when I found out why the fort was built here: It was to provide protection after the outbreak of the Paiute Indian (Pyramid Lake) War in May of 1860 for the California Emigrant Trail and the Pony Express employees, as they both shared the Central Overland Route. The Central Overland California and Pike's Peak Express Company, better known as the

Pony Express, ran from April 1860 to October/November 1861. A short time for such a revered historic organization! I have always been fascinated with the 1800s—the pioneers coming out West and the famous Pony Express. These ruins raised a question in my mind: If these ruins are still standing, how many other Pony Express stations are still standing in Nevada? The "seed" to find the answers had been planted, and quickly came to root!

This was the beginning of an extensive personal project that I have now been working on for several years. My dream began as a vision of a photography coffee table book, and finally that desire is coming to a reality. No one is paying me to do this—it is a labor of love. The journal that you are reading now shares the behind-the-scenes experiences I encountered while working towards creating that coffee table book. *That* book will include my top pick of my Pony Express (XP) photographs, along with a few historical photos and brief stories about the sites and the employees who worked there, Native Americans who were already living there, and, of course, the brave riders that passed through. What began as a *Nevada* Pony Express coffee table book...soon turned into *more* states...And in these first three years, our journey from Sacramento, California, to Salt Lake City, Utah, produced so much information that we stopped there to take time to put it all together. But we are hoping to go all the way to St. Joseph, Missouri in the future.*

I decided to keep this journal while working on the coffee table book project because I had seen another photographer do the same for one of her projects. While capturing photographs for her main book project, she kept notes of her day-to-day activities; she then placed behind-the-scenes photos next to those notes. I thought, "Wow! What a great idea!" Many of the sites we visited along our journey were not always Pony Express related, and I

believed that keeping this journal would be a great way to record and share them as well. So I started this journal on day one, as soon as we hit the road following the Pony Express Trail. This book is our way of sharing with you *our* behind-the-scenes photos and notes from the making of our coffee table book, *Remnants of the Pony Express.**

As you follow our journey, you will discover that locating the stations was not an easy task. I have therefore combined my research and hard-earned knowledge of the many locations to create a separate map* with the GPS (global positioning system) coordinates of all the stations and the *extra sites* we will be sharing together in this journal. I advise that you do not use our journals to follow the trail. There are times I recorded early on, "*Nothing remains,*" *or* "*No documentation,*" for a site, only to find out later there was, and we then visited it. Keep in mind this is a daily journal, so you are reading what I knew for *that* day only. Occasionally, I add an "Addendum" when needed to fill in a blank for you, the reader. :-)

**In order to keep up to date on our travels and find these and other great resources, please visit:*
www.CarlaEPhotography.com

This journey didn't just happen; many things had to fall into place for it to become possible. Not being independently wealthy, a lot of thought and planning went into this journey to make it financially feasible. I had been renting a room from my sister in Nevada since 2013 (*while renting my house in Washington out*), having moved here in order to be closer to my family, and to be here when Bennett joined us in October of that same year. But now it was time for me to consider moving out to give them back their space and start a new chapter in my own life. With my

new plan, I needed not only a place to live but the means to be self-supporting while traveling. So...

I sold my house and moved all my "stuff" from a storage unit in Washington to one in Nevada. I sold my new Chevrolet Silverado pickup, as it had payments and I wanted none; also, it was only a 1500 with a short bed. I used that money to pay cash for a slightly older Silverado 2500—a five speed long bed with low miles. I needed a larger truck, as my plan was to purchase an RV. I soon found and purchased a 26' 5th wheel. This new Pony Express photography adventure inspired all of these new ideas for how to get out on my own. I could now live wherever there would be a wide spot off the road. Well, at least in Nevada, that is true; once you get out in the middle of the 58 million acres of public lands, you can park most anywhere!

Another part of the new plan was to find a travel buddy. For years I have wanted a Blue Heeler, an Australian Cattle Dog. I just happened to look for one at the perfect time, as there was a litter of pups nearby in Red Rock, ready for adoption. Suzanne, Bennett and I drove out to look at the eight-week-old puppies. We met the parents, and they were not overly aggressive towards us, which was a good thing. The puppy with a patch over his left eye had been on my radar from the photos I had seen of the pups. I wanted my great-nephew, Bennett, to come along; since he was only two years old, I wanted to observe the reaction of the puppies to him. *(My Australian Kelpie, Keela, had passed away six months before, at the age of 14 years old. She was not keen on seeing our new little person being in our laps. This new puppy would have to learn the ropes of having little ones around.)*

The puppy with the left eye patch turned out not to be very friendly with Bennett. I was bummed; you see, I am left handed, and was going to call him "Lefty." Oh, well,

as God would have it, there was another puppy who would not leave our side, and just *loved* Bennett! He had such a sweet disposition, and I knew he was the one. I didn't leave and take time to think about it...I didn't need to. We took him home that same day. After a few posts on Facebook and Instagram asking folks for naming options, we named him "Rider." My niece, Ashley, came up with the name. She thought that since my journey was about the Pony Express *riders*, and he would be *riding* along with me on this adventure...what a perfect name it would be. I agreed, as did many of my friends and family on social media...so *Rider* it was!

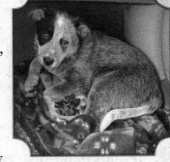

You might be wondering how I have time to travel and do all of this...and being well under the official age of retirement...Well, let us go back in time just a bit more to clarify and perhaps satisfy your curiosity and help you know more about me...*ever so briefly*. Here come some of the nitty gritty details of my life...

For many years, I had a lucrative job as a civil engineering technician, which I enjoyed. Also, for over seven years, I was the founder and volunteer of a very busy therapeutic riding center in Redding, California...but that all changed when I was infected with Lyme disease and three coinfections, all from a tick bite. This bite happened right after completing chemo and radiation treatments for breast cancer. Although I had continued to work

throughout my cancer treatments, it was the Lyme disease that took me down. I was forced to retire.

In 2009 and 2010, my life changed drastically even more. I lost my mother to her battle with cancer. Soon after, we had to put down our 16 year old Border Collie/Australian Cattle Dog, Buddy. A few months later, when I was just getting to where I could physically ride again, my horse, Tuch, went lame during a hunting trip and had to be put down. My son, Cody, went off to college, and the nest was empty. Then I went through a divorce and all that that entails. Within a very short period of time, my whole life had changed. I suddenly FELT alone, even though I was not, in reality, completely without the love and support of my family and Heavenly Father...For the next few years, my life was spent searching for ways to heal, grieve and move on from the ashes of a lot of heartache and physical pain. Thankfully, after that time, I started to once again see the light at the end of the tunnel.

> *...to bestow on them a crown of beauty instead of ashes, the oil of joy instead of mourning, and a garment of praise instead of a spirit of despair... Isaiah 61:3*

This journey, this tribute to the legacy of the Pony Express, grew out of this search. To this day, it is a fight for my body to keep living. I am thankful, though, for every single day, even through the pain, that I can still enjoy my family, and that my photography gives me a strong sense of purpose. I have learned to not fight the bad days. I find it is best to go with the flow of what I *can* do, and not focus on or regret the things I can't. I continue taking the necessary supplements and medicines as I strive to push through my everyday life. I pray; I read positive books; I listen to uplifting music; I walk while listening to podcasts about how to write and be an entrepreneur. I am doing *my*

best, though not near perfect, to always be thankful for the everyday triumphs.

Traveling with an RV has given me freedom; when I feel fatigued or in pain, all I need to do is pull over and rest until it passes. My days are full, purposeful, and fulfilling. What started out as a short road trip enabled me to find a whole tribe of new friends—YOU! Thank you for "riding shotgun in spirit" on our adventures. :-) *

My short photographic research undertaking opened doors to a whole new realm of adventure, and evolved into a multi-year journey. I have learned so much, and love that I can share it with you. So...now that you understand a little more about how and why I'm doing this—let's get back to our adventure, *Rider, on the Pony Express Trail!*

During the next year, after that first visit to Fort Churchill, I got all the before-mentioned selling and buying completed. All the while studying everything I could find to prepare for this journey. There was some information online about the Pony Express stations, but none I could find on *where* they were located. Fortunately, I found a few informative—though older—books with maps at the local Sparks Library. I read them many times, and they were checked out once more to go on this trip with us. I have to admit—the more I studied, the more I realized how little I knew about the Pony Express, and especially their trail! I was an avid fan of the series *Young Riders* many years ago, but afraid that did little for this adventure...lol. ;-) *

*For those of you who are not familiar with social media abbreviations, *lol* or *LOL* means *laughing out loud*. You will also find various other conventions used throughout my journal:
;-) wink: :-) smile: :-(sad: :-o shock or surprise.

So, with Rider as my new personal traveling assistant, we are finally ready to begin our journey. I pray he will love this adventurous living as much as I do!

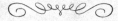

2015 JOURNAL

Welcome to our Nevada Pony Express Adventure!

OCTOBER 12, 2015
SPARKS TO GENOA

Woo Hoo!! It is our first day of setting out to follow the *Nevada portion of the Pony Express Trail*!

Today was an exciting and nervous day for me. Just the thought of taking off on a journey with a new puppy, and having never traveled alone with a 26' 5th wheel being tugged behind—all added up to being a much-needed rush for this single gal in her 50's! My self-confidence has been strengthened by my adventurous spirit, and it has overwhelmed my heart to get out there. I might as well tell ya right off: I am a Christian, and my faith and strength comes from the Lord. I feel led to go on this journey, and I am excited to hit the road. I also would like to personally thank you, dear Reader, for hopping in and "riding shotgun in spirit" with us! Knowing that I will be sharing this journey with you also helps me to not feel alone. I am thrilled, knowing you will be sharing the day-to-day experiences—both challenges and celebrations—with Rider and me! :-)

Thank you!

After taking everything that was battery powered off of their chargers, we finished loading up. Rider and I were off! Off in the head, some may say...haha...but nonetheless, we were going for it!

First to Walmart for some supplies...bottled water!... and other necessities.

Next, we hit the gas station near 395 and McCarren... then on to 395 South to start our trip. We got to Genoa about 3:30 p.m., which I thought would be perfect timing to get my Pony Express Passport from the Mormon Station Museum. I knew that it would be closing at 4:00, but to no avail. Rushing up to the old log house, we found the door was locked. I walked around the corner to see if the town office was open, but it, too, was closed. I photographed a few of the historic old businesses in town while there. Then

I went in to the little sandwich deli shop on the corner. The young men working there assured me that the museum

should be open in the morning. I asked if they knew where I could park my trailer for the night while I waited. They suggested the city park, just a block west of them. Before moving my RV, though, I walked just up to the courthouse building, and it was open for another ten minutes! I went in and found out they had a whole corner dedicated to the Pony Express, including a replica of the *mochila (a unique saddle bag used for the Central Overland Pony Express)*! I promised the nice lady at the desk I would be back in the morning with my camera!

Fortunately, the young men from the corner deli were correct about a good place to park my RV. I went up to the turnaround and pulled off to the side of the road next to the park. Rider and I have a great place to rest for the night!

Once the RV was parked, I ate a quick bite, grabbed my camera and took off back to the center of town. I gathered pictures of the monument in front of the firehouse that explained about this Pony Express station site. The first six months of the Pony Express's operation, the young riders also lived here. It was a place of rest between rides. After that, it was a station like most of the others: *Hop off, hop on* and *get going*!

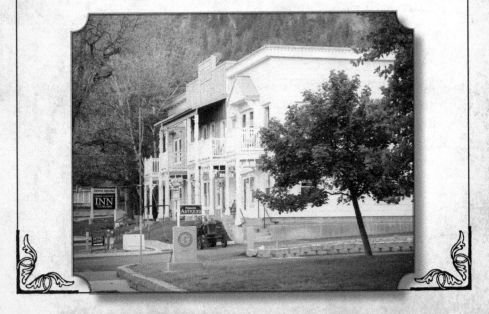

Being so exhausted from the past few days of getting ready, Rider and I slept in! When I finally got up, he was excited to go for a walk right away. I took him out to the grassy area of the park, and he was surprised to see some strange looking four-legged grass-eating critters! He let out a soft

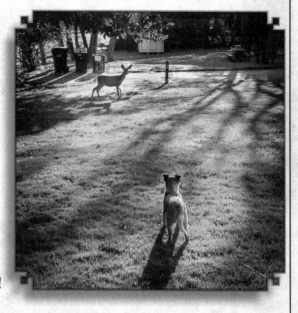

growl, then a little yelp, then just watched with amazement as the deer ignored his tough persona and quickly went back to eating.

Once I finally got some coffee down, along with some crackers and cheese, I took off towards the museum for my morning walk. Genoa is a small town; all of it is within walking distance from the city park. At the Mormon Station Museum, I met Ranger Daniel, who was outside visiting with other travelers. To not interrupt, I had tried to open the museum door first and found it was still locked. He opened it up once he finished answering all of the other visitor's questions. Once we were inside, I asked about the Pony Express Passport. He looked, but never found one. What he did have was the Nevada State Parks Passport. He gave me one after stamping our location in the booklet.

While touring the museum, Daniel shared with me the story about the piano they had. It had been the piano at the Pony Express station across the street. He said that a few days before the devastating fire of 1910, the piano had been shipped to St. Joseph, Missouri. Some time ago it was brought back home here to the Mormon Station. He said, "Imagine the riders leaning on this piano and gathering around in the evening after supper."

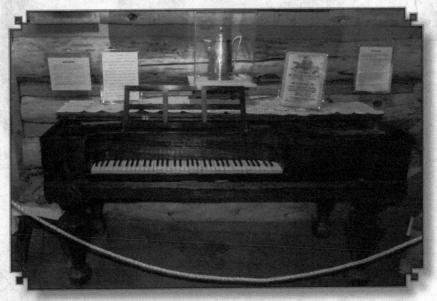

The museum also had photos of the livery stable and the blacksmith shop on display. When I completed my visit with Daniel, and the taking of my photos, I crossed the street to the Courthouse Museum.

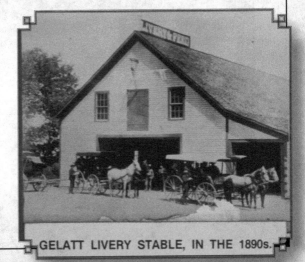

GELATT LIVERY STABLE, IN THE 1890s.

Though not the same person as yesterday, another very cheerful lady greeted me at the entrance. We talked about my wanting to get photos of the replica mochila they had in their Pony Express room. She was very helpful, cheerfully removing the signs that said, "DO NOT TOUCH."

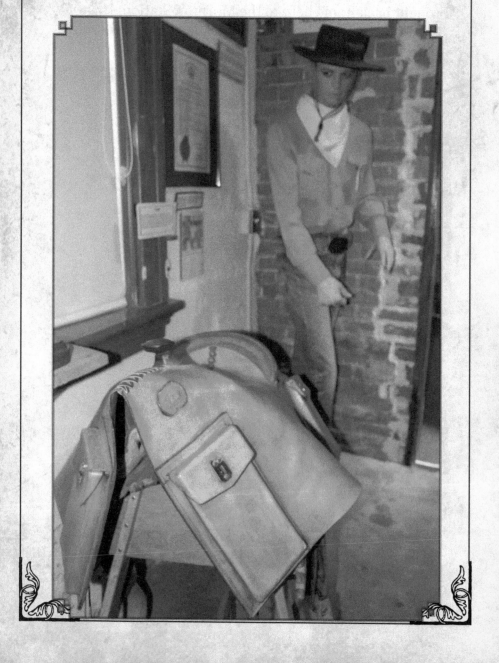

Also, last night I had noticed that there were a couple of *Bibles* in a cubby area. I had wondered if the larger one was an original *Pony Express Bible,* perhaps given to a rider?!* Upon closer observation, we discovered that it

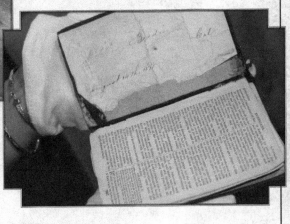

was a replica of the ones given to the Centennial Riders in 1960. Next, she pulled out the pocket-sized *Bible* that had been sitting next to it. After putting on white

museum gloves, she opened it up. It had a hand-written note inside, dated 1881.

Though it turned out not to be an authentic XP** (Pony Express) *Bible* either, it was still very cool to see!

Before leaving the courthouse, the nice lady took the time to share with me the books they had available for sale on the Pony Express. I didn't purchase any, as I have seven in my trailer now that were checked out from the Washoe County Sparks Library.

* A *Bible* was part of the equipment given to each Pony Express rider right after being sworn in, along with a rifle, pistol, knife and a bugle.

** The initials "XP" were said in some references to have been used by the Pony Express to brand their horses; in others it states there is no proof of that. Today, it is commonly used as an abbreviation for *Pony Express.*

Where the Livery Stable and Blacksmith shop once stood.

Genoa, Nevada 2015

Court House Museum

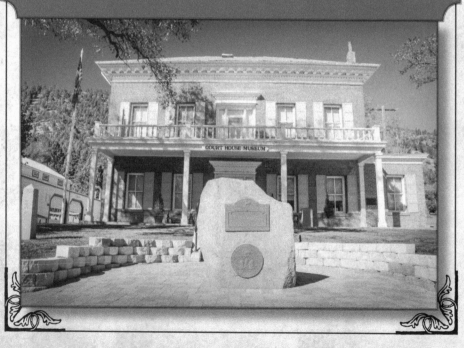

We also discussed the possibilities of where the station would have been located. After some consideration, and looking at the map of the city at the time of the XP, we concluded it must have been where the gazebo and picnic tables are, next to Mormon Station. These are directly across the street from the courthouse. The monument in front of the current fire station declares that it marks the location, but I believe that was the store where the young men LIVED. Across the street was the livery stable and blacksmith shop. I guess that is something to think about... What would you call the station's location: "Where the livery stables were?" or "Where the riders slept?" I hadn't thought about how this distinction would make a difference in nailing down the location of the station before.

I toured the rest of the courthouse. It was beautifully designed, with a complete courtroom set up, a full kitchen of yesteryear, a school room, a parlor, and a nursery with a collection of dolls. Lots of pictures of the settlers were scattered throughout.

Once I left the museum, I headed back to take Rider out for a walk and get some lunch.

Now to decide when and where to go next. Do I stop in Carson City, to take a photo of the location of where the station was, but is now non-existent? Or head to Dayton?

Tonight, still camped in Genoa, I continued my studies of the Nevada stations. So many are off the beaten path and some are on private property. I found a few extra stops to add to our trip: petroglyphs and a couple of the Overland Stage stops.

I have to admit, when I started this project idea, I was very naïve...I believed the *AUTO TOUR* signs I kept seeing on Highway 50 meant that most of the stations were going to be ON Highway 50! Haha...Well, regardless, I am happy to capture what we can!

Exhausted and my head still spinning, I am going to bed...reminding myself to only focus on the next few stations. Fortunately, they are close together...

October 14, 2015
Genoa to Dayton to Miller's/Reed's to Fort Churchill XP Stations

We woke up to a beautiful, cool morning. The last couple of nights have been in the mid 40's and the days in the 70's; we couldn't ask for better weather. I keep the heater on at night and set at 62 to keep the chill off...mostly for Rider's sake. He still sleeps in a crate, with his blankee. Oh—puppy training! Something I had forgotten over the last 14 years, and, oh, how fun it is! Haha!

After enjoying my coffee, feeding and walking Rider, I went back to studying the stations. As I sat at the dining table, looking out the window, I noticed a woman cleaning the bathrooms in the park. When I first parked here, I had noticed there was a water spigot near the road. I still needed to fill my fresh water tanks up whenever I found a place to do so. (*At my sister's, the water spigot was in her back yard and my hose wasn't long enough to reach the trailer.*) I stopped my studies for a bit and went out to ask her about it. After good morning pleasantries, I asked her if the water was safe for drinking. She told me that it was. I asked if I could pay to fill up my tank? She was gracious and told me it would be fine and to go ahead. After getting the trailer ready to be moved and Rider inside the truck, I pulled the trailer closer to the spigot and filled up. Then we were back on the trail!

After deliberating with myself—haha—I was glad I had decided to just drive around Carson City, as there was so

much traffic! I didn't want to try to pull the trailer through downtown, so I took the turnoff to Highway 50. The station location there is said to be on Carson Street between 4th and 5th Street, across from the Legislative Building. From what I have learned, there are no remains, but I will go back for a day visit and take pictures at a later time (*with just my truck*). I will capture the location regardless of what stands on it, and will also visit the Nevada State Museum.

Next Stop: Dayton/Nevada City XP Station

We continued on to Dayton to find the Union Hotel. (*In the 1860s, Dayton was called both "Chinatown" and "Nevada City."*) Some of the books I researched said there was nothing left of the stations. There had been two sites in Dayton: The first was Spafford's Hall Station, but after a short time, the Pony was moved to the new stage station, said to have been the building constructed west of the Grueber House (*now called the Union Hotel*).

Several books state that the Spafford's Hall location is now a gravel pit. The other station has been said to have no remains either, and the site was listed as being where the Union Hotel stands. Other sources, however, state that *one* stone wall of the original Pony Express station still stands, and it should be in the courtyard next to the Union Hotel. I tried to find the Union Hotel—which I knew to be on Main Street—on my GPS, but it kept trying to take me to Silver City's Main Street, which is on the road going up toward Virginia City. So, do not try to find it that way! Not being afraid to ask for directions, I drove in to Dayton and went to a gas station in town to ask someone. Just when pulling into town, I saw a Main Street sign, but thought best to ask anyways, as the same street had two names on the overhead signal light...confusing! A nice fella coming out of the gas station pointed to the street north of us, and

said that that cross street was Main Street, and where the Historical District was located. I thanked him and pulled across the street into the Carson Train Station parking lot. I gave Rider a drink and a quick walk, and put him in the crate inside the trailer.

From where we had parked, I could see the two story building with a sign on top reading "Union Hotel." The building had either recently sold or was for sale,

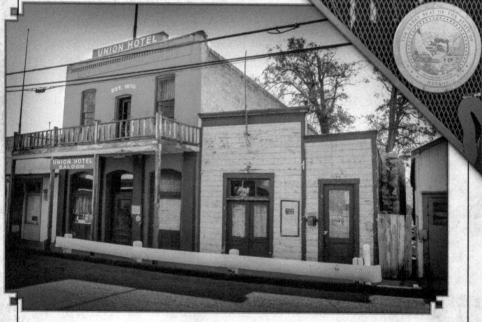

UNION HOTEL & POST OFFICE

THE ORIGINAL UNION HOTEL WAS LOCA-
TED ACROSS THE STREET. IT WAS RE-
BUILT HERE IN 1870 AFTER A FIRE DE-
STROYED THE OLD HOTEL. THE FORMER
POST OFFICE SITE ORIGINALLY HOUSED
THE DINING ROOM AND A BARBER SHOP.
THE FREESTANDING ROCK WALL IS THE
ORIGINAL WALL OF THE OVERLAND STAGE
STATION AND PONY EXPRESS STOP.
STATE HISTORICAL MARKER NO. 188
NEVADA STATE PARK SYSTEM
NSP DAYTON HISTORICAL SOCIETY
12-31-73 "PRIVATE PROPERTY NOT OPEN TO THE PUBLIC"

and was not accessible to the public. Just at the end of the wooden addition of the brick hotel, I was excited to find the stone wall! Though difficult to really get a great picture, I did the best I could to be creative! I took photos of the historical marker, Main Street, the hotel, and other buildings all around the district. It was a leisurely walk, as this part of town was only a few square blocks. While

snapping away at one old building, now a pet grooming business, a man came out to greet me. We introduced ourselves; his name was Mike. I told him about my Pony Express

adventure and he shared with me about his building. It was originally built for a butcher. Mike bought it from a gal named Terri, who had run a deli from

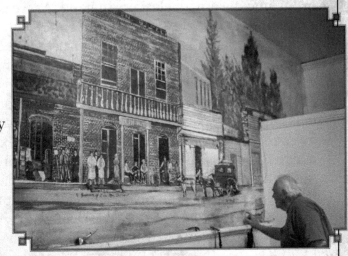

the building for many years. From 1993 to 2000, she hand painted a mural depicting how Main Street had looked in the 1800s. I snapped a photo of Mike pointing at the mural.

As we talked about the building, he explained that all of the stone buildings in Dayton were built by the Chinese. The side walls of this building were made of rock and resembled the Pony Express wall next to the hotel. The bricks on the front of Mike's building were beautiful, and I thought that they had been manufactured and added later from the looks of them. He said no, that the Chinese craftsmen had *hand* cut these blocks to create the diamond pattern I was viewing.

Before I departed, Mike asked me to wait a minute, as he wanted to show me a book (*Nevada Ghost Towns*) that had his building in it. It had a picture of a butcher standing over some meat with cleavers in hand. As we were looking through this book, I saw the Union Hotel with the wooden addition on the side. The wooden structure at that time was a barber shop. In the photo, it showed a sign hanging above the door that read, "25 Cent Haircuts"...I guess that is true about "Shave and a Haircut...Two Bits"! (*If you don't know what that is referring to, ask someone over 50. ;-)*) We bid farewell to each other, and I walked back to the train station where I had parked. I took Rider for a potty break near some railroad remnants. I captured a quick pic of the ruins with my phone and posted it on social media to show where I was and to say, "Howdy."

We loaded up and drove down a few more streets, where I found some other great buildings to capture, including the firehouse/jail combo, barns, and the local museum...but found it to be closed today. (*Museum Barn below*)

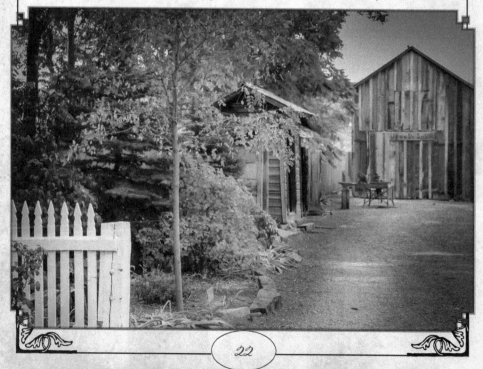

FIREHOUSE AND JAIL RESTORATION

BUILT OF WOOD, CIRCA 1861, THIS BUILDING HOUSED THE WELLS, FARGO OVERLAND STAGE STATION, AND THE DAYTON FIREHOUSE, MANNED BY VOLUNTEERS USING THE "BUCKET BRIGADE" METHOD TO FIGHT FIRES. AFTER THE DISASTROUS FIRE OF 1867, A SMALL HAND PUMPER WAS PURCHASED AND WATER STORAGE CISTERNS WERE INSTALLED UNDER MAIN, PIKE AND GATES STREETS. THE HAND PUMPER WAS REPLACED IN 1894 WITH A LARGER "KNICKERBOCKER" HAND PUMPER, NOW RESTORED AND ON DISPLAY IN VIRGINIA CITY'S "COMSTOCK FIREMEN'S MUSEUM".

IN THE LATE 1860S, THE BUILDING BURNED TO THE BASEMENT LEVEL. IN 1875 IT WAS REBUILT OF LOCAL RUBBLE ROCK AND BRICK ON THE BASEMENT'S ORIGINAL STONE WALLS. WHEN THE LYON COUNTY COURTHOUSE IN DAYTON BURNED IN 1909, THE JAIL CELLS WERE MOVED HERE. OVER TIME, FLOODS IN GOLD CREEK BETWEEN 1861 AND 1955 DEPOSITED SEDIMENTS IN THE BASEMENT, WEAKENING THE WOODEN PIERS SUPPORTING THE UPPER FLOOR.

IN 2008, THE HISTORICAL SOCIETY OF DAYTON VALLEY STABILIZED THE BUILDING'S FOUNDATION, REPLACED FLOOR SUPPORTS, REHABILITATED THE BUILDING'S DOORS AND WINDOW FRAMES, INSTALLED A RETAINING WALL AND EROSION PROTECTION ALONG THE CREEKBED.

THE HSDV ACKNOWLEDGES THE FOLLOWING CONTRIBUTORS: KEYSTONE MASONRY, CROM-STANLEY ENGINEERING, R.P. SURVEYING & ENGINEERING, PARAMOUNT IRON & HANDRAIL, BANTA CONSTRUCTION, GEOLOGIST DOUG PARCELLS, BURROWS BROTHERS CONCRETE, CAL-VADA CONSTRUCTION, AND HSDV MEMBERS, GARY McELROY, PROJECT MANAGER, AND STONY TENNANT, TENNANT CONSTRUCTION CO., CONSTRUCTION MANAGER, FOR DONATING COUNTLESS HOURS TO THIS PROJECT.

THIS PROJECT WAS FUNDED WITH THE ASSISTANCE OF THE STATE OF NEVADA COMMISSION FOR CULTURAL AFFAIRS.

BUILDING RE-DEDICATED IN MAY 2010

Wells, Fargo Overland Stage Station and Dayton Firehouse

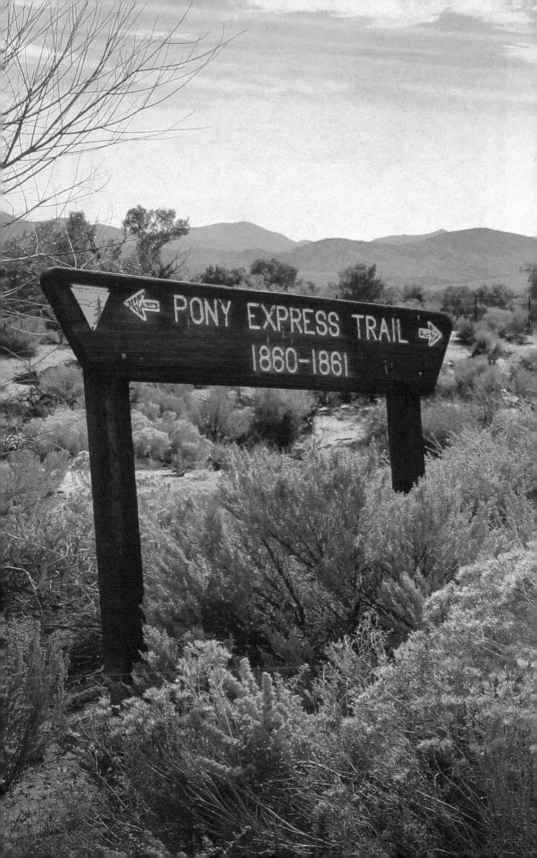

Next Stop: Miller's/Reeds XP Station

We were off again, back on Highway 50 heading east! We were trying to find Miller's (or Reed's) Station, located on River Road, heading toward Fort Churchill. Well, a lot has changed since the *Nevada Pony Express Guidebook* was published, nearly 50 years ago. As we followed the route, we found a park is now at the end of River Road, so I pulled back out onto Highway 50. About a half mile from there was a road called Fort Churchill. I knew that the River Road I was looking for was supposed to take us all the way to the fort, so I turned. I stopped to ask a contractor who was working in the brand-new subdivision about the new road...He said that it did go all the way through. After a few miles, we came up on an old ranch. I took photos of the old feeders alongside of the road.

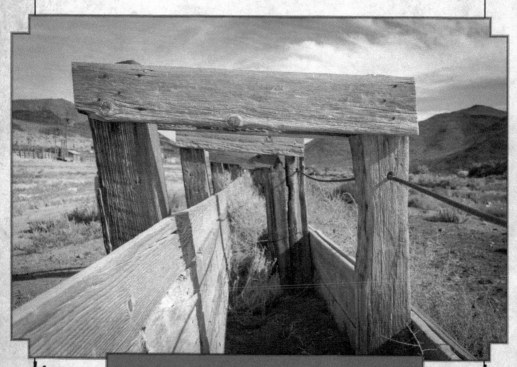

Feeders on Ranch near Millers

While here, I met a man in a pickup who was leaving from his job at a car testing site. We chatted, and he told me that the old stage station was on Hodges' place, and believed that would be where Miller's Station would have been. He said that it is on private property and that I wouldn't be able to see it from the road; also that Hodges wouldn't like me to trespass. He mentioned that the road was going to get a lot worse, too, and suggested that with me pulling a trailer, I should probably turn around. I decided since he knows the road, I should take his advice.

While looking for a place to turn around, I noticed on the right (west) side, about 1/8 of a mile off the road, some kind of structure that was pretty tall protruding out of the trees. As I got closer, I realized it was a bridge. On the left side of the road was a house, and a good turn-around spot,

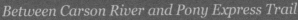
Between Carson River and Pony Express Trail

so I did just that. Then I got out of my truck to capture photos of the bridge. As I was taking pictures, a gal came out of the house and asked if all was okay...I explained that I was taking pictures of the bridge...she then told me that it was a train bridge. All the tracks to and fro had been removed; all that was left of the old railroad was that old bridge. How cool to see this piece of history! She and I visited a while, then Rider and I were again heading back to Highway 50.

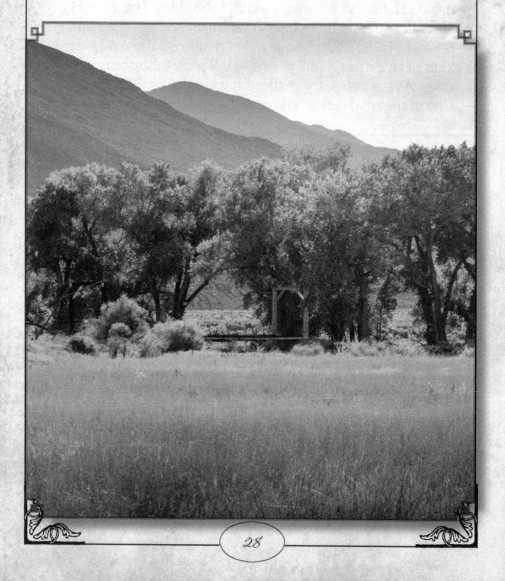

Next Stop: Fort Churchill

Highway 50 took us to Silver Springs, where we took 95 Alt South to get to Fort Churchill. By now it was about 4:00 p.m.

As we pulled in to Fort Churchill, I parked by the cemetery, where the pay station for the park was located. Upon getting the envelope to pay, I noticed that there was another box, and inside of it was the fort's stamp for my Nevada State Parks Passport. I stamped my passport, then we headed to the campgrounds to find our home for the next few days. We found a nice spot in the back, closest to the Carson River. This is a well-cared for and beautiful campground. Most of their spots are great, whether a tent or large RV site. Getting *in* is a bit tight for large RVs, though. The one in front of me was a 5th wheel, high-rise version, and was rubbing trees both top and sides. This is exactly why I got the low rise and only a 26-footer for my travels. Also, many parks have a 28' maximum length limit on their RV sites, and I wanted it to be easy to find a campsite.

Parked at last! I actually "cooked" me some dinner tonight...fried taters, beans and bread...Beans have often times been touted as the main food group for cowboys in the West. I chuckled and thought...hmm, how fitting I should eat them on this journey, too...

After dinner and clean-up, I took the evening to do more research about the three local Pony Express stations: Fort Churchill, Buckland's Station, and Hooten's Well. Buckland's Station provided service for the Pony Express for the first few months of operation. Then, due to the Pyramid War between the settlers and the Paiute Indians, the fort was built to protect the settlers as well as our XP riders and the mail they carried. The fort's headquarters building became the new Pony Express station.

Tomorrow we are going to start with Hooten's Well. It is about 15 miles east of Buckland's Station. I am a bit concerned about the road going out to Hooten's Well, so that is why I decided to go there first. I want to have plenty of daylight time, just in case we have any issues.

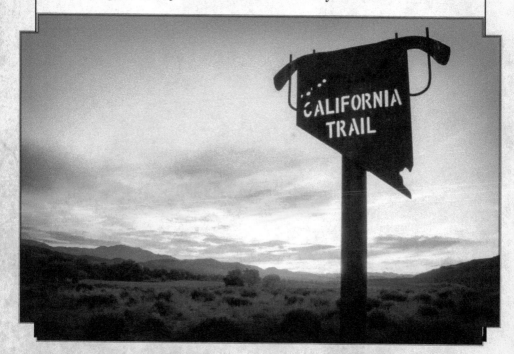

Around 6:30, I went out to take some photos of the valley where the Pony Express Road leads into Fort Churchill, from the west. I photographed the kiosks and the sign explaining that this was also the route of the California Emigrant Trail. I also went to get a few shots of the fort, but unfortunately it was already too dark.

Now, early to bed, so I will be well rested and can rise early to prepare for the drive tomorrow!

October 15, 2015
Fort Churchill to Hooten's Well XP Station to Fort Churchill

This morning we got up early, yet we waited until the ranger station (*next to the museum by the fort*) was open before heading out for Hooten's Well. I was hoping that they would have more information about the site and possibly know the current road conditions. I went in to speak to the ranger, and she told me she had never been there. She did have a brochure for the area, though, and it had a small map on it.

The brochure showed a Simpson Road leading out to Hooten's Well. The ranger explained it was a dirt, sandy road...and the only sign showing where to turn onto it read, "Campgrounds." I left her my information and camp number, letting her know when we should be back...just in case we had any problems.

Now, with this new brochure, my *Nevada Atlas*, and notes from Bill Mooney, we set out for the day's adventure. Rider and I pulled onto Simpson Road, feeling a bit concerned with not knowing the road's condition. I have to admit I was a bit nervous, knowing that the road was

A short time back, I met Bill Mooney via Facebook through another friend via Facebook—Lisa Bedell. Bill shared with me about his journey, taken back in 1993. He rode horseback across the whole state of Nevada, following the Pony Express Trail. His wife, Aline, assisted him by pulling their horse trailer with two more horses for him to rotate as needed. He had journaled his trip, and rode it in eight days! Thank you, Bill, for meeting with me and sharing your maps and knowledge of the Pony trail!

one that is less traveled, and we were going into the desert approximately 14 miles.

The road was washboard for the first two miles or so. Then we got into some muddy areas. I followed old tracks that went up the side of the hill in one area, and we were driving on the hill at about a 30° angle. Fortunately, the last eight miles of the road were pretty good. I was excited—and relieved—when I saw the corrals in the distance! Yahoo, Rider! We found it, and we made it safely!

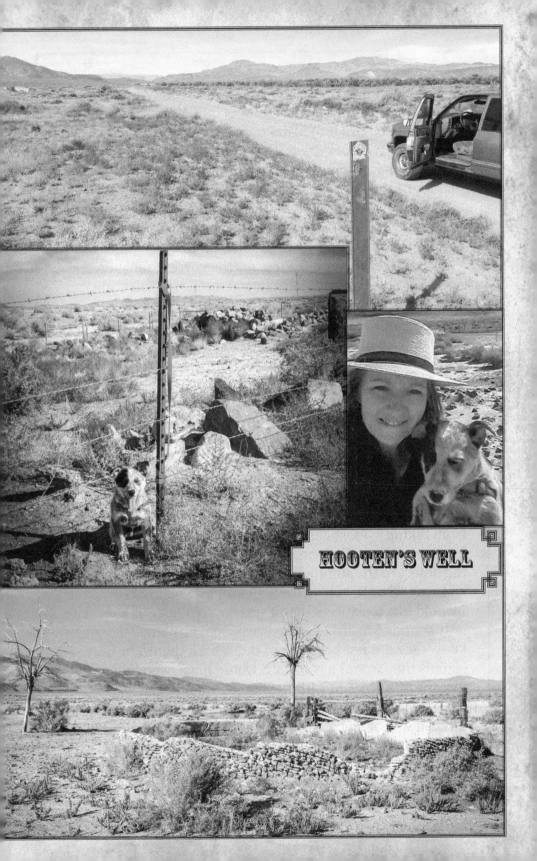

HOOTEN'S WELL

I had read there wasn't much left of this station, as far as ruins go, but I thought there was quite a bit. Especially when we compare it to just a rock wall next to an old hotel! There were two rock areas. One appeared to be a large, round, rock watering hole. Then there was a fenced-off area that looked to have been a rock corral with foundation/ walls for a building. Rider and I got lots of pictures here... It was like finding a treasure in the desert! I walked all around the site. There were wooden (willow branches for some of it) corrals and feeders for the current rancher. Also, a small pond/watering hole. Hmm, was this from THE well?

The research in hand, though old, stated that we could have kept following this road all the way to the Carson Sink Station. I chose not to, as it is also accessible by going back to Silver Springs, then to Fallon and back down Highway 95. Also, it would have made the trip back to our camp at Fort Churchill longer today. As we headed back, it was at a much quicker pace than when coming in...as we now knew the road conditions.

After our long hike this morning, at around 85°, I had worked up a sweat. As I was driving back, I pondered for a while on this: I have sweat in my eyes from my brow just from hiking a short while this morning...What did it feel like to be a Pony Express rider, riding full speed across the desert in the summer heat...for hours...along with not knowing what to expect from all around you...?! Wow...and I would like to express that it was so, *so* quiet out here. The only sounds I heard were an occasional airplane, and we know they did not hear one of those back then! The only sounds they would have heard would have been their own heartbeat in rhythm with the horse's hoof beats!

When we got back to the park, I first stopped to take some photos of the fort from the road. The road elevation is a bit

higher than the walking trails, where I shot from before, giving an overall better view of the fort. We then headed back to the trailer. I enjoyed eating my leftovers from last night's dinner. Yes, more taters and beans! Then Rider and I took a siesta! A luxury a Pony Express rider didn't often get! But, hey—I am only following the route, not delivering the mail! ;-)

About 4:30, I headed out to take photos of the fort, as I wanted to make sure to have enough evening light this time! There was some cloud cover tonight that made for a beautiful sunset! The temperature was about 70°, and made for a very enjoyable evening. I took lots of photos, including trying several different angles and viewpoints. I made sure to get several shots of the Headquarters Building, as that is where the Pony Express riders remount station was located. The horse and riders ran between the headquarters and the living quarters (the two story) buildings found at the northeast corner of the fort.

This evening, I posted a picture of Rider and me, from Hooten's Well Station, on Facebook. Then I took some time to chat with a few friends while enjoying some sweet iced tea.

It's now around 9:20, and I am headed off to bed... tomorrow we are leaving here and heading to visit Buckland's Station, followed by Cold Springs! I have so enjoyed my stay here. I would highly recommend this place if you are ever in the area and looking for a great place to camp...that comes with rich history!

Numaga, a war leader of the Pyramid Lake Paiutes, spoke against war with the emigrants. But, when war became inevitable, he led the united force successfully against the opposing forces.

A vigilante disaster
The Pyramid Lake War of 1860

The kidnapping of several Indian women by white men at William's Station led to deaths of the perpetrators by an Indian scouting party sent out from Pyramid Lake.

Just two days after the killings, some 105 white volunteers met at the burned remnants of William's Station. The volunteers thought they would have a bit of a skirmish with the Indians, kill a few of them, and on the whole have a rather enjoyable time.

On May 12th, near Pyramid Lake, the vigilante group finally sighted their intended victims. Paiute and Bannock People had gathered at Pyramid Lake to discuss the explosive situation with the whites, but the killings precipitated a war.

The Indian warriors cleverly drew the whites into an ambush and when the vigilante retreat began, the warriors were in hot pursuit. In the panic of retreat, the soldiers were easy targets. Of the 105 men who went to fight and have a good time, 76 were killed.

News of the disastrous defeat spread quickly through the Comstock settlements, and appeals for aid brought not only troops, but also set the stage for the construction of Fort Churchill. Regular army troops sent from California forced the Indian people into retreat.

Major William Ormsby was the ranking officer of the vigilantes, but for some reason was not given command. He was killed in the disastrous expedition.

Fort Churchill Museum Display

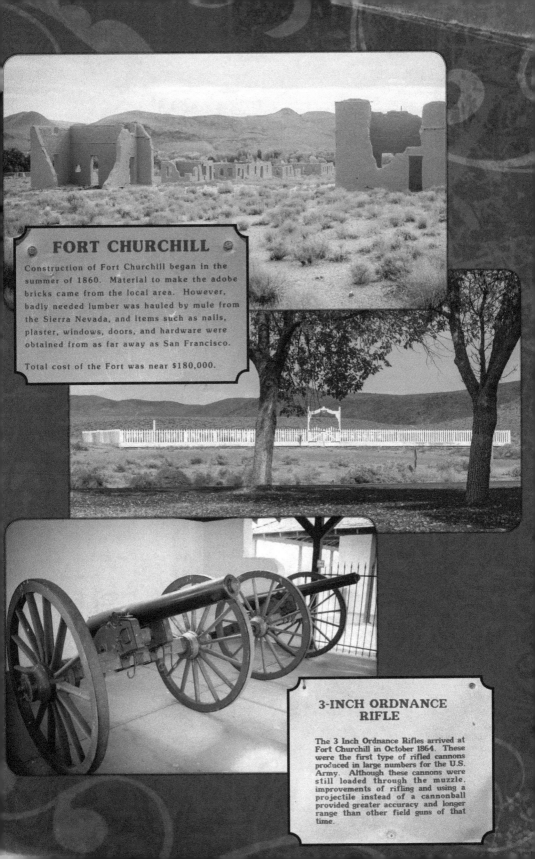

FORT CHURCHILL

Construction of Fort Churchill began in the summer of 1860. Material to make the adobe bricks came from the local area. However, badly needed lumber was hauled by mule from the Sierra Nevada, and items such as nails, plaster, windows, doors, and hardware were obtained from as far away as San Francisco.

Total cost of the Fort was near $180,000.

3-INCH ORDNANCE RIFLE

The 3 Inch Ordnance Rifles arrived at Fort Churchill in October 1864. These were the first type of rifled cannons produced in large numbers for the U.S. Army. Although these cannons were still loaded through the muzzle, improvements of rifling and using a projectile instead of a cannonball provided greater accuracy and longer range than other field guns of that time.

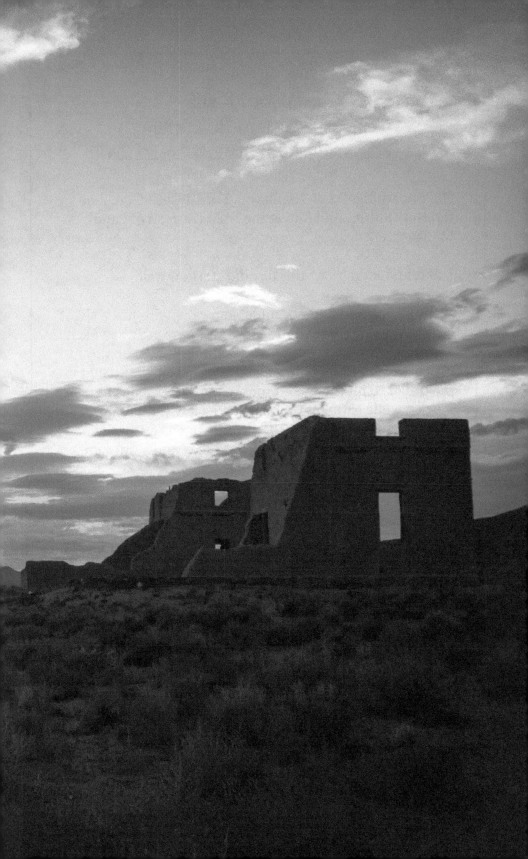

October 16, 2015
Fort Churchill to Buckland's to
Carson's Sink XP Stations to Fallon

Oh, my, what a DAY! Thank you, Lord Jesus...God...and the Holy Spirit...and Ken at the BLM (Bureau of Land Management)!

But first let me say: this day *did* start off well.

It was overcast and 60°, quiet and calm with just a slight breeze blowing through the cottonwood trees. It had been a great visit at the Fort Churchill campgrounds. I enjoyed my coffee, fed Rider, and started getting things situated in the trailer to hit the road. I took a look at my maps to plan my day while eating my banana and a few vanilla wafers for breakfast. After finishing the cleanup of our camp site and hooking up the trailer (in one shot I may add!), we were off to Buckland's Station.

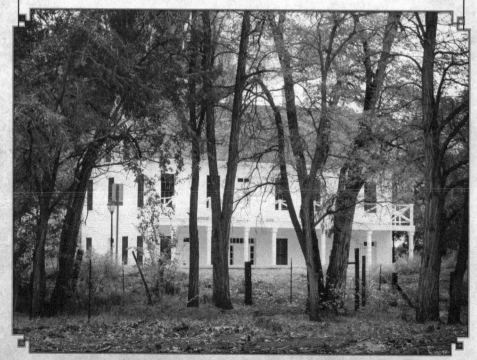

At this historical site today, a two-story house stands; it was once used for the stagecoach stop, a hotel, and a trading post. Across the street are a few buildings, barns, and some corrals, all located behind a large parking area near the road. Which facilities were used for the Pony, I am not sure—if any. Some sources state none of them were. Regardless, I captured lots of photos of the old buildings and barns! Also, for you tractor buffs out there, there were many in the pasture next to the barn closest to the highway. The sign said that the locals put them there on loan for the site to display many of the different types of farm tools used over the last 150 years.

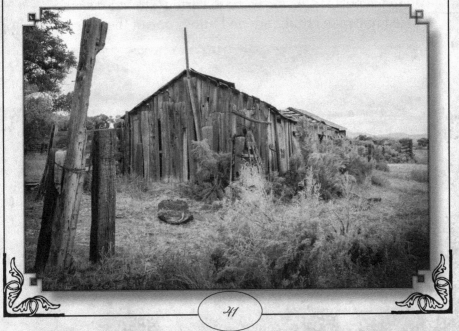

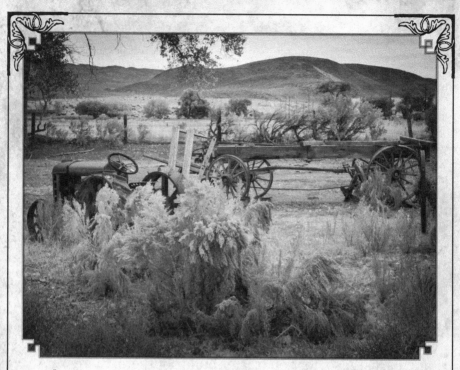

There is a nice park next to the parking lot with large trees, barbeque grills, a few tables, and more farm art. The trees were already showing their fall spirit by beaming with beautiful colors of yellow and orange...in their midst, a few old fence posts tilted skyward in various directions, and a rusted hay rake lay abandoned under one of them.

I managed to capture a photo of Rider under it...well, more like he "photobombed" my shot! Funny boy! So I decided to turn my camera on him...on purpose...I captured him

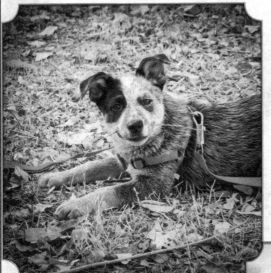

with a stick in his mouth while lying in the beautiful fall leaves and looking at me. It was a puppy cuteness overload photo! :-)

We walked back to the parking lot, and I picked Rider up for us to take a selfie with my phone to share later on social media.

We were in front of one of the leaning buildings by the gate. I have to admit, it was difficult to stop taking photos here, as I have a strong love for old barns and the like!

While opening the door to my truck to load Rider, I heard one of the strangest things...It sounded like there were horses running, and one whinnying. I looked toward the area I heard it from, but there were no horses anywhere that I could see. It gave me chills...My mind immediately thought of a Pony Express rider running in for his next mount! It was truly strange, and regardless of what it was, it was a blessing for me to have that feeling, even if it was for only a few moments...to have the feeling as if I was back

in time and seeing it...feeling it...live! I thanked God for the experience and got into my truck and we headed out.

Next Stop: Carson Sink Station

Well, that was the plan anyway! I followed the map and notes from *The Pony Express Guidebook*, which suggested taking US 50 through Fallon, and then taking US 95 Alt South for 14 miles. Once we passed the 14 miles on my truck odometer, I still had not seen my turnoff that should have been on the right-hand side of the road. The first mistake I made was answering the phone when we were getting close to the turn. About a mile later, when I could turn around, I did. Mind you, the trailer was attached. My directions had said take Smith Road past Smith Ranch... Well, friends, there more often than not are NO ROAD SIGNS in the Nevada desert! When heading back towards Fallon, I saw a sign that said, "Top Gun Race Track." Well, I knew that the road from Hooten's Well went all the way through to Carson Sink, and that it crossed the TOPGUN training facility, which they don't think highly of us passing through.

Anyway...I took the road that said "Top Gun," and it immediately forked. I chose the one that was straight, as that was how the road I was looking for was on my map. I soon met a fella coming down the hill. I asked him if this was the road that went through to Buckland's. He said no, but the other one did. He said it would be a bit much with me pulling a trailer...I explained that I was looking for the Carson Sink XP Station. It was supposed to be only a half mile off the highway, where I would find old corrals where I could park at, then I was to walk to the ruins. He said he didn't know anything about all that, but then repeated that it was the road to Buckland's. So...I took it. Well, right off, it didn't feel right. The road was not straight, yet it had been recently graded (*so had the other end when going*

to Hooten's Well), so I thought this must be it. As far as I could see, there were no other roads in the distance that I could have taken. I was at the base of a hill that looked out over the salt flats. Well, a mile and a half in, lots of tight turns and sloping back and forth...still no corrals...no place to turn around this 40-foot moving machine, and no way I could back all the way out. So...I stopped...just like we tell our children when they are lost...*STOP*. I was almost in panic mode at this point.

Was I going to have to follow this road all the way to Hooten's Well before I found a wide spot? Was I going to have to stay in the desert for the night? Should I leave my trailer and drive to find a spot to turn around without it? If I did, would my trailer be okay? "Oh, God," I prayed, "please give me guidance! I know I am not going to die out here, but what *am* I going to do?!"

I called the Nevada Ranger Station that I found on the internet. Yes, THANK YA JESUS! I had the ability to use my phone to make a CALL and search for information online!!! The ranger that answered said he had no idea where I was, and this sounded like a BLM call to him. He was nice enough to share the number with me.

I called the BLM, and a gal answered the phone. I explained to her my predicament...she put me on hold. She had no idea where I was either...(*I shared with them exactly where we were according to the Nevada Map Atlas...another big THANK YOU goes out to Bill Mooney, who shared that with me, along with where to get one, and that I best have it with me at all times!*) The gal put me on hold for ten minutes while looking for someone who knew the area. She came back on and said, "Sorry, I am still looking." After another 15 minutes, she put me on the phone with Ken. I explained to him where we were, according to the atlas. He said he didn't have a *Nevada Atlas* in the office. I said, "What?!" He then stated, "I do

have one in my truck; I will go out and get it." I was so relieved to hear that! He put me on hold while he went out to get it.

Ken and I went over the atlas/map, and I shared the page and location of where we were at. There was a road just north of me on the map that was the Smith Road I had been looking for...ugh! I was on some unnamed roadway! It showed that this road tee'd at the western end of it, but that was still a ways from where we were at. He suggested I just turn around...at which point I gave kind of a crazy lady laugh. "Aaah, Ken? If I could do that I would have!"

He said "Oh, okay."

Ken went online and searched on *Google Earth*. He found that the road at the west end was just a two track and kept heading further in to the hills. I sighed. "That's not good." BUT...he suggested that maybe I could at least turn around there and come back out the same way? I thought, "Well, what choice do I have?" I knew I wasn't going to try and back out of there for sure, as the road was too winding and soft for that. There was a berm on both sides of the road, and the road was about a truck and a half wide. Ken was so kind; he gave me his personal cell number to call him back on in case it got past 5:00 and he had to leave work. At this time it was 4:40-ish. I told him I would let him know, and that if he hadn't heard from me by 6:00, to send help, as I probably didn't have phone service. We hung up and I continued down the road. About three quarters of a mile further in, I came up on a narrow driveway off to the left. It was about one car width and had berms on both sides of the entrance. I prayed...should I try it? Or should I keep going and try to find a wider spot? In the back of my mind, I couldn't help but keep thinking about what will happen if I get stuck...with a trailer in tow, being miles off the pavement? My mind kept racing. How expensive would that would be? What if I had to leave my

trailer? Would it be safe out here? *(What would you have done?)* I snapped out of it, and got back to praying for guidance. The still, small voice inside said..."*Do it.*" So, I did! I decided to try it.

I pulled wide to get the trailer up the driveway without going over the berm. Once the end of the trailer was lined up straight with the truck, I started cranking hard to back it over the berm, hoping to end up on the roadway behind. At this point, I almost got stuck while pushing the trailer over that berm with my truck now half off of the narrow driveway. I was trying to turn as tight as I could without jackknifing the trailer, so as to get it on the road and turned back in the new direction. After the tires started spinning, I went forward; fortunately the tires only spun a little bit, and then the truck moved forward. *Thank you, GOD!* Backing it again, my good ole truck pushed that trailer right up and over that berm, and I backed it right down the center of the road. Let me tell you what...I said, "Praise ya, Jesus!...Thank ya, Lord! Woohoo!!!"...took a deep breath... and said, "Thank ya, Lord!" again. Whew! This was a great worship time for me...lol.

Hallelujah! We were headed back! I stopped for a moment to call Ken. I let him know we were all good and heading back out toward the highway. I thanked him again for assisting me through my mistake and told him how much I appreciated him talking me through it. I was truly grateful for his time and help.

Slow and easy we went back down this treacherous road. Most of it was two miles per hour because of the many rocks on the road, ruts and repeat. Oh, and did I mention? While I was so nervous, it also made Rider very nervous... he was chewing on the seat, then on my hat's stampede string—a hand-braided rawhide and horsehair stampede string, I might add. I told him, "I don't think so, puppy!" I reached down onto the floor and picked up his toy, "Here you go, chew on this. Good boy."

Once we got near the end, and close to the highway, I stopped to check out the trailer. I had to relight the fridge and adjust all the stuff in the back of my truck to where it was supposed to be. Then we hit the pavement!! Whoop whoop!

As we were heading back toward Fallon, I spotted THE ROAD I had missed. It was on the other side of the salt flats. I could see that there would have been no way to pull down there with my trailer. The road was not marked, of course, no turning lane...haha, and the road went straight down the embankment to an opening between two posts on each side of a cattle guard. So, if you are ever looking for Smith Road, make sure to turn before the bend on US 95 and before heading up the hill, on the north side of the salt flats. Just look down the side of the road in the ditch, and there it is.

We are now parked at Walmart in Fallon, Nevada. What a relief to have survived the day not getting stuck. Don't get me wrong: I love the solitude of the desert and spending

time out and away from street lamps...but also must say...I prefer to do so when it is by *my* choice and not the desert's.

Well, I am calling it a day...Heading in to Walmart for a few things, and then back out here to get some sleep. Tomorrow is another adventure of its own, so I better rest up.

Thank you, Lord, for you and your angels watching over Rider and me, and our truck and trailer today. Amen.

OCTOBER 17, 2015
FALLON WALMART

We continued to stay at Walmart for another day/night. The weather was predicting rain, and I needed to study anyway. I spent the day doing research, reading library books and highlighting locations on maps. I did a little shopping before retiring for the night.

That is all...I know, not an exciting adventure there...haha.

October 18, 2015
Fallon Walmart to Churchill Fairgrounds

Woke up this morning to rain.

While doing research for places to camp, I had found the Churchill Fairgrounds, located here in Fallon. They have sites for RV camping as well as horse camping, both with hook-ups. The sewer is a dump station, though, so figure out what is best for your situation. I have not been on the road long, so I decided to dump afterwards. As of today, the cost to camp was $15/night.

This was a great place to rest. Being plugged in has it perks, of course. First and foremost, it charges my RV's batteries. Also, yesterday I purchased a movie—*Fly Boys*—at the store, to enjoy for this evening. It was a pretty good movie, about the first ever fighter pilots from America going to France to train. I also purchased an indoor antenna and a surge protector...neither worked in the trailer. Bummer.

Most of today was spent continuing my studies. When I say that I am studying maps, here is what that looks like: I go from the *xphomestation.com* site...to the guide books... to the atlas to mark them down...then to the *Google* satellite maps to see the view. All the while, trying to get a better feel of where the stations are located and what to expect. I am checking for things like: Will I have to walk in to a site? Can I drive to it with the trailer? And if not, where will be a good place to leave it behind?

After these next few stations, we will be getting into the more remote station site locations, and we will no longer be near Highway 50. There may be times we can take the route from station to station...but often, we will not be able to. Nevada has many mountain ranges to cross when heading west to east. So, what happens there is that I must

go to the station, come back to Highway 50, follow it a few miles, then take another road north to the next station... repeat.

I enjoyed a hot shower, watched my movie, and called it a night..."It's a night!" (*Something my dad always says... lol.*)

October 19, 2015
Churchill Fairgrounds to Fallon Walmart

We woke up to more rain, so we came back to Walmart. We are blessed to have this option, as many Walmarts no longer allow overnight parking. Thank you, Fallon! Also, where we park along the curb has weeds and the like so that I can walk Rider right out my door.

I took the antenna and the power surge protector back to the store. Then purchased more groceries and drinking water. Even sitting in one place still uses up supplies! ;-)

I did just a bit more map planning, as I found a couple of cool spots I would like to stop and visit that have petroglyphs!

October 20, 2015
Fallon to Grimes Point Petroglyphs to Sand Springs to Cold Springs XP Stations

Mini-celebration this morning...The sun was shining! We got up early to return to our trip! Ya*hoo*! I am thankful for the rain, though, as it has given me time to highlight new places and learn more about the XP locations.

First things first: Before heading out of town, we topped off the truck's fuel and we drove back down the highway to Big R Stores to top off the propane tanks as well. The rest of our journey will be more isolated, and with my off-road adventures putting on the extra miles, I will fill up every chance I can get! Austin, Eureka and Ely are the towns I know have fuel, so it should work out great. My generator is full, and I have two extra gas cans that are full as well, and they can be used for emergency fuel for my pickup, just in case we need it.

Next Stop: Grimes Point Petroglyphs
We continued to follow Highway 50 East on the Pony Express auto trail. Today's first stop was at Grimes Point Petroglyphs. Though it is not an XP station, it was near their trail. Makes one wonder, while traveling at a high rate of speed, did they ever even notice the petroglyphs as they rode by? They are up a bit higher in elevation than the probable trail, but after a lot of rain in the valley, maybe they ventured up near them? In my research, I have not found any note of them. But, for myself, and others

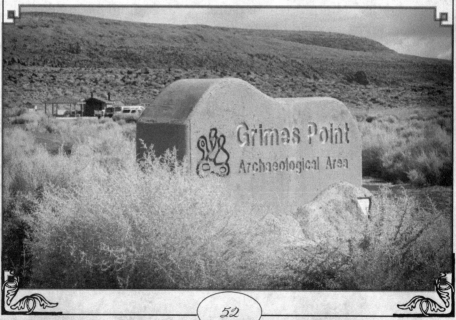

traveling this section of Nevada today, I believe it to be a must see! And as far as the native tribes who lived here in 1860-1861, and long before the 1800s, they are very much a part of the XP story as well.

When we pulled in, I was a bit disappointed, as there were two large buses that had just unloaded about 40 kids on a field trip! Ugh. I knew this would make it a challenge to get photographs. I told myself to chill...haha—and to just walk a different path as best I could for a while. As I pulled in and around the paved parking area, the buses made it pretty tight. I had to run over a boulder while going past them. We then found a narrow spot to park just off to the side of the road coming in. There was a small unpaved parking area, but after our recent rains, I figured it best to not pull my trailer out there. I parked as close to the edge of the pavement as best I could. Rider had to stay in the trailer, as there were signs saying, "No dogs allowed on the trail." Sorry, little buddy.

As I walked along the first trail, I was in awe of how many petroglyphs there were! They were in every direction; it seemed at first glance like they were on every rock! You

really had to pay attention and look at all angles on the rocks. They were near and far from the marked trail. I wished I had brought my binoculars. I did learn a bit from listening to the children while they read their handouts they brought from school. One of the teachers shared how this location was once Carson Lake beach front property. It was thought that the petroglyphs were an assortment of pictures, from men's hunting stories to perhaps children's drawings. The archeologists were said to debate these things. As I observed them, I figured it really is anyone's guess.

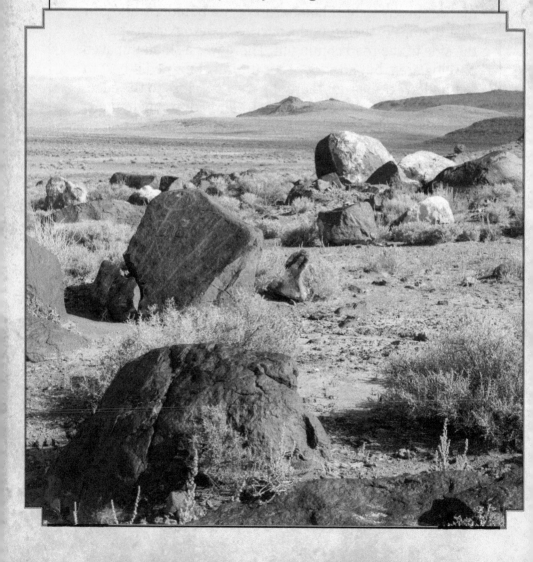

UNANSWERED QUESTIONS

Scholars and archaeologists still debate the mystery and meaning of the rock engravings. Whether the artist was depicting stars in the sky, hunting, ritual practices, or something entirely different is unknown. What is obvious is that the petroglyphs are fragile remnants of people who lived here long, long ago.

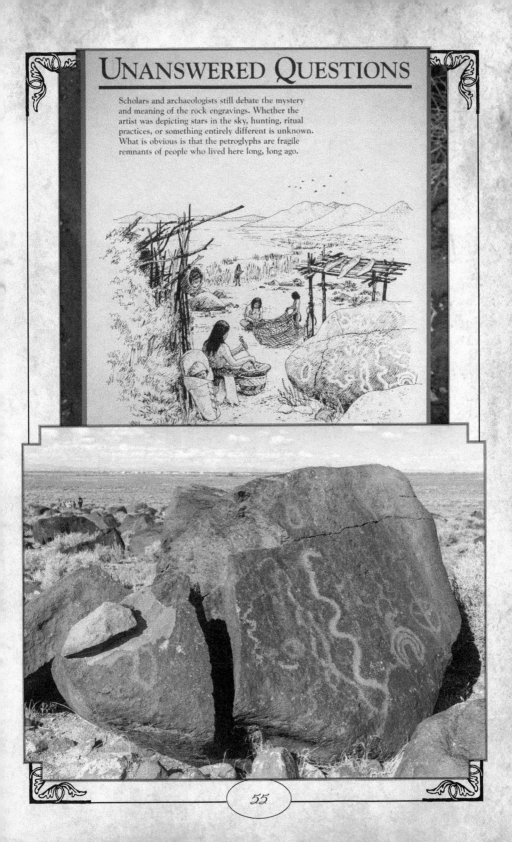

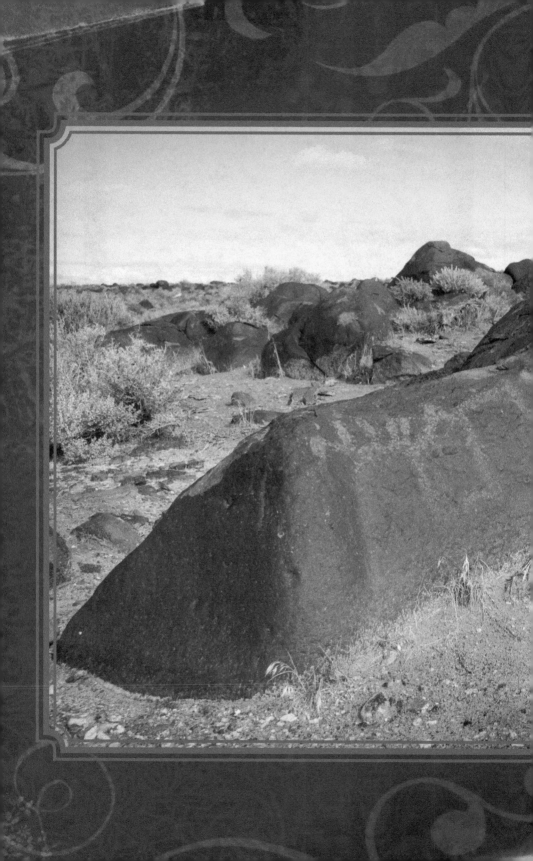

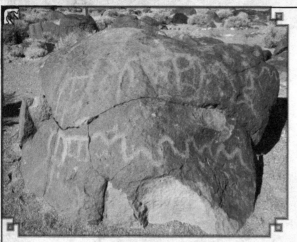

Once all the school kids were loaded up and gone, it became very quiet...peaceful...serene, even. The breeze was ever so soft, just perfect; I enjoyed feeling the coolness of the early morning on my face and taking in the sweet smells of the air after it rains. It was all quite spiritual to me...a calmness...I could almost feel the history of those who were

here before. I strolled for well over an hour, all alone, just taking it all in. I then sat in the sun for a while, becoming one with my surroundings. As I looked around, I began

imagining the children of years ago, playing by the water and drawing on these black rocks...picturing the young, brave warriors carving their hunting stories out as they told them to their friends, wives and children...

Well, snapping back to today, belonging to this modern time, I took a few selfies with the rocks. I posted them this evening on Facebook. I took a lot of photos of this place, including the signs sharing the history of the area.

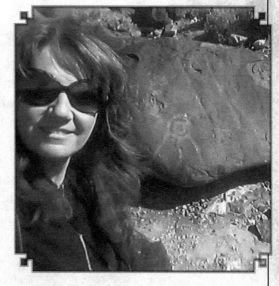

Upon returning to the truck and trailer, I took Rider for a walk around the parking area and let him stretch. Then we loaded up and hit the road again!

Next Stop: Sand Springs XP Station

The weather was starting to cloud up, but it was not supposed to rain, and I sure hoped that it wouldn't.

Sand Springs, I found from my research, has a very interesting history. As I have mentioned, my main books of study are dated from 1908 to 1976. Fortunately, one of the books I checked out recently from the Sparks Library is a bit newer. The book is a research book written by students of the University of Nevada, Reno (UNR). A group of archaeology students did a study in 1976 that caused them to find this station! They found it preserved under a mound of sand! My older books had a picture of a monument with an inscription that stated that the station would have

been close to Sand Mountain. Another said there were no remains. (The students' research was performed the year after the *Nevada Pony Express Guidebook* was published!) Well, thanks to these students, we can now visit this historical site.

We continued following Highway 50; the turnoff was supposed to be the same road that leads into the Sand Mountain Recreational Area on the north side of the highway. According to my books, Sand Mountain was large enough that we would see it long before the turnoff...boy, were they right! It was easy to spot, for sure. The signs for the turnoff are quite clear as well.

Sand Mountain is a popular spot for ATV recreational activities. I have an America the Beautiful Pass for all National Parks, and thought I would see if I could use it there, possibly stay for the night...unfortunately, on their website, it said they didn't honor it for this park, as they only accept pre-purchased one-week passes.

As we turned up the road heading toward the large mountain, I wasn't sure about where the XP station was, except that it would be on the left side going in. About a quarter mile in, I saw the sign for it pointing down a well-maintained gravel road. I was pulling my trailer, though, and not sure if I could turn around once we got in there. I drove up to the Ranger Station at the check-in for Sand Mountain to ask them if I could; it was

only another half mile up. The check-in was plainly visible to where I was contemplating turning in. The station was unattended, and I realized it was Wednesday, their one *free* day a week to ride in the park! Okay, now what? Well, I went back down the road to one of the large pull-out areas (areas that folks have made from going around the large speed bumps on the road), and we parked. I thought it would be best to walk in to the XP site and not worry about possibly getting stuck.

The weather was changing quickly, and it became pretty chilly. The wind had picked up as well. I put on my heavy coat, grabbed a bottle of water, a snack, my camera and, of course, Rider! He could go to this site, and off we went. The road was about a mile and a half in to the station. Easily could be driven by any car. After about a half hour, we made it to the parking area...Wouldn't ya know it? I could have easily turned around in there. Oh, well, a good brisk walk was good for us. Rider is getting somewhat

better about being on the leash, but he is young and gets distracted a LOT! Haha. The challenge is keeping him from circling me and not tripping me. I say, "*Puppy*!?!" a lot.

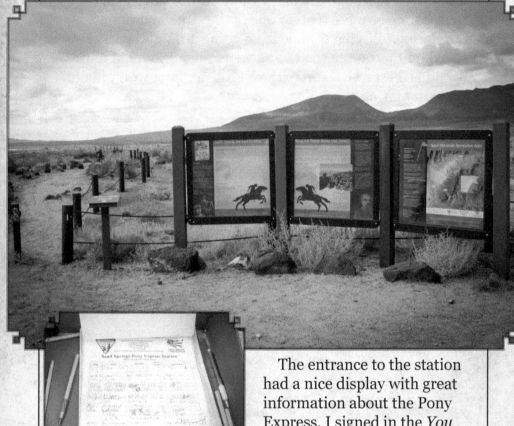

The entrance to the station had a nice display with great information about the Pony Express. I signed in the *You Were Here* book, and we went in. There were simple arrow markers to follow, though they were not marked to explain where they would take you. Of course, I could see the LARGE station and headed for it. You could walk right in and go through the rooms! In each room, there were plaques describing how the room had been used.

Trying to take pictures while walking a puppy on a leash is not a good combination, let me tell ya! He would not

stand still while I was trying to take pictures. He would either pull on me or make circles around me and have me all tangled up. We worked on, "Lie down; stay," but to no avail; he would only last for a few seconds. I decided to put his leash on a pole, where he wouldn't get wrapped up, and said, "Stay." Well, now he was whining at me. Oh, bother (*as Winnie the Pooh would say*)...lol. I walked around and got pictures of all the rooms and angles I could think of. It was amazing to me that this had all been buried by sand—made me think of the discoveries of Egyptian sites seen on TV!

A strange phenomenon about the nearby Sand Mountain is that you can *hear* it! It makes a *boom* sound. My research on it said it was due to it "moving." I did get to hear this boom, and it was quite unique and a strange experience. I had never heard of such a thing! The topography in this area is that there is a large valley to the south, and there are mountains to the north; the winds blow the sand into this basin and catch it there, which made the Sand Mountain. This is probably why the students of UNR would think to search for the XP station buried under the sand!

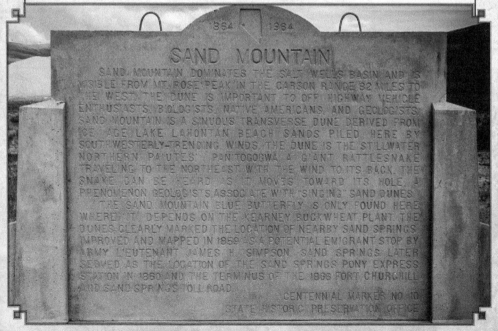

SAND SPRINGS PONY EXPRESS STATION

Built in March 1860, this station was used by the Pony Express until it was driven out of business by the first Transcontinental Telegraph in November 1861. The Telegraph and the Overland Stage Company continued to make use of the station throughout the 1860s. Other freight companies, such as Wells Fargo, occasionally used the building until about 1900.

REDISCOVERING THE PAST

Abandoned and forgotten, over the years the site was almost completely buried by drift sand. The station was not rediscovered until 1975. The next year, a team of archaeologists from the University of Nevada, Reno, excavated the site and removed all artifacts from the station. This research has led to a better understanding of this important part of our heritage. A historically accurate stabilization of the station was completed in 1997.

You are welcome to explore Sand Springs, but PLEASE do not climb on the fragile walls or remove anything from the site.

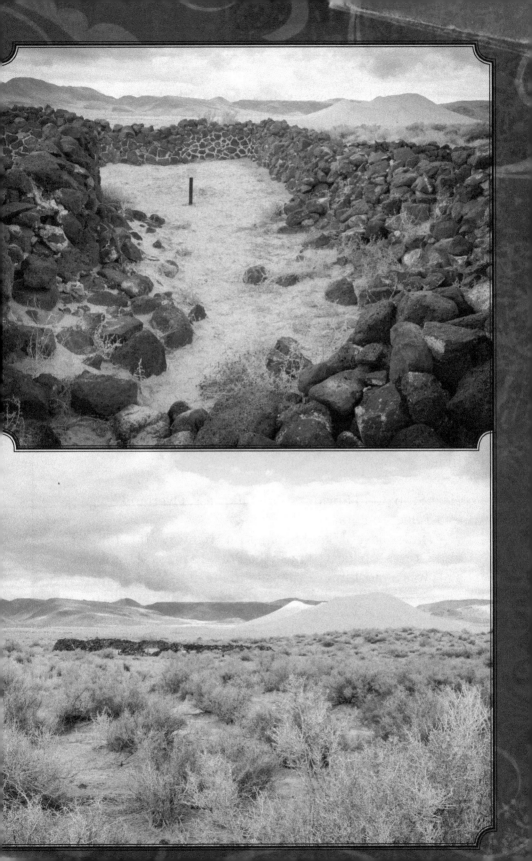

I followed the arrows leading south of the large station, thinking it might take me to more ruins, but found they lead to signs showing botanical descriptions of the local vegetation. I then followed arrows pointing the other direction around the back of the large ruins, and got a bit of a view overlooking the site and got pictures from this angle as well. It was starting to rain slightly, and I decided now would be a good time to head back to the truck, since it was a bit of a walk. Rider did really well on the leash going back—reminded me of riding a horse back to the trailer or barn: a lot straighter line and quicker pace...lol. And actually, Rider walked *me* back, as he had the leash in his mouth the whole way...Oh, puppies. Thank God, they are cute and funny their first year of training!

In the *Nevada Pony Express Guidebook*, it is mentioned there was an XP relay station between Sand Springs and Cold Springs; others do not mention a site there. But due to the distance, some believe there would have been one. If there *was* one, the station site is unknown to me at this time.

Next Stop: Cold Springs—Pony Express, Overland Stage and Telegraph Stations!

36 miles east of Sand Springs on Highway 50 I stopped at the rest stop located near the Pony Express station. This was a most interesting site to me, due to its history

and stories of riders and station keepers. I did not go up to the XP site tonight, as it is a 1.5 mile hike up the hillside to get to it. I took a few minutes to

read and photograph the informative signs about the Pony before leaving. It was cold and windy while there, too.

The time I arrived was around 3:30, and I like to camp by 4:30, so I started looking for my options. I drove across the highway to a paved parking lot that was between the two large sites of the Overland Stage Station and the telegraph station. They were on the other side of a dirt road that ran parallel to the highway.

Rider and I decided to take a walk west, down to the stage station first. I was bummed to find, but understand in order to protect, that it was completely fenced off with a six foot chain-link fence with barbed wire across the top. I put my camera lens through the fence and over it, when I could reach, to try and get the best pictures I could. Just to the east of this chain-link area, there were a few short rock walls; they were behind a four-strand barbed wire ranch fence. I captured them as well. We walked back to where we had parked and read the Nevada state historical sign.

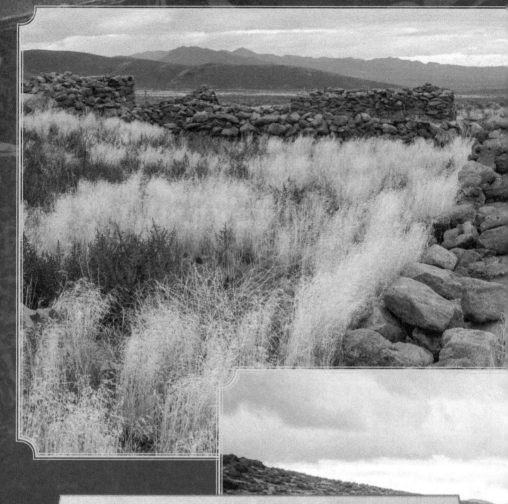

The Overland Stage

In 1857, Congress awarded a contract to John Butterfield to transport mail from Missouri to the West Coast. Originally following a southerly route through Texas and Arizona, the stage line switched to the Central Overland Route after the outbreak of the Civil War. By this time, Wells, Fargo & Co. had taken over operations of the company. Traveling the shorter central route, stagecoaches took an average of 23 days to travel from the Mississippi to the West Coast. During the 1860s, the stagecoach was the most popular means of carrying people, mail, and valuables throughout the West.

Historical photo of 1868 Wells Fargo Ticket from Austin, Nevada, to Salt Lake City, Utah.

Stagecoach Travel: No Picnic

Wells Fargo Driver "Old Charley" Parkhurst

Stagecoach travel was anything but luxurious. Summer travel was generally hot and always dusty, with travelers completely covered by a fine powder. Winter travel was just as uncomfortable, with passengers warding off extreme cold with shawls, blankets, and buffalo robes. When the trail was too steep on the uphill grade, passengers got out and walked. In mud, deep snow, or boggy areas, passengers were expected to get out to lighten the load and help push.

Did You Know?

The name "stagecoach" comes from the fact that these vehicles traveled by "stages," changing teams at intervals.

THE OVERLAND STAGE STATION

Constructed using the volcanic lava rock found throughout the area, the Cold Springs Stage Station was built in 1861. The original Pony Express Station was built 1½ miles to the east of here in 1860. When the stage station was erected, the Pony Express moved its operations to this building. The stage station consisted of two buildings, this one and the one you see to the west. Based on archaeological findings, this building was probably the station headquarters.

LIFE ON THE EDGE

Life at Cold Springs was not for the timid. The two- to three-man station crew endured the barest, leanest forms of living. They ate, lived, and slept in this crude structure for months at a time. Floors, when dry, were dirt and when wet, they were mud. Sanitary facilities were primitive. The handmade furniture was crude and utilitarian at best. There were no luxuries, only the necessities of life: food, water, and a firearm for protection.

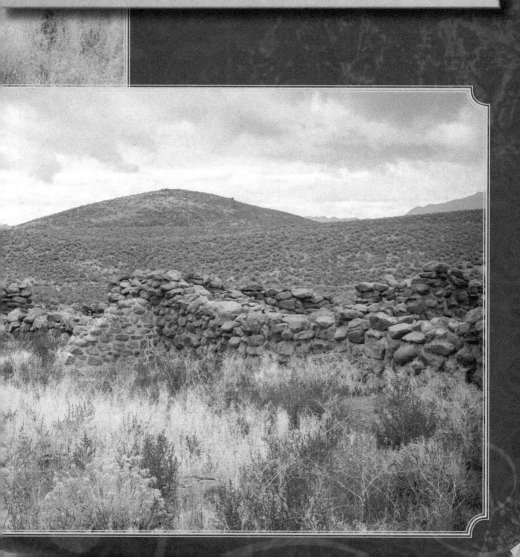

The telegraph station was just east of there, and a short ways down the dirt road. I could see from where I stood that there was an area that looked to be like a gravel turnaround, just off of the highway. It looked to be right in front of the telegraph station, so I drove down to check it out. It was a nice large area. I had plenty of room to turn around. I pointed my truck toward the road and backed it in a bit more to get further off the highway. Once parked, we walked down to the telegraph site. It, too, was behind

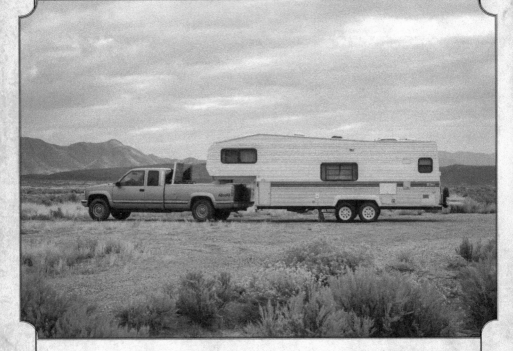

a chain-link fence with barbed wire on top. But this time I was discouraged even more; I couldn't even stick the lens through the fence here, as it was set back about 30 feet behind the four-strand barbed wire ranch fence. Yes, I looked for a good spot to climb through, over, under...but it was too tight to do by myself. I just had to get photos of what I saw...a fenced-in telegraph station.

We camped here for the night. I figured here would be a safer bet than the paved lot, as travelers may want to stop to read the historical signs like we did. Also, I spotted a gate right across the street from here that looks like it will lead us up to the XP station. We will head out that way early in the morning.

The wind has stopped and it is perfectly still outside. Rider and I enjoyed a few minutes watching the sun set and just taking it all in before coming inside to eat and rest.

We have a big day planned for tomorrow. I am so excited about hiking up to the Cold Springs XP Station, as it is said to be the LARGEST ruins left of all the ones in Nevada!

October 21, 2015
Cold Springs to Jacobsville/Reese River XP Station to Austin to Stokes Castle to Bob Scott Campground

After finishing my much needed coffee, I fed Rider, then packed up: water – check; snacks – check; 9mm loaded and placed securely in its holster and on to my hip – check. We were ready for our day's adventure.

We left the trailer at 7:30 a.m. It was very chilly, breezy and cloudy this morning. The sun wasn't to be over the mountain, just behind the station, for another hour. I left the telegraph station site and went directly across the street to the dirt road. We went through the barbed wire gate we found unlocked. A little tricky taking a wild puppy on a leash through a barbed wire gate, let me tell ya! We made it through and closed it back up with not too many injuries.

We headed up the road, knowing it was only supposed to be 1.5 miles straight out from the rest stop where we were at yesterday, but obviously, we were not leaving from there. In a short distance, we ran into a "Y" in the road. One option led straight, the other towards the right. I chose straight.

Soon we came to a large fenced area. The research from the guidebook had said the ruins were fenced in. I couldn't see any ruins, but we went in to the area at a spot where we found the fence was down on the ground. A few steps in, and I sure was grateful that I had Rider on a leash, as there was a 30" gaping hole in the ground...then another...and yet another!

"*Uh, oh!*" I thought. This area was fenced for good reason...to keep folks and cattle *out*! Not sure if it was holes cored for mining or what? But if Rider had gone down one, I would have lost my puppy, as these holes were deep!

We backtracked right out of there, then we followed the fence line to go around this section of whatever it was.

Once we were back on the road, I realized that it was now heading north, and I knew from my satellite picture of the ruins that that would not be the correct direction we wanted to go. I could see on the hillside what I thought could be the station, so we started cutting our own trail across and through the sagebrush towards it.

I took our new trail all the way to what I thought was our ruins...Well, it wasn't. It was a LOT of rocks piled up next

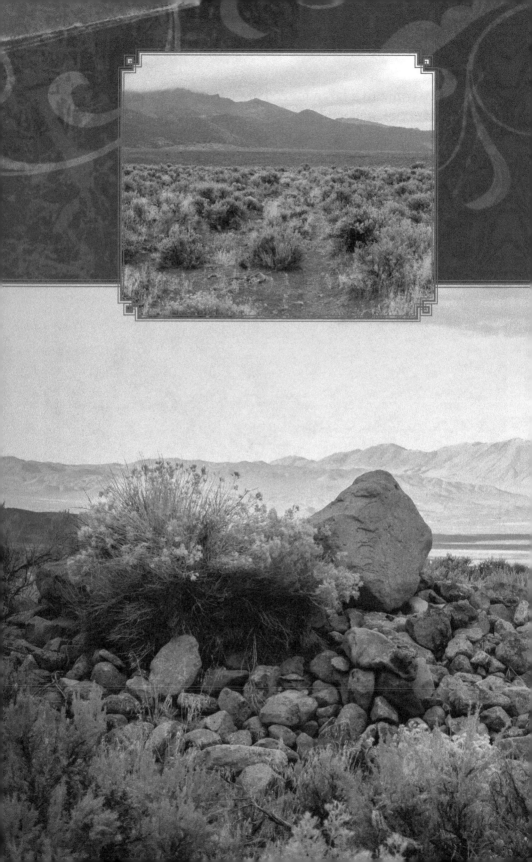

to a seasonal creek bed. Oops. So, I scanned the horizon once more. But before leaving this spot, I did capture a lot of pictures of those rocks, as they had beautiful wildflowers in full bloom projecting from them. The sun was just coming over the mountain now...and bringing all things to life...It was darn right beautiful. (*See previous pages*)

Looking into the distance, I could see some straight lines over on the hillside northwest of me. Again, I have to admit...I wish I had brought my binoculars!!

I prayed, "God, *please* show me where these ruins are!" As God is my witness, light beams came out of the clouds and were shining on those straight lines I had seen in the

distance. As I huffed and puffed climbing in these hills,
I said, "Lord...I think you are showing me the way, and I
have faith you are!"

Now heading northwest on my own cut-across path
again, I ran across an old overgrown road. I followed it
for a while, then it started heading away from what I now
realized were the actual ruins, so I left it behind. The light
beams were still shining on the site, and I stopped to
capture this beautiful view. Then I resumed to continue
towards them.

After one and a half hours and probably three miles from
where we started, we finally made it!!!

The guidebook was correct; the ruins are fenced off. If you keep walking towards the back of them, you will find that there is an opening, though, and you can go inside! Yay! They even have one of those *You Were Here* sign-in boxes by the gate.

While I was about to sign in, Rider started growling and barking...looking off into the sagebrush near the corner of the station ruins. It made the hairs on the back of my neck stand. I called out, "Is someone there? Hello?" but no one answered. I didn't see or hear anything, but Rider kept growling. I pulled him back closer to me and uncovered my 9mm on my hip. I waited a few seconds, then went back to signing in on the register. Within a few moments, Rider seemed to not have a care in the world. I have no idea what he saw, but it made for a spooky moment or two, I have to admit.

You see, I know that a rider died here. J.G. Kelly, a station keeper at Cold Springs, wrote about it. See below. *(Reminder: More history will be included in "Remnants of the Pony Express" coffee table book.)*

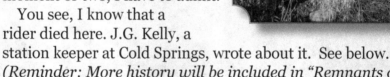

J. G. Kelly, assistant stationkeeper
at Cold Springs, wrote:

"...The next day one of our riders, a Mexican, rode into camp with a bullet hole through him from left to the right side, having been shot by Indians while coming down Edwards Creek in the Quaking Aspen Bottom. He was tenderly cared for, but died before surgical aid could reach him."

Once Rider was in the fenced-in area, I let him run amuck, with his leash still attached in case I needed to snatch him up. Boy, hidey, (*that's Texan for Boy, Howdy!*) he sure loved that!

There were informative signs in each of the rooms explaining what they were used for. I took photos of each sign and room. There were three very large rooms, the middle being the largest. It was said that this room was where they kept the horses. The room off to the right was where they stored the hay and feed, then the one on the left was where the men lived. It had a nice large fireplace and lots of gun ports that pointed in every direction.

I enjoyed this station quite a bit. Even though entering it felt quite eerie, I took my time. We stayed for almost an hour, walking through, and even got a couple of selfies.

As we were leaving the site, I looked for a better trail back down the hillside; I figured there had to be one! Wouldn't ya know it? There was a road...that took me all the way back to my truck... Remember the "Y" intersection I came up on when we first came through the barbed wire gate this morning? Well, I should have gone to the right. This road would also be okay for a four-wheel-drive vehicle that has good clearance and off-road tires, as there were a lot of boulders in the road. Also, I spotted the walking trail that went down the hill to the rest stop; from where I stood, it looked like it would have been easy to follow to the ruins.

It was 11:47 a.m. when we made it back to the truck and trailer. Woohoo! What should have been a little over three miles to and fro took me three and a half hours of hiking, probably 5+ miles, round trip! Hey, it was an adventure!

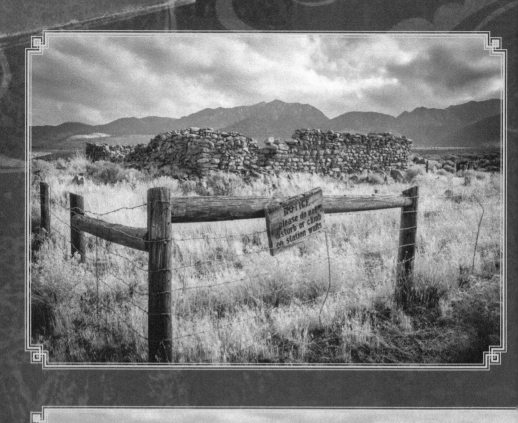

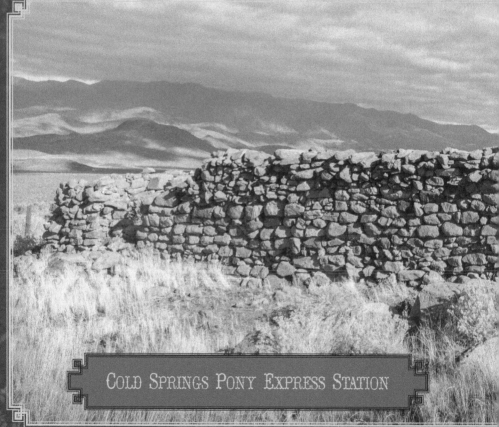

COLD SPRINGS PONY EXPRESS STATION

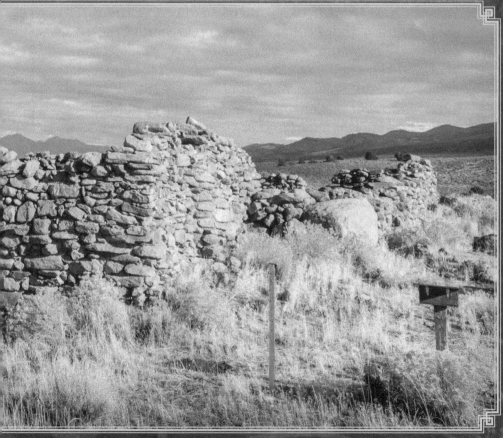

LOOKING BACK AT REST STOP AND TRUCK

Next Station: Edwards Creek (*No Documentation Available*)

The next XP station, some say, would have been Edwards Creek. The guidebook states there are some ruins along Edwards Creek, but there is no documentation of there being a site there. Sorry, no pictures of this possible site.

Next Station: Smith Creek (*Thought Inaccessible*)

This was a home station where riders would rest and wait before returning on their route. There are some stories about this site for sure, but to no avail; it is on private land behind locked gates. It is recorded that there are ruins east of the ranch headquarters—an adobe building with a willow roof, said to be the corral, and a rock/adobe structure that served as the station. Only the adobe portion is original; a rock wall was added later. Sorry, no pictures for this one.

(*Since taking this trip, I have learned [from the Nevada Pony Express Guidebook, p. 39] of an alternate route, just west of Austin, that I could have taken to Smith Creek. I am considering going back to see if owners will let me take pictures. Page 34 of the guidebook had said no way to drive from Cold Springs to Smith Creek because of locked gates; I thought this meant I couldn't go there at all. Now—and back home—I find p. 39 notes...Ugh!*)

Next Station: Dry Wells (*Location Uncertain*) or Jacobsville/Reese River XP Station

After Smith Creek, according to some of the research documents, would have been Dry Wells Pony Express Station. Yet others state it would be Jacobsville/Reese River Station. Most historians believe that that would have been too far of a distance, being that it is 30 miles. Which is why they believed that Dry Wells would have been the probable next location for a remount station. The exact location of Dry Wells is unknown, and was said to have

been abandoned upon the end of the XP in 1861. Since there are no records or location, that I know of, there are no notes or photos to share for this one either.

Our next stop was not an XP Station; it was an addition to our list of sites to visit, the New Pass Hotel and Store. Unfortunately, the road down to the station and hotel ruins looked to have been washed out, and also went behind large rock formations. I saw no place to pull over, as we were climbing the pass when I saw the dirt road. Even if I had a place to pull over, that would have meant I had to walk behind the rock formations, and I didn't think that would be wise to do by myself. With no visibility from the highway, it would have been difficult for someone to find me if something were to have happened. Also, I had NO phone reception in this area.

(*I am so very thankful for all of you who have sent me notes that you were praying for my safety on this trip. I know a few of you probably think I am crazy for traveling alone...lol. I never see myself as being alone, though; the good Lord is always with me...throw in a silly puppy and a 9mm, and I do well...Also, I do my best to not be "stupid" to my surroundings or a situation. I pray for guidance, and from time to time I do take some risks, for sure, but if it doesn't feel right, I don't do it.*)

Next Stop: New Pass Stage Station

At the top of the pass, we pulled off the highway into the parking lot for the New Pass Stage Station. The size of the ruins here is remarkable! I spent as much time as I could, trying to get decent shots of the ruins through another chain-link fence with barbed wire on top. At least in one location, there was a gate I could shoot through. Also, there were a few corners that had been pushed down on the top...probably from other photographers trying to get their shots!

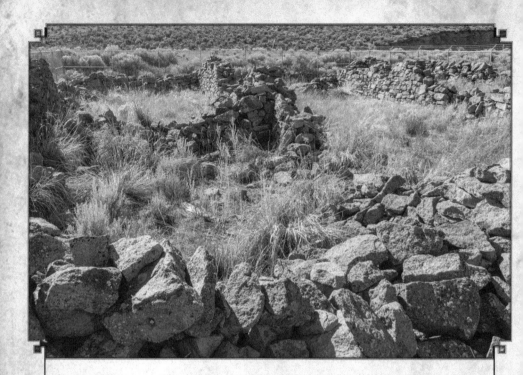

After going all the way around the station a few times, I captured the historical landmark sign and the views from the roadway, as this site and the highway were cut right through a beautiful red rock mountain.

NEW PASS STATION

IN 1861, THE ROCKS COMPOSING THE WALLS OF THIS STAGE STATION AND FREIGHTER STOP WERE IN NEAT ROWS AND ROOFED WITH BUNDLES OF WILLOW. IT WAS ONE PART OF "STAGECOACH KING" JOHN BUTTERFIELD'S OVERLAND MAIL & STAGE COMPANY ROAD SYSTEMS, WHICH AT THE TIME BEGAN TRAVERSING THIS CENTRAL ROUTE BETWEEN SALT LAKE CITY, UTAH AND GENOA, NEVADA.

THE NATURAL SPRING HERE WAS INADEQUATE FOR BOTH HUMANS AND HORSES. HOWEVER, DIVISION SUPERINTENDENT THOMAS PLAIN'S SUPPORT RANCH, ONE MILE TO THE WEST, KEPT THIS IMPORTANT TEAM-WATERING AND STOCK REPLACEMENT STOP OPERATING.

COMPLETION OF THE FIRST TRANSCONTINENTAL RAILROAD MEANT THE EVENTUAL DEMISE OF THE OVERLAND STAGE LINE. IN 1866, BUTTERFIELD SOLD OUT TO WELLS FARGO AND COMPANY. BY FEBRUARY 1869 WELLS FARGO SUSPENDED ALL OPERATIONS ON THE CENTRAL ROUTE AND THE NEW PASS STATION FADED INTO HISTORY.

STATE HISTORICAL MARKER No. 135
NEVADA STATE HISTORIC PRESERVATION OFFICE
DEPARTMENT OF CULTURAL AFFAIRS
BOY SCOUTS OF AMERICA TROOP 76, RENO

Next Station: Mount Airy (*No Visible Evidence*)

 The next Pony Express station listed was Mount Airy. It was a remount station from July, 1861, until the end of the Pony. It then continued to be an Overland Stage Station through mid-1868. My research asserts that all the structures are gone. No pictures of the site—only the pass's elevation marker as we were going over the crest of the pass. The photo is not very sharp, though, as I shot it while driving past the sign. (*Elevation 6679*)

Next Stop: Jacobsville/Reese River XP Station

My next hope was to find ruins at the Jacobsville/Reese River XP Station. We stopped at the large paved parking area, where there is a historical landmark sign. I took photos of it, as it explained a bit about the site and that Jacobsville was about a mile north of this location. I also photographed the surrounding area to show what a Pony rider would have seen while riding through this wide open valley. There is confusion from my research as to whether or not there were any ruins of this site. The 50-year-old guidebook only stated, "...an adobe complex, which ruins can be seen northwest of Jacobsville." Pretty vague for a location. I did walk quite a ways and never found anything.

Wide open spaces near Jacobsville/Reese River

Next Stop: Stokes Castle and Austin, Nevada

I went through this quiet little town and stopped at the courthouse. In the first room off to our left, I met Donna, who was sitting at her desk. We chatted a bit, and I asked her about the passport I had been looking for. What I found out was that there is *not* one for the Pony Express, but it is for the "Survival of the Loneliest Highway." (*WHY I wanted this passport: When you have five or more of the town stamps listed along the "Survival of the Loneliest Highway" passport, you will get a souvenir and a signed certificate from the Nevada state governor stating you survived! How cool is that!?*)

She gave me one and stamped it for not only here, but she also had the stamps to many of the other places I had already been! There were only two that she didn't have— that was Carson City and Dayton. I will have to go back to get those now that I have it.

I shared with Donna about my journey and asked if she knew if there were any remains of the Jacobsville XP Station. She said she didn't know, but then took me across the hall to meet other locals who were gathered for an afternoon visit. She introduced me to an older gentleman, and—sorry, I cannot remember his name—I asked him the same question; he said that he didn't think there was anything left. Then I asked about the road conditions going up to Stokes Castle. (*When we were pulling into Austin, I drove by a sign for it that pointed up a long, slightly steep, gravel road. I was concerned about pulling the RV up there when I saw it.*) He told me that it was a good road, and there was a large turnaround on top by the castle. He added that the road was winding and to be cautious of others, but that it wasn't traveled much, and though it had rained recently, it should still be okay.

Before leaving the courthouse, I went back to Donna's office, as she had gone back to her desk; I wanted to ask

her if she knew of any "reasonably priced" camp spots that were nearby. She told me about Bob Scott Campground, just seven miles east of town, and about the Spencer Hot Springs Campground, which she really liked. I told her since I am by myself, I think I will have to skip the Hot Springs this go around, but sure sounds wonderful.

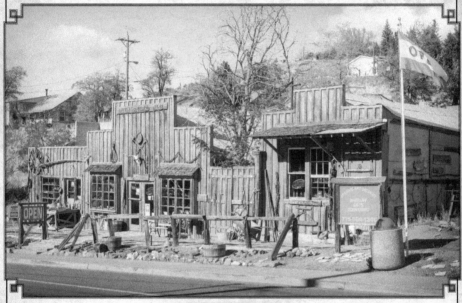

AUSTIN, NEVADA

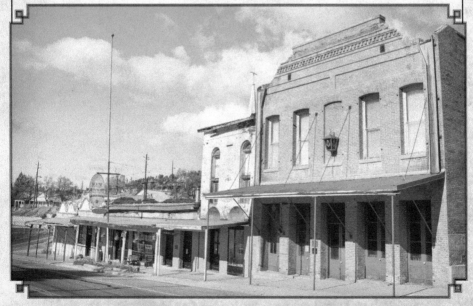

STOKES CASTLE

Anson Phelps Stokes, mine developer, railroad magnate and member of a prominent eastern family, built Stokes Castle as a summer home for his sons. After the castle (or the tower, as the Stokes family always referred to it) was completed in June 1897, the Stokes family used it for two months. Since then, with one possible exception, the structure has remained unoccupied.

Stokes Castle is made of huge, granite stones, raised with a hand winch and held in position by rock wedging and clay mortar. The architectural model for the castle was a medieval tower Anson Stokes had seen and admired near Rome. This building originally had three floors, each with a fireplace, plate glass windows, balconies on the second and third floors, and a battlemented terrace on the roof. It had plumbing and sumptuous furnishings.

Stokes Castle has served for decades as an iconic Nevada building often photographed by enthusiasts of Western history.

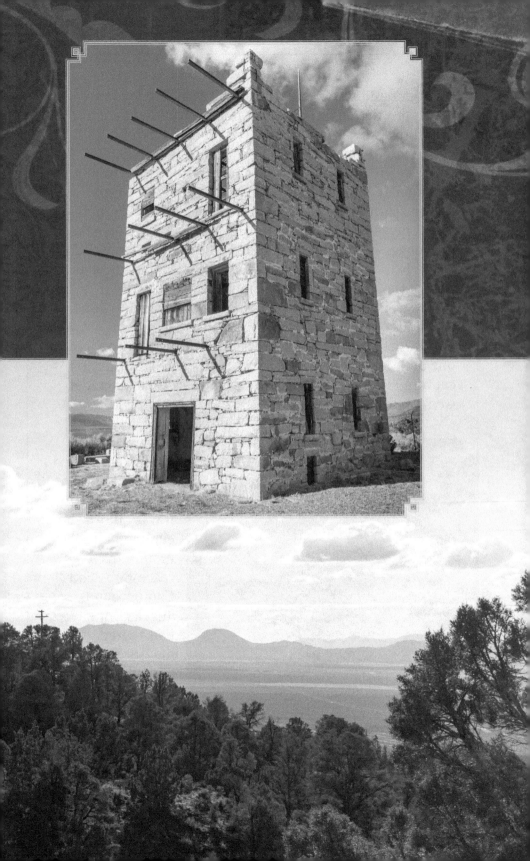

Rider and I went up to Stokes Castle. The road was wet with a few minor slip-outs, but not too bad that I couldn't get quite a way around them. The road was barely wide enough for two vehicles, so be cautious if you take the trip. The views while we were climbing to the top were spectacular!!! The castle overlooked the valley west of Austin. The castle structure was fenced off, so I did my best to put my lens through the fence. I am getting to love these challenges of chain-link fences...Hahaha! For a few of the shots, I stood up on top of a nearby picnic table to get a shot of the whole fortress without the fence.

It was still early afternoon, so I had dark shadows on two sides of the castle, but made the best of the time I had there. Just a few hundred yards from the castle, I noticed one of those large wooden mining structures (a sifter?). I captured it, too, and the gorgeous background views that went on for miles.

It was getting late, so we started our journey east. As we left Austin, it was quite a slow climb up into the mountains to reach Bob Scott Campground. Just as Donna had shared with me, seven miles and on the left, there was a large sign. *Yahoo*, we made it! Not the typical sagebrush

views we have been seeing...we were now in the trees, and it was very green and beautiful. There were many great camping spots, too! The best part? Most of them were pull through, right next to the campground road! I *love* that, as I am tired!!!

We enjoyed hiking around a bit and checking out the campgrounds before retiring. There is no one else here. It is very quiet, except for an occasional passerby on the highway.

OCTOBER 22, 2015
BOB SCOTT CAMPGROUND TO HICKISON PETROGLYPHS TO DRY CREEK TO SULPHUR SPRINGS XP STATIONS TO EUREKA REST STOP

When we woke up this morning, it was very crisp and quite cold! The ground was white from frost. The sun was coming up and shining through the trees...It was a beautiful mountain morning!

Next Station: Simpson Park XP Station *(Inaccessible)*

It is listed as being on private land, so I did not go there. No pictures.

From my research, it sounds like it was a beautiful location.

> *Just north of Bob Scott Campground was the site of Simpson Park, named after Lt. J.H. Simpson. He was the surveyor who laid the route (previously used by Chorpenning for the "Jackass Mail") from Salt Lake to Carson Valley in 1859. Then later, the Pony Express, the Overland Stage and the telegraph would all follow. This site was a home station for Chorpenning and was later improved by the Pony and the Overland. There was plenty of water and good grazing, so it became a district headquarters during the Pyramid Lake War. The Nevada Pony Express Guidebook lists this site as being on private land.*

Next Stop: Cape Horn Overland Mail Station

Well, at least that was the plan. Somehow I missed it, and figured the road must have not been a very good one, since I never even saw it!

Onward we went to the Hickison Petroglyphs. There was a good sign showing directions; the road going up to the site was gravel, and wide enough for two vehicles. When we got about a half mile up the road, it split in two directions.

The signs read "Campground" to the left and "Trail" to the right. The one on the right was a pretty muddy road. So we continued toward the campgrounds. We met another camper heading out and stopped them to ask if we could see the petroglyphs from the campgrounds. He replied, "Yes, there is a trail leading from the parking area."

We reached the parking area and found that it was a bit tight to park. I tried to get up as close to the trees as possible so that I would not block the turnaround for others...we had to go under the trees, and they scraped the trailer roof a bit.

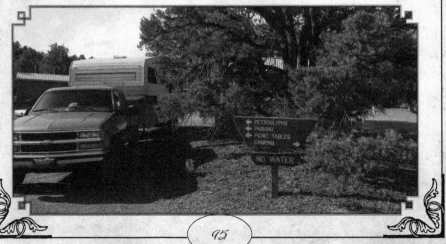

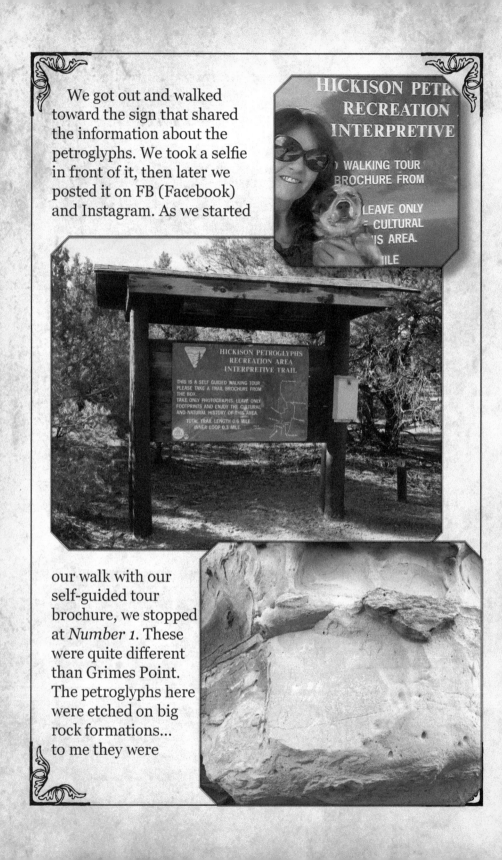

We got out and walked toward the sign that shared the information about the petroglyphs. We took a selfie in front of it, then later we posted it on FB (Facebook) and Instagram. As we started

our walk with our self-guided tour brochure, we stopped at *Number 1*. These were quite different than Grimes Point. The petroglyphs here were etched on big rock formations... to me they were

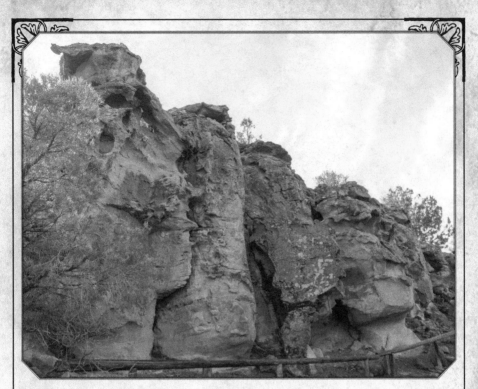

very different pictures and harder to see. Some were very visible, but most had been scratched...not sure of the cause there. Also, idiots had marked their own initials on some of the stones, too. This area had lots of trees, and was a very beautiful area. We walked down the trail and up to the lookout spot. We climbed up the short distance and photographed the Westerly scenery. Then we went

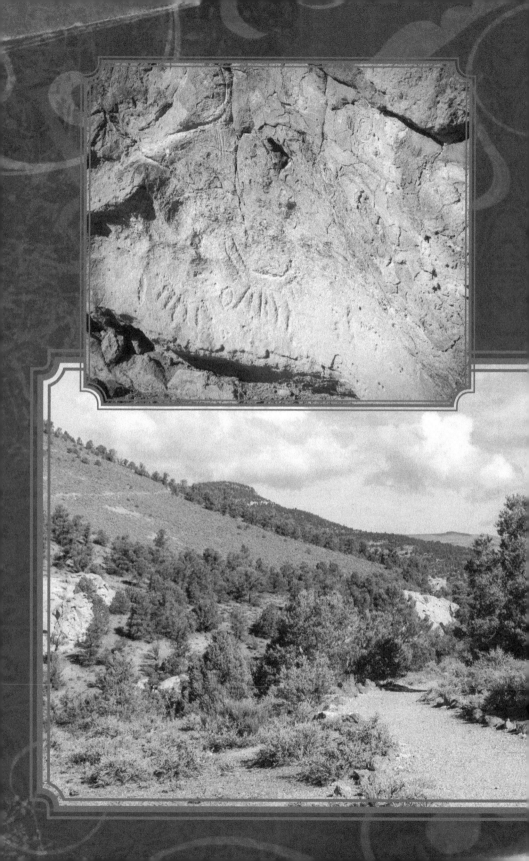

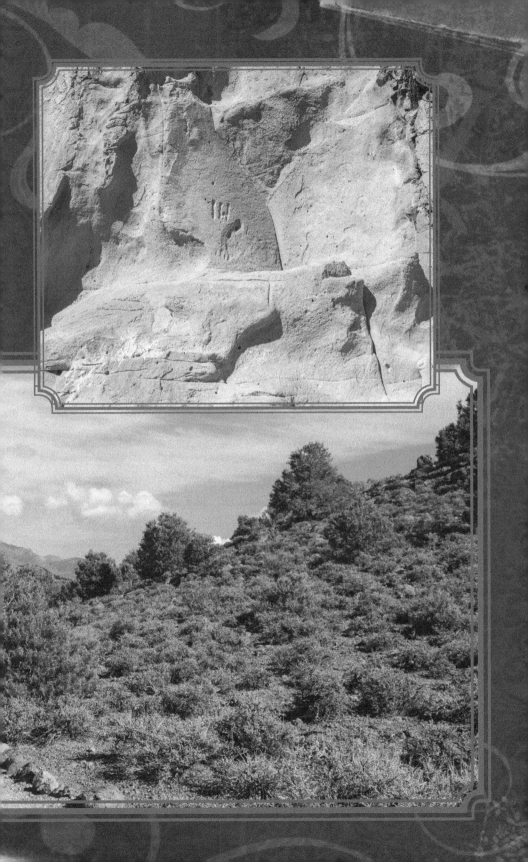

back to the self-guided tour, which shared information about more of the petroglyphs, the interesting trees and the different types of grasses along the hillside. One of my favorite petroglyphs here looked like a prehistoric dinosaur. It was etched at the base of a very large rock.

In all, we spent about an hour here. We viewed the camping area from the road. The spots appeared to be very nice and would probably be a great place to camp. Do keep in mind, though, it is dry camping—there are no services of any kind, meaning, NOT EVEN WATER. Check out the picture of their table covering; it was quite unique.

Next Stop: Dry Creek XP Station

The turnoff for Dry Creek was *very* easy to spot...There was a big sign that read, "Dry Creek," with an arrow pointing left. Can't get any better than that! Haha.

The gravel road looked like a good road, but since I have never been down it, I left the trailer at the turnaround spot by the mailboxes near the highway.

Following our map, we stayed to the left at the "Y" split. But first we stopped and took photos here. The guidebook mentioned that there should have been remnants scattered about, left behind from the Overland Stage Station that once stood there. There was nothing, no ruins or anything, that I could find.

We continued by following the road to the left. We passed a sign for the XP trail and continued up to the ranch headquarters. The guidebook suggested asking permission before visiting the ruins of the station.

We pulled through the ranch gate and stopped at what looked to me like the main house. I was amazed at all the stone outbuildings with sod roofs! A gal came out to greet me; I gave her my business card and introduced myself. She said she was the girlfriend of the owner of the ranch. I asked if he was around and she told me that he was not, and wasn't in phone range either as he was out cutting wood with the neighbor.

She was quite irritated with my presence, and began to share with me that people were always coming up to the house and asking if they could take photos and would continue to chat at length. I apologized if I was disturbing her, and explained that I came up to the house out of respect for their property, to get permission to photograph the ruins for my photo book. She said that was appreciated, but then told me to go back down to where I had seen the XP crossing sign and follow it...and make sure I shut the ranch gate on my way out. I replied with an, "Of course," then explained that I am a ranch girl and know that if a gate has to be opened it has to be shut.

As I prepared to leave, I asked her, "Do you know if I can drive out to the ruins that are down there? Or would it be better for me to walk in?"

She replied, "That is for you to decide, not me."

I followed up by asking, "How far is the marker that the ranch put up, forty plus years ago, from the ranch road?"

She said, "I am not good with that sort of thing, but even the horses have trouble getting to the site."

Final question I asked: "May I take photos of the buildings here by the house?"

She answered, "No."

Then, just before I parted, she added, "Well, okay, if they are for your own personal use, go ahead. But I don't want to see them in a book or online somewhere."

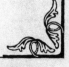

I respectfully replied, "I prefer not to take any then, as that is why I am here."

In all, we visited for about 30 minutes, and I even introduced her to Rider. Before leaving, she did give me the ranch owner's phone number. I thanked her for her time and headed out.

I took a few more photos of the XP sign and the gate where it pointed...There was a sign by the gate that read, "NO TRESPASSING." UGH...I was *very* discouraged by this site. But, I guess if I lived there, perhaps I might feel the same way...I don't know.

Back to the trailer I went with photos of a sign and a gate that said, "No Trespassing."

As I was hooking my trailer back up, a nice couple heading to California stopped to ask if I needed help. I said, "Thank you! All is okay. I am just reconnecting from my trip up the road." Their stopping was refreshing after my disappointment with Dry Creek Station. I plan on trying to get to this site another time. I wish I could ride a horse in, or a Gator, or something! I think this was a good place to have had a travel partner with me. Dry Creek Station has one of the most colorful stories, too. I need a picture for my book!

Next, we were heading toward the town of Eureka. My plan was to stay there and drop the trailer while going out to Sulphur Springs in the morning. But, with missing Cape Horn and not much time spent at Dry Creek, it was still early and only two o'clock. When I saw the sign for the road heading toward Sulphur Springs, Highway 278, I quickly decided—what the heck! We are going now!

Highway 278 and Sadler Brown

Next Stop: Sulphur Springs

 I knew from my notes and maps I was to take a dirt road
at about 14 miles out from Highway 50, but there was a
sign I had seen at the intersection of 50 and 278 for the
XP, and it said 19 miles. I drove past my originally planned
cutoff to see what was at the 19 mile location. I found it was
where the XP trail crossed Highway 278. There appeared to
be a parking area there, but I knew it wasn't a station...we
turned around and headed back to our original cutoff.

 The road was called Sadler Brown. And yet again, not
knowing what kind of roads might be ahead, I dropped
my trailer by the highway. (*That one off-road adventure
pulling an RV was enough for me; I learned my lesson!*)
I was to follow this road for four miles to where it cut off
to the right and headed to Diamond Springs XP Station.
The maps I had placed the station on the corner of that
intersection. We pulled over and started our search.
I couldn't see anything resembling ruins. I knew that
there had been an Overland Station here as well, and the
40-plus-year-old guidebook said that there were remnants
of many eras left behind. But nothing...

*Looking east toward
Diamond Springs*

While I was scanning the horizon of the valley, I heard a couple of vehicles coming down the road. I waved them down to stop, and asked if they knew where the site was. The gal in the first car said her mom might know, and she was in the car behind her. I walked back to *her* car, then asked the same question. She stated she wasn't sure, but then suggested I follow her, as she might have an idea of where it was. We went another half mile and she pulled over. To the right of us were mounds of gravel from mining. She looked around and said she didn't know where it could be, but thought it was around this spot somewhere. I thanked them both for their time, then told them I was going to take some photos of the area, at least, and maybe walk around some more.

Let's back up in time for just a second...Earlier, when I was dropping the trailer, I asked God (*I talk to him all the time*)...should I take my 200mm telephoto lens? Just in case? To this point I hadn't needed it...and for some reason felt I might, so I did.

Well, since I thought the ruins were off to the right of the road and couldn't see them, I put my 200mm lens on to scan the area. I knew that the site was supposed to be fenced off, as there was a well...I saw a fenced area about 1/4 mile off the road and still couldn't see anything resembling ruins. I decided to photograph the gate that was leading off to the supposed area.

With the long lens on, I had to back up, as I was too close to get it all in the frame. I kept backing

up...now I was up on the hillside across the road from the gate. While backing up, I always watch where I am heading, and as I looked over my right shoulder... LO and BEHOLD!! I found the site! LOL...*Thank you, God!* If I hadn't had on the long lens, I would have never looked on this side of the road. First, I saw one tall post that was charred. I knew from my research that this was one of the stations that had been burned by the Indians. I looked around the base of that post and saw more very short posts, all in a line, and with a square corner. Woo Hoo! I found it! There were so many things on the ground; it was absolutely amazing. Not big tall rock walls like so many of the other sites, but there were small treasures all around. I found a horseshoe, a hoof pick, all kinds of cans, a pail, part of a wagon wheel, broken glass of fine china (the blue and white china), and all kinds of colored glass. I believe the recent rains must have uncovered all of these treasures!

I took lots of photos here...it was by far a favorite, since it was so hard for me to find. The area I spotted first must have been the barn area. As I headed south, I found the XP post marker—the one made of a shiny metal that I have seen at a few of the other locations. That is also where I found the well to be, inside the supposedly fenced-off area. Remember that was noted in the 40-year-old guidebook. A few of the fence posts were still standing, but there was no wire around it. I took lots of pictures here, mostly because it felt like we had solved a grand treasure hunt! It will be a challenge going through all the photos, and then to decide what to share!

SULPHER SPRINGS

BITS & PIECES

The next XP station would have been the Diamond Springs Station. But the 40-year-old guidebook said that there was nothing left, only a grove of trees marking the spot, and a sign by the ranch house. We were running out of daylight, so we chose to head back to the trailer.

When got back to my trailer, the sun was setting behind a beautiful cloudy sky, so I took a few moments to capture the view of the road heading north and the sunset. Then I hooked up the trailer and we were off to Eureka!

Currently a county seat, Eureka is historic in itself. First settled by silver miners in 1864, it was quite a boom town in its heyday. There are lots of old buildings still standing. I found the museum, but couldn't find any parking where we could fit this big rig for the night. I sat there at the stop sign in front of it and searched on my *RV Parky* App for our overnight parking. There was a rest stop just up the road

about a mile. Perfect! We will come back in the morning when the town is open and explore then.

When I got to the rest stop, the sun was about gone, but I could see that there was an old mining camp just across the highway. Looks like it may be a great photo op for the early morning!

While Rider and I took a walk around the nice rest stop, we saw a few deer in the meadow. It was too dark to bother grabbing the camera. Then all of a sudden, "Rraaerr!" Several feral cats sprang out of the garbage cans as we passed by and scared the heck out of me! Rider wasn't sure what had happened...lol.

We came back inside and enjoyed a bite to eat...then early to bed once again.

OCTOBER 23, 2015
EUREKA REST STOP TO
SIGHTSEEING IN EUREKA TO ELY

This morning we were up bright and early. I fed and walked Rider, then rushed him back in to grab my camera. There were no deer in the meadow this morning. Oh, well...but across the two lane highway I went. There was frost again this morning; the ground was white and crisp. The old mining camp had a few buildings and a corral. I took photos of the hillside where the mine was tucked inside. After shooting all that I could, I jogged back across the road. I stopped at the large monument that stood proudly in the middle of the rest stop parking lot. The sign explained Eureka's status during the mining times of its creation. There were over 10,000 people living here in its prime! Then, in a quick moment, I was back inside my warm trailer to enjoy my morning coffee.

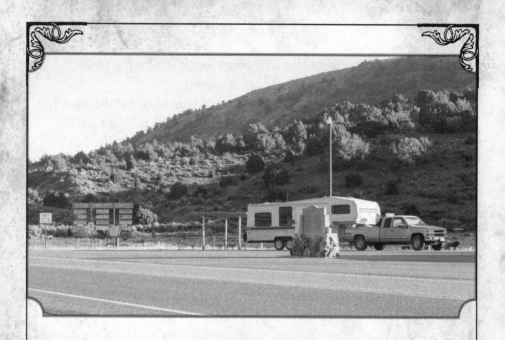

Rest Area near Eureka, Nevada. 18 Hour Limit

Across Highway 50 is an old mining camp.

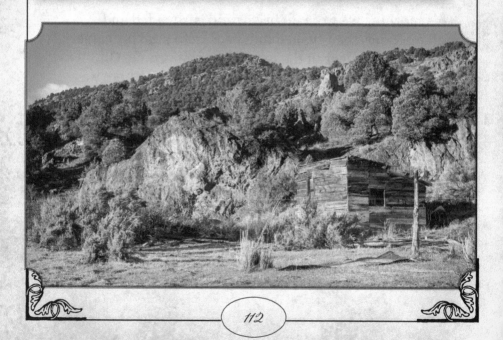

After having my coffee, I looked out the kitchen window and noticed a sheriff's deputy parked in the rest stop. He was probably watching for speeders, I would imagine, as this location was right where the highway came in to town. I decided to take Rider out and go chat with him.

The officer was a very nice young man. Rider really liked him and I had a hard time keeping him from jumping on his pristine uniform! I introduced myself and asked him if there was any place in town where I could safely park my RV while I walked around town? I mentioned that there weren't any places on the street when we came in to town yesterday evening. He said that there were some town meetings last night and that's why there probably were no places to park. He claimed that this morning there should be plenty, and to just park along the sidewalk.

We visited a bit, and I shared with him about some of my treasures that I have found on our journeys. He asked to see them, and then even took the time to call a cousin about a pink bottle I had, as he was a bottle collector. The collector told him that it was probably a perfume bottle due to the color, and he didn't think it would be worth more than a few bucks. Crud...lol. As the officer was looking at it, he started pouring the sand out, and there was a silver flume-looking thing inside. It appears to say, "Brass," and definitely says, "U.S.A." on it...neither of us was sure of what it is! Funny, I didn't know there was anything in it! It is cool, though! When we were done chatting, I bid him good day, then Rider and I loaded up and headed back into town.

Rider had to stay in the crate this morning, as I knew I was going to be gone for a while. First stop planned was the museums and then the highly recommended, by all brochures, famous *Opera House*.

 I chose the museum first. This site had been the first newspaper company in Eureka. It was closed now, with a sign on the door that read, "Be Back Soon." What does that mean? When did they leave?...lol. So, I walked to the antique store next door and visited with the lady there. She had a poster on the wall I would love to have been able to get a copy of. It showed some of the young boys who were XP riders! She didn't know where it had come from, other than it was from an old calendar. Bummer! They all looked about 14 to 17 years of age, each with a rolled cigarette hanging from their mouths. I had never seen this photo anywhere before. I mentioned to her the conversation I had with the officer this morning about the bottle. She said she had never seen pink glass before and had no idea of its value. She thought her best guess would also be that it was a perfume bottle due to the color.

 I left the antique store and headed back to the museum. This time, I met a man outside who was dropping something off. He shared that the lady who worked there was supposed to be there, so was sure that she would be back soon. He left a small box with instructions for a treasure hunt...he said that it was for a child's birthday party that they were celebrating. He asked me to share with her that the box was for the kids and the note was for the adults. I said I would if she came soon, otherwise I was

going to keep touring the town and be back there later. I waited for about five minutes, and then started walking and taking pics of the quaint old mining town while heading toward the Opera House.

The Opera House was indeed a treat! I walked in, donated a few dollars, and then started towards the stage. Here I met Leanna. She was mopping the hardwood floors in front of the stage. I asked if I could come in, and she stopped mopping and greeted me and said a resounding, "Yes, please do!" I started capturing photos while sharing with her about my travels of following the XP trail and hoping to put together a book of sorts of my travels. She noticed that there was a white screen covering the stage and told me to hold up a minute...she would fix that! She then went up and onto the stage and started pulling things...then, this beautiful painted curtain came down! She told me it was painted in the early 1920's (or 30's?). I told her, "Thank you, thank you, as that makes for a much better picture!" lol...Then she took me on a personal tour. I could hear children downstairs, and she told me we could go down there, but it was a birthday party, so we were not to interrupt. (*It was those soon-to-be treasure seekers!*) The walls were colorful, with writing of all kinds all over them. Leanna explained that all the entertainers who ever played here had written notes on the hallways and backstage over the years. I took pics of these, too. She took me backstage and around the back stairs...this was very cool! Then she said she must get back to work, as there was a Halloween event this evening she was preparing for. Then she told me I had to go up in the balcony area and get the view from there...which I obliged! After shooting way too many pictures of the same things over and over, because I wanted to get the feel of what I was seeing captured in the photograph...Finally, when

Eureka Opera House

The opera house was constructed by Richard Ryland Joseph Winzell, and M.D. Foley in October through December of 1880. They used the foundation of the Odd Fellows Hall. The building had been destroyed earlier in the year during a disastrous fire. One account described the new opera house as throughly fire proof, with two foot thick masonry walls, a brick and iron front and a slate roof. The official grand opening of the Eureka Opera House was held in January 1881, with the drama, "Forget Me Not." The building was the center for all activities in Eureka for many decades. Plays, masquerade balls, dances, operas, concerts and other social events were held. Ads for local merchants painted in 1924 by the Twin City Scenic Company can still be seen on the stage Oleo Curtain. Silent movies were first shown in 1915. By the 1940's the opera house name changed to the Eureka Theater. Movies were shown until the theater closed in 1958. The building stood idle until Eureka County purchased and restored it to its current splendor in 1993 and the original name of the Eureka Opera House was restored.

Dedicated June 6th 2009 (6014) by Lucinda Jane Saunders
ECV Chapter #1881 / Credo Quia Absurdum

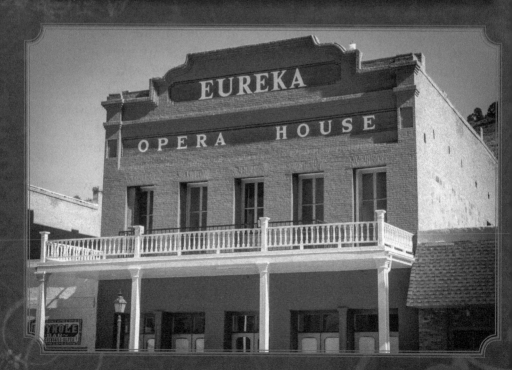

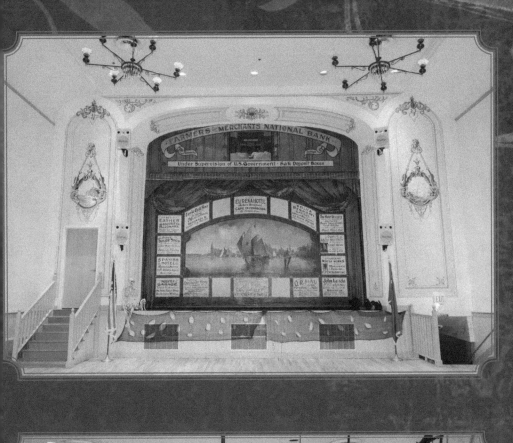

Autographed
Hallways

Bead cape worn by Lola Montez (1818-1861), legendary
actress, dancer, and entertainer of the gold rush camps.

Entertainers

heading to leave...Leanna met me at the door. We chatted about places we had lived and seen in our lives. She, too, was about 50 years old and had raised a family. She shared that when she lived here as a young mother, they had to drive all the way to Reno to get supplies! She exclaimed that teenage boys sure could eat! I agreed. I told her I couldn't imagine the drive—and twice a month! Wow!

She reminded me, "Don't forget to sign in!"

I did. I did this at every opportunity. I had at all of my stops. Then, as we were winding down, I noticed a bunch of brochures by the door and saw one of the Ely steam train. Ely was my next evening's stop, and I asked her if she had ever ridden the train there. She replied with a joyous, "YES, and I loved it!" She went on to share that their train was robbed by horseback riders and that the kids were given a $1000 dollar bill at the end of their ride. She explained that the train did different themes throughout the year, and that I should go. I told her I have *never* been on *any* train, and I was going to do it! She then recommended that I make sure I go into the courthouse before leaving Eureka, as it, too, was open to the public and right across the street... so off I went. What a great place the Opera House was, but it was Leanna who made it so special today! *Thank you, my new friend!*

The Courthouse was in beautiful condition. A very nice lady greeted me at the desk in one of the first

offices. She stamped my passport and gave me instructions of what to see in the courthouse. Upstairs was the original courtroom...beautiful! All the woodwork was just amazing. There were lots of pictures hanging on the walls of the days that Eureka was in full bloom.

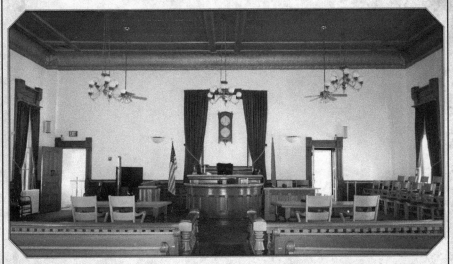

Once I came back down the stairs, the nice lady greeted me again. She said, "Follow me." She took me to a hallway with photographs that had been donated to the courthouse...then she shared where the local artists' works were hanging, just around the corner. I tell ya, this town, too, was as warm and welcoming as Austin! (*I am so sorry I didn't get her name!*)

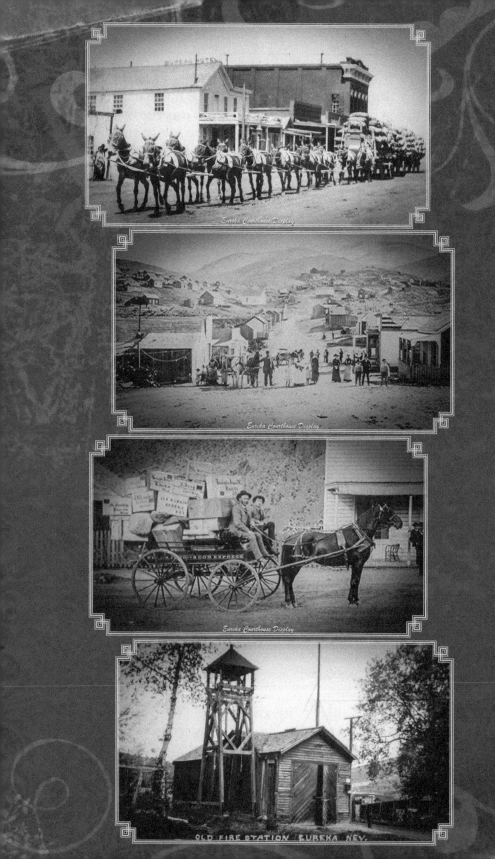

Eureka Courthouse Display

Eureka Courthouse Display

Eureka Courthouse Display

OLD FIRE STATION EUREKA NEV.

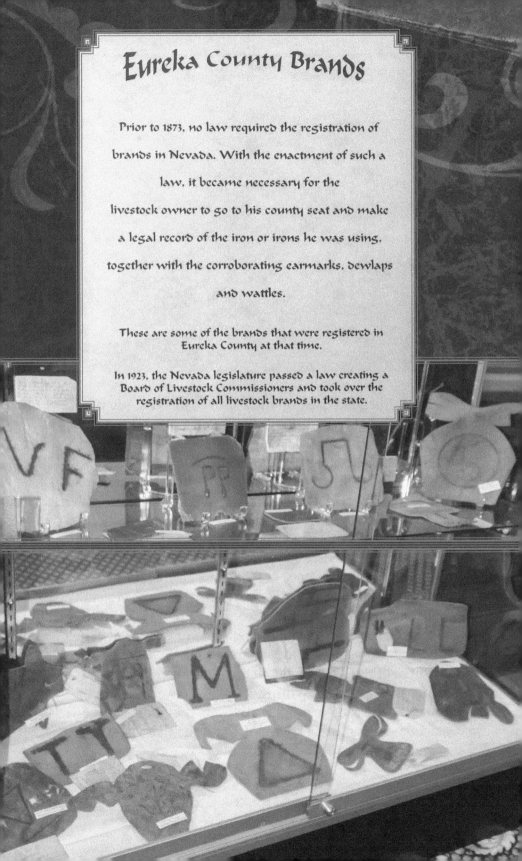

Eureka County Brands

Prior to 1873, no law required the registration of brands in Nevada. With the enactment of such a law, it became necessary for the livestock owner to go to his county seat and make a legal record of the iron or irons he was using, together with the corroborating earmarks, dewlaps and wattles.

These are some of the brands that were registered in Eureka County at that time.

In 1923, the Nevada legislature passed a law creating a Board of Livestock Commissioners and took over the registration of all livestock brands in the state.

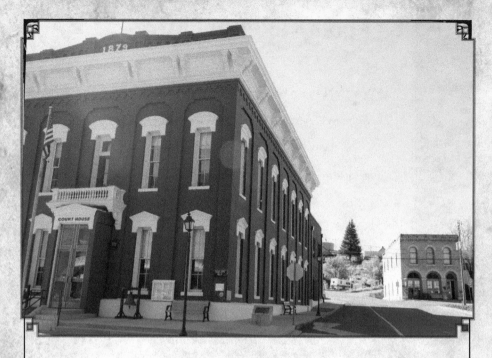

Next, I headed back up the hill once again to see if anyone was at the museum yet. This time she was there. Very funny—I found out that I had just missed her; she had been at the Opera House just before I was, as she was in on this birthday party treasure hunt! What a great idea—and how awesome that the whole town participates! I introduced myself and explained to her, too, about my XP adventure and asked her if there was anything in the museum about it. She said there was not too much, but there was a lot of history here! Then she shared the history of the building—how it was the original newspaper, and still has the original printing room—*intact*! WOW! What a room! There were old newspapers lining the walls, the printing press, and all the makings for a newspaper! I took pictures of the papers and all the equipment. While I was doing so, I met a nice young couple who were also there touring. It was their umpteenth time, they said. The gal said she still notices articles on the walls that she hadn't seen before. I said, "I bet!"

Then upstairs I went to see the rest of the museum. They had 1800s fireman tools and clothing, a kitchen, band uniforms, baseball uniforms from the early 1900s, and of course mining artifacts. There were ranch brands on old wooden doors, and there was horse tack scattered about. In one of the glass cases, there was a pair of old spurs. Then I spotted something I didn't even know ever existed...an ox shoe!?! I never knew that an ox would need to wear shoes! I don't know why, but I never even considered it. Yep, got a photo of that, too! Then I made it back downstairs just in time to see some children running in to get their toy from the box for the treasure hunt...such excitement for the kids and the adults.

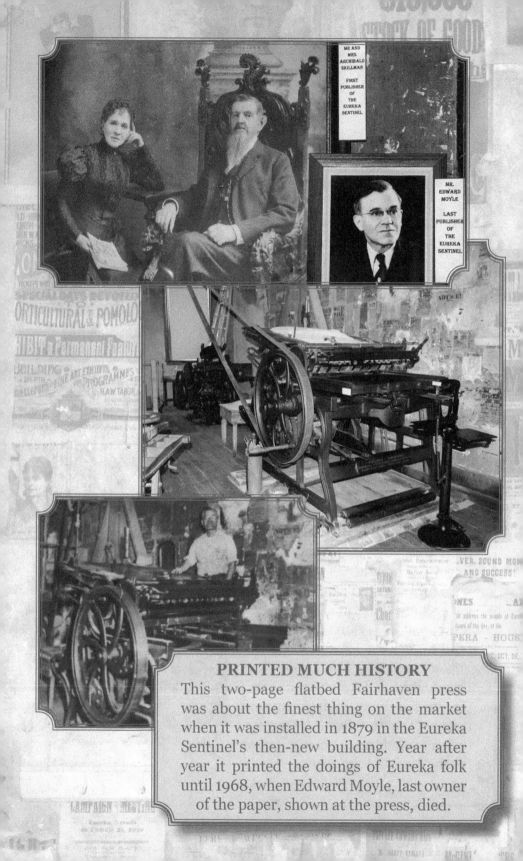

PRINTED MUCH HISTORY

This two-page flatbed Fairhaven press was about the finest thing on the market when it was installed in 1879 in the Eureka Sentinel's then-new building. Year after year it printed the doings of Eureka folk until 1968, when Edward Moyle, last owner of the paper, shown at the press, died.

MR AND MRS ARCHIBALD SKILLMAN FIRST PUBLISHER OF THE EUREKA SENTINEL

MR. EDWARD MOYLE LAST PUBLISHER OF THE EUREKA SENTINEL

EUREKA SENTINEL

Ox Shoes

**Donated by
Dorothy (Borgna) and Earl Melander
In Memory of Earle Borgna**

EUREKA
MUSEUM

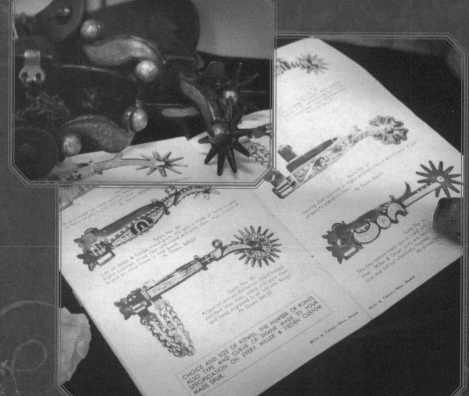

CHOICE AND SIZE OF ROWEL, THE NUMBER OF POINTS
ALSO TYPE AND CURVE OF SHANK, MADE TO YOUR
SPECIFICATION ON EVERY MILLER & TIETJEN CUSTOM
MADE SPUR.

H. A. MEKIM,

North Main Street,

EUREKA, NEVADA.

MANUFACTURER AND DEALER IN

Harness, Saddles,

BRIDLES, WHIPS, SPURS,

AND ALL GOODS IN THE SADDLERY LINE.

Harness and Saddles Repaired Promptly and at Low Prices.

June 1st 93

SOLD TO

Chas Minnich

GILHAM'S

COW BOY DOUBLE CINCH

Eureka Museum Display

I looked around the gift store a short bit, then signed the guest book, made a donation, thanked the lovely gal, and was back out the door.

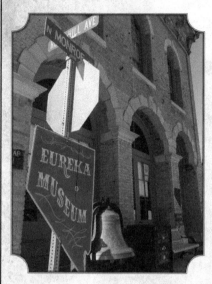

After getting more pics of the buildings in town, I hurried to get Rider out for a walk. He was so happy to see me. :-) But I am afraid he was not so happy to get back in the truck...lol. But he did.

Before moving my truck, I got on the phone and called the Ely train station to check on ticket availability for tomorrow. The gal said, "We have plenty of tickets! No problem!" and, "See ya at 12:45 tomorrow!"

Since our stay in Ely put us a ways south of the XP trail (*I had to travel out of the way some to avoid dirt and two-track roads*), we checked online to find where we were going to stay next. I called and made reservations for the RV Park at the Prospector Casino in Ely. I wanted a boondocking break. The *Lonesome Dove* DVD collection I bought before my trip was calling my name. I had started it before heading out and needed to get back to their story for a time...

I took pictures of the drive through the mountains to Ely, and we made it before dark. I set up the TV and made dinner—even enjoyed some popcorn tonight, courtesy of the Prospector lobby. HA! Life is good.

I am so excited about riding the Ely steam train tomorrow...I feel like a little kid.

October 24, 2015
Ely Prospector Hotel to
Nevada Northern Railway Museum
to Schellbourne Rest Stop

The RV park check-out this morning was at 11:00. That was
no problem for me today, as I was so excited to get ready
and head to the *Nevada Northern Railway Museum* train
station! I got the water tanks filled, other tanks dumped,
the RV batteries were all charged up—and we were outta
there!

At 11:00 a.m., I was at the train station. I walked Rider
around so he could see a few of the sights, too...as I had to
break it to him: Sorry, pup, no dogs allowed on the train. :-(
Around noon, I put him back in his crate in the trailer,
opened all the windows, as today was a beautiful day and
the weather was perfect—a high of 73°!
I hurried like a child going to Disneyland to get my
train ticket! I walked through the inside of the station
for a few minutes, but the anticipation for the train drew
me outside. The engineer was getting the old Engine #40
fired up for our run. The *shush-shush-shush* sound was
almost hypnotizing. I took pics of the angles I could get,
then realized I still had 45 minutes to wait...lol. I went
upstairs to the museum and looked at the offices and the
memorabilia they had. The purchase of my train ticket also
included a pass to enter the museum. Pretty cool, huh? The
ticket, by the way, was only $27, and I got it for a discount
of $21 since I have a AAA membership. Pretty great deal, I
think!
After finishing up with getting pictures inside and a shot
of the engine through the upstairs window, I headed back

outside. I visited with others who were waiting to board the train as well. Many were true steam engine enthusiasts and were quite knowledgeable about it all. Several suggested that the Silverton Train out of Durango, Colorado, was also a must if I liked this one.

Well, the black smoke was really pouring out of the stack now, and time was growing close...Still feeling giddy, I got in line. There were many volunteers running this event, and all dressed according to the era. "ALL ABOARD!" Our tickets were torn and on the train we went. There was a passenger car for folks who wanted to sit inside. I got a picture, then hurried to the outside car where most of the passengers chose to sit at today. Like I said earlier, it was a beautiful day, and of course you would want to sit outside so that you could get the full feel of being on the train...hear that whistle blow, loud and clear! My camera was ready, and so was I!

The train started off as a bit of a rough ride. A short while after we were going, the conductor came by and punched our tickets, just like they did over a hundred years ago. I asked him if, when he was done, could I please get a photo with him. He said, "Absolutely!" A nice gentleman on the train took it for me.

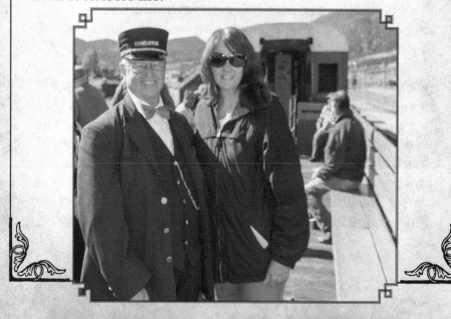

We rode by the city of Ely, then past ranches, and one house of ill repute. (*We are in Nevada, ya know.*) One conductor volunteer said that usually the girls come outside to wave at the train. (*We did see them waving on the way back.*) A gentleman over the loudspeaker was sharing information about all the sites we were seeing, though a little hard to hear at times due to the sound of the train rolling on the tracks, but nonetheless was very informative...when you could hear.

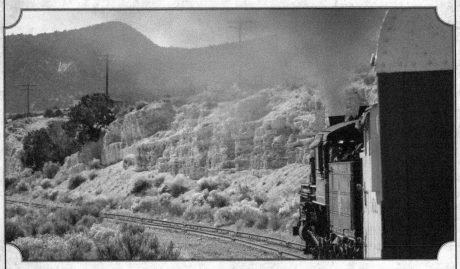

The train ride was 90 minutes. We went through two tunnels, and my favorite thing was hearing the whistle blow before all road crossings and tunnel entrances. I videoed this a couple of times as best I could. I set my camera to a fast shutter speed, as the train was pretty rocky. I pray they come out.

Aliens !?

Mining

Yesterday and Today

Nevada Northern Railway
Engine #40

On the way back to the train station, they offer an early drop-off at one end of the train station for those who also want to tour the mechanics' shop and other buildings. This, too, was awesome, as there were snow plows, cranes and other equipment in the "parking garage" next to the shop. Before going inside to the mechanics' shop, I spotted a very dirty cat. He was sitting next to a man dressed in period overalls that were also dirty from working. The cat fit in, as if he were a volunteer as well. Of course, I shot a few photos of him, too. His name was catchy, but I can't remember now what it was... Grimy? Dirty? Or something to do with being covered in smoot...

The inside of the mechanics' shop was like Santa's Workshop for train mechanics: there were all the tools you could imagine. All the large tools that it took to work on these massive machines were neatly organized, ready for use. This is where the magic happens to restore and maintain the trains and the

cars. The volunteers love their work and take great pride in the service they provide for us to enjoy this wonderful part of history...

Safety First. This was their motto, and they have it printed on everything...clothes, buildings and even the trains.

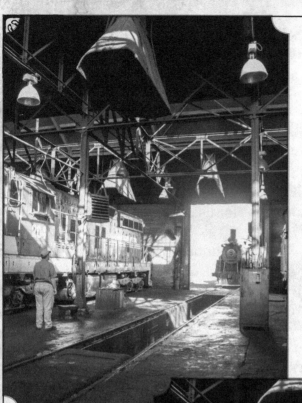

Just on the other side of the mechanics' shop was the garage, where more engines and historical cars of many kinds were stored. Our volunteer host was very knowledgeable and shared the history of each.

Before leaving the garage, I visited with a few of the other passengers, and then I headed back to the trailer. I knew Rider would be ready to see me, and get outside for a break. He was, and he did!

Now for the next leg of our trip, and back to the Nevada Pony Express adventure.

Schellbourne, here we come!

The plan tonight was to stay at the rest stop near the Schellbourne Ranch. This location was in the center of several Pony Express stations, and right on the trail. In one direction, heading west, was the Egan Canyon Station. Heading east, was the Schellbourne Station, then the Stone House and, finally, Antelope Springs.

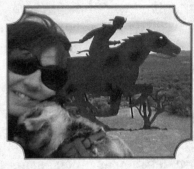

We made it to the rest stop about 5:00 p.m., and the sun was beginning to set. This is a great rest stop with lots of information about the Pony Express. There is even a larger-than-life sheet metal cut-out of a horse and XP rider! It is very cool!

I found a great place to park our RV that was away from the truck parking. Before I could put Rider out on his lead, which is connected to the trailer, I had to clear an area, as there was a lot of trash in the vegetation where he could do his business. My poor puppy, he is about trucked out...lol.

I have been contemplating this evening on how long I can stay here, and how many stations I could get done from here.

Egan Canyon is 15 miles west, and the literature I have states that there is nothing of the XP station standing. It does mention, though, that there are a few graves and some mining camps up there. Bill Mooney had mentioned he did not see the graves when he passed through, so I have to keep in mind I may not find them.

Then the other direction. It is four miles to the Schellbourne site. Research states it has a lot of ruins... from there, eight miles to Stone House, which was noted

to also be a well preserved site...then another 14 miles to the Antelope Springs Station. The old guidebook makes mention of there once being a log cabin there, but as we know, a lot has changed since it was published. So, with this information—and limited daylight—I am going to go east tomorrow!

(*I am limited on time, as I have to be in Winnemucca on the evening of October 26th to prepare for my booth at the Ranch Rodeo Finals. I will be sharing my Western artwork and offering it for sale there.*)

The wind has begun to pick up, and the trailer is moving quite a bit...but that will probably help rock me to sleep tonight. I am in bed already, and it is before 8:00. Many nights on this trip I have been hitting the hay by 7:00. It gets dark pretty early...and with no power—heck, why not? With our days spent getting up early every morning, with lots of driving and hiking...it has been nice to be able to rest in between as much as possible.

October 25, 2015
Schellbourne Rest Stop to Schellbourne to Spring Valley to Antelope Springs XP Stations to Schellbourne Rest Stop

As I prepared to head out this morning, I wrote a note and hung it on the window. (*On this entire trip, I have kept family and friends updated at all times on my daily agendas; when I was heading out...where I was leaving from...where I was going...and when I should be back by, at the latest.*) I shared that I was leaving my trailer here only temporarily, then stated what I was doing, and where

I was going. First and foremost, I didn't want a Highway Patrol to think it was abandoned, in case I didn't make it back for a few days...and also, I had added that I would be back soon, and should be back by dark at the latest...and if I wasn't, to please send assistance.

On each outing I took snacks and water, and carried a side arm at all times. Though the weather was cool, I never knew what I might run into while in the desert. Most of the stations are made of rock, and snakes and critters like rocks...lol! Me, I don't like snakes, and I wasn't gonna let them hold me back from doing this adventure! Also, I am no fool; there are some not-so-nice people in the world... they weren't going to stop me either. I have to say, I have been blessed with how many wonderful people I have met on this journey! I am truly grateful to have met every one of you. *Thank you! Thank you, Lord for watching over us this entire trip!*

Next Stop: Schellbourne XP Station

The road heading out was a well-maintained gravel road. Boy, it sure was nice to not be pulling the trailer.

It was a quick four miles to the Schellbourne Ranch, our first stop for the day. My 40-year-old guidebook recommended folks to go to the ranch headquarters and ask for permission before visiting the ruins...I was praying this would turn out better than Dry Creek.

Upon pulling around the right turn that leads in to the ranch, I was very impressed by the awesome sign at the entrance and the tree-lined driveway

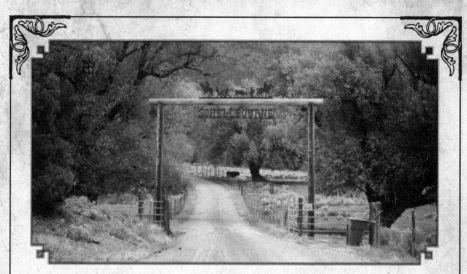

behind. There was a huge log-built home on the hill off to the left as you pull around the first corner. There appeared to be no one home. Just behind it, there was a modular home and a pickup was parked nearby, so I decided to head there. I parked near the house, took a deep breath, and walked up to the door and knocked. A big dog started barking, and little Rider stood up and looked through the truck window and watched me as I waited by the door. A nice-looking, 40-something gentleman opened the door and a big black Labrador came racing out for me to pet him. What a relief he was friendly! I introduced myself and gave the gentleman my card. I explained to him that I had started on the other side of the state taking pictures of XP ruins and hoped that I could get pictures of the ruins here. *(I could see them when I parked the truck...Wow! Now this was a site!!!)*

He said, "Sure, they are a part of history and should be shared. Are you writing a book?" *(Hallelujah!!!)*

I explained that I was doing a coffee table book with the photos. I was so relieved by his hospitality, and continued to thank him many times. Also, I was so excited! He shared with me that, after I shot the ruins, if I were interested, there was a small cemetery just past them, at the end of the

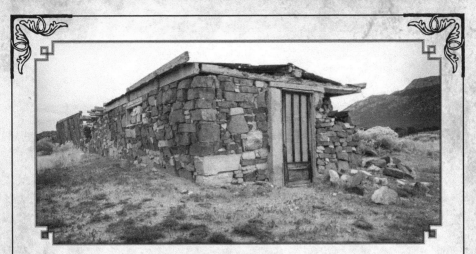

tree line. I responded with a profound, "YES! That would be great!" He went back inside with his nice, giant pup, and I headed for the truck to get my camera!

Right by my truck there was a small rock building. I started snapping photos right there! Then I jumped into the truck to head to the next set of ruins. This place was pretty much a city in its prime. There had been 20+ blacksmiths, a bank, hotel...and so much more, including our Pony Express station, though I was not sure where it was—only that it was a log building.

One of the buildings had about 10' high walls, with the metal shutters you see in many historical buildings. (*I have learned they were used primarily to keep fires from spreading.*) After getting as many angles as I could of all of the building ruins, I got in my truck and headed for the cemetery.

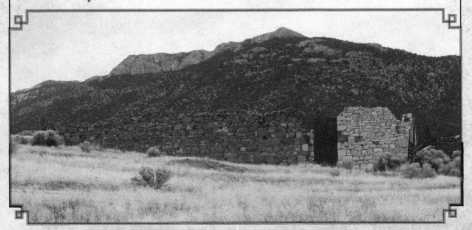

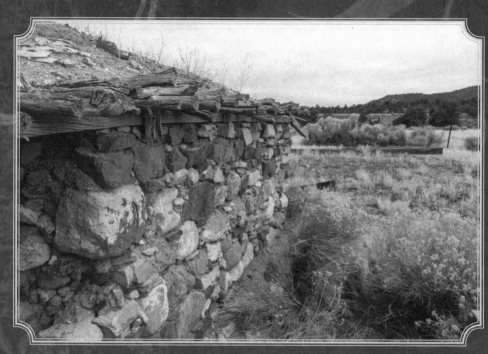

SCHELLBOURNE

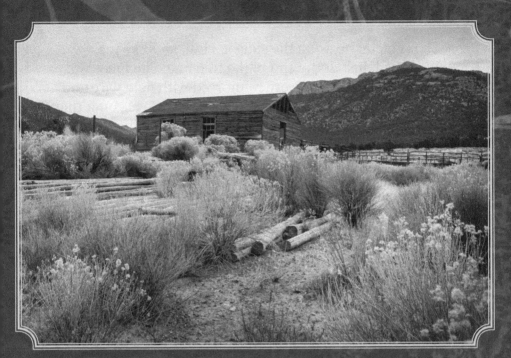

RUINS

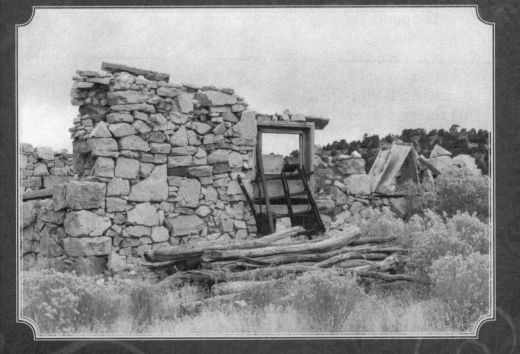

The cemetery was on the side of a hill, and like the man shared, just at the end of the tree line. The fence was made of branches that were reinforced with field wire and T-posts. There was a large metal cross with Jesus on it that stood proudly in the middle. There were wooden crosses and metal crosses for grave markers. It wasn't a very large cemetery, but I was so curious about who was buried here... were they of one family? Were the small crosses for children? So often, from that era, you see so many that were. On the metal markers, it appeared there were names that had been dotted out by punching holes through the metal. I zoomed in best I could to maybe tell later when I get them on my computer.

This was an absolutely beautiful setting for a resting place. These graves were overlooking the Steptoe Valley. This ranch site had plenty of water and green pastures. The trees lining the ranch road were large from their age. Their leaves were turning to beautiful fall colors, which beckoned me to photograph them as well.

As I stood there, appreciating the distant view, and then drawing back to my surroundings of these ruins and graves...I tried to picture the people running around, the sounds of the stages coming in...the pioneers passing through with their wagons...with 20 blacksmith shops—this place had to be hopping! Just think of the history that took place here! I felt almost sad to leave...I walked Rider for a minute, and then back in the truck we went.

We had a lot of miles to cover today. As I passed the ranch house, I honked my horn twice, to say a farewell and let him know I was leaving. Then, just a couple hundred yards past the house, I saw a building...I had missed it on the way in! It was a log barn, with large poles pointing to the sky! I stopped to capture it...Was this a barn originally? Or a part of the XP station? I don't know, but it was worthy of my capture.

Back in my truck and slowly out of the drive we went...
Enjoying my surroundings, I took another pic of the sign,
now reading backwards, and in the background, the sign
with the XP arrows for the trail.

Leaving the ranch, we made a right (east), heading
toward Spring Valley.

Next Stop: Spring Valley/Stone House XP Station
Following the *Nevada Atlas*, I knew that there would be
a ranch where the road was going to split, and that we were
to go toward the right. As I approached this intersection,
I saw a few young men walking to the mailbox. I asked
them if this was the ranch showing on the map, as it had a
different name. Also, if they knew where the Stone House
was? Or Spring Valley XP Station? They said they didn't
know about the ranch name and had never heard of either
one. Oh, well, I figured this had to be our turn, and off I
went to the right.

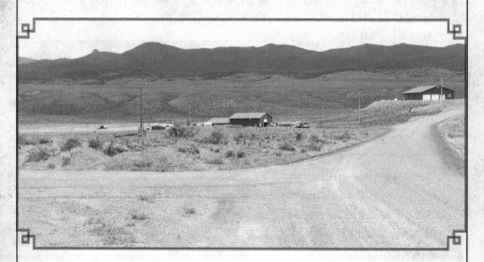

We drove for only a short bit when I spotted some mules
in the pasture off to the left. Of course I did a quick stop,
got a couple quick pics—I love mules, by the way—then

back in the truck. Yes, sometimes I see "squirrels," too...lol *(meaning easily sidetracked at times!).*

A few more miles down the road, we came up on a large lush pasture with a pond, just off to the right-hand side. At the end of that meadow, there was a house sitting right by the road. Yes! It was our Stone House, and so easily

accessible! The house was not fenced off. There was no one there, nor did it appear anyone could live there. We pulled over and parked just across the road, by the sign pointing to Ibapah, Utah. I put Rider on his leash, and we walked over to check it out.

The windows were missing, but the roof had been re-tar papered for protection. The walls were thick and strong looking and—yes!—all of stone! I looked in the first window

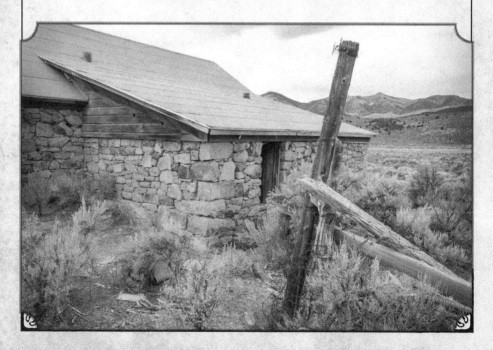

in the front, and you could see the ceilings were falling down. Then we started walking around the side of the house and could see that the ceilings were not so bad in the other rooms. I started to back up to take a picture through the window, and as I looked back, I could see where the ground was missing...Yes, missing. It was the area around the edges of a root cellar or dugout. There were beams with a sod roof that still covered most of it. It kinda freaked me out, as it was not easily visible. It heightened my senses, making me become even more aware of the ground around me. With these old, old places, you must pay attention to the ground, as there could be holes where there once was an outhouse, or a well, or an underground structure like this root cellar. This was when I put Rider back in the truck so I could pay attention to my feet and not worry about his, too!

I took some pictures of the dugout as best I could, then turned back to the house. I took more pictures through the window, as I knew I was *not* going to go inside. The floors were wood and the ceilings were falling—not a good place to walk around in.

When we had parked, I had noticed that there were corrals out back. There were a few mounds between them and the house. There were a lot of tin cans and the like scattered about as well. After I walked up the fence line, I was able to see the full view of the corrals. Lo and behold, there was an old log barn or cabin!

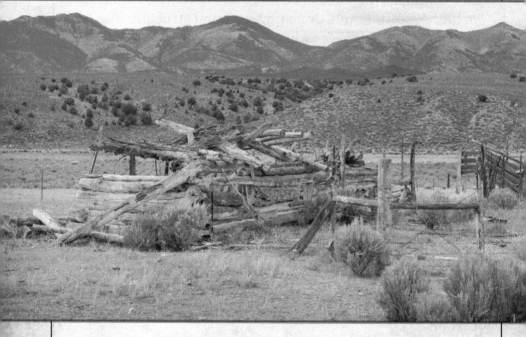

Woohoo! I love to find unexpected barns! The corrals were made mostly of willow branches and any other wood product available. There was also a loading ramp, and we know that that wouldn't be part of the original stage or Pony station. Yet, it was all very cool, and I took lots of pictures here.

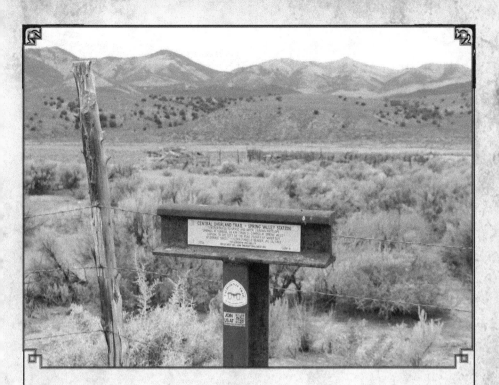

While continuing my walk down the fence line, I found a sign posted on what looked like a railroad rail, and on it read:

CENTRAL OVERLAND TRAIL — SPRING VALLEY STATION
Sixteen miles to grass and water. Leaving Antelope Springs at sunrise, 10 a.m. finds us camped at Spring Valley Station, to the left of the road. Plenty of water but miserable grass.
- Flora Isabelle Bender, Jul 14, 1863 (Trails West, Inc)

Nice!
Then it was back to the truck to give Rider a much needed break, as I spent quite a while soaking up this place! Wow! *Two* great finds in one morning! Loving it!

Next Stop: Antelope Springs XP Station

Remember where I mentioned the sign for Ibapah, by where we parked? It also listed that it was the turnoff for Antelope Springs as well. Not quite so mysterious as other sites we have had to look for, but that's okay...I enjoyed knowing where we were at. We knew that it was another 14 miles down this gravel road. But that the next turnoff to the station was a bit sketchier to find on the *Atlas*.

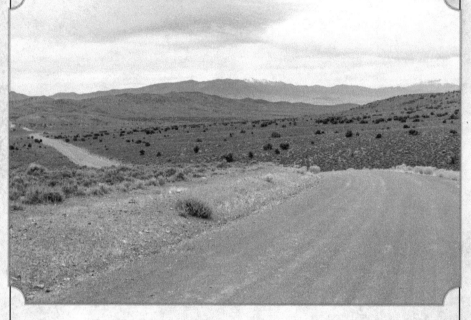

Going over the hill from Spring Valley to Antelope Springs was a bit of a bumpy ride, but nonetheless, it was still a pretty darn good road. When we crested over the top and saw the view, I stopped. What a beautiful view of this wide open valley! The road now was very good, and I actually reached speeds of about 50mph...when acceptable, of course, and with good visibility, which in that valley there was plenty of. As I drove for about eight miles in the vastness, I imagined that a Pony Express rider would have

enjoyed his run through this valley for that very reason. There would be a lot less stress for him when he could see all around in every direction!

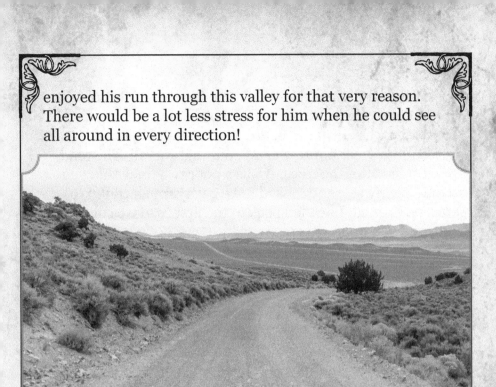

When we finally reached the XP sign cutting across the road, I turned left and headed up the hill on the two-track trail. When we had gone about a half mile, there was a sign

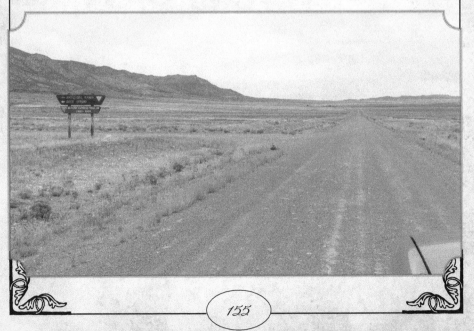

pointing to the right that read, "Old Lincoln Highway."
From there, I could see a grove of pines. I wondered if
the cabin was down there. So, we turned. Well, it was
probably a great hunting camp, but that was all. The road
continued after the trees; it was a poor two track that you
could barely see, and looked to be a very rough trail. We
turned around. I headed back to the first road we cut off
on, and kept following it.

There were groves of pine
trees in so many places.
*(Again, I was missing
the ONE main ingredient
that I failed to bring with
me: BINOCULARS!!!)* I
checked as many groves
as I could by walking to
them, then back to the
truck. Pull forward and
repeat...ugh...I never did

find a log cabin. Now I really do wonder if it still exists...
But I had to drive out there to at least look for it. Besides, I

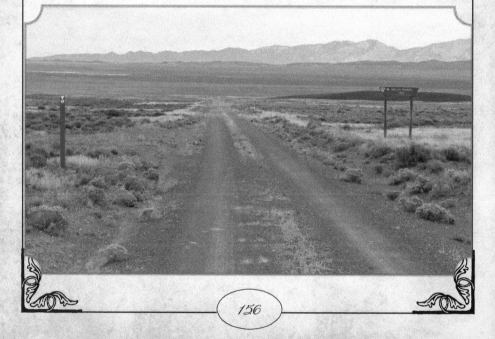

had read from the old guidebook that he recommended this part of the XP trail most of all, for the good road and the beautiful views. I am glad I listened.

I let Rider out for a while to let him run his furry little butt off, while I walked around and ate a snack and drank some water...and enjoyed the gorgeous views of the wide open spaces.

The wind had started to pick up and it began to look like a rainstorm was heading towards us...After giving Rider a good drink, we headed back through the valley again towards the rest stop.

After Antelope Springs, there was mention of a couple more stations heading towards Utah. The research had stated their exact locations were unknown. One was said to possibly be on the Goshute Reservation. The information was way too vague for me to pursue them.

The drive was easier heading back, now that I knew the road, the turnoffs and the distance by landmarks. I took in the views and bid farewell to Antelope Springs Valley... then Stone House...then Schellbourne Ranch...then, while I was coming up and over, and almost could see the highway at the Schellbourne rest stop, I noticed a sign on the north side of the road. I got out and read it. It was the old telegraph location! It was surrounded by huge black rocks

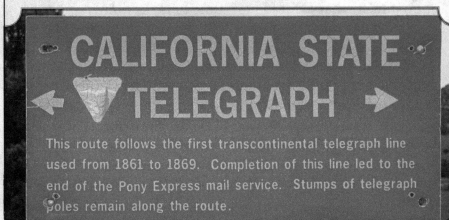

CALIFORNIA STATE
← ▼ TELEGRAPH →

This route follows the first transcontinental telegraph line used from 1861 to 1869. Completion of this line led to the end of the Pony Express mail service. Stumps of telegraph poles remain along the route.

and a few posts sticking up out of the ground with the Pony Express Trail in the distance. Nice bonus!

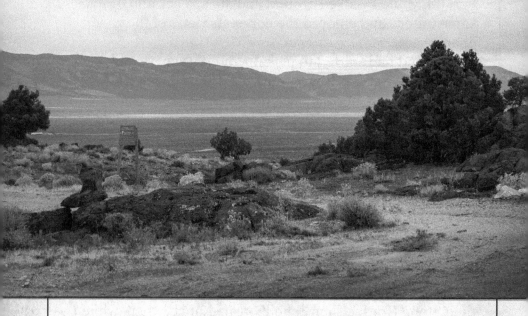

We then continued back down the hill into Steptoe Valley, and back to our trailer we went.

When we arrived back at the trailer, it was about 4:00... As you know, most nights I have tried to camp by 4:30-5:00 p.m. so that I would have time to make dinner and recap my day, plan the next...Well, not tonight! I realized today was already Sunday, and I had to be in Winnemucca by Monday evening to get prepared for setup on Tuesday morning at the WSRRA Finals (Western States Ranch Rodeo Association Finals)...and we still had one more stop to go...Elko. I decided to head to Wells, Nevada. There is a Flying J there that I had stayed at before. I knew exactly where we were going to park.

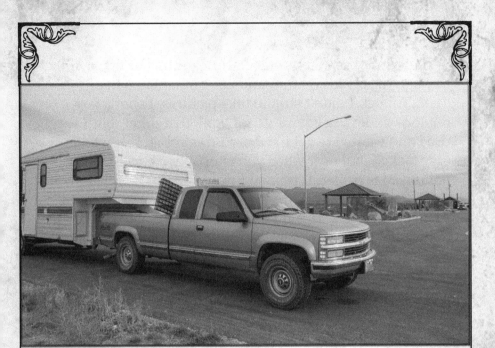

We hooked up the trailer and said "Good Bye" to the Schellbourne rest stop.

The drive over was spectacular! Beautiful lighting coming through the clouds on the sandstone mountains to my east...Though I didn't stop to take pictures, I shot a few out the window...a big no-no for a photographer, but I was tired and wanted to get to where I was going. It's not an easy task to pull over when you're on a two lane highway pulling a 26' trailer. I decided I would accept it and enjoy it as a treat to share with the good Lord...He has blessed me so much on this journey! I am so thankful. Each day, before we would head out, I literally prayed, "Lord, please send your legions of angels to watch over Rider and me, and our truck and trailer today. Keep us, those around us, all safe, and may we enjoy everything we do. Amen." I would have doubts and fears that tried to sneak in occasionally about changing a truck tire with the trailer attached, or getting way back somewhere and having truck trouble—but I never did, and I know it was answered prayers. My truck is well maintained and so is the trailer, but both are far from new!

Thank you, Lord, for the protection and blessings.

We made it to Wells and I had on my mind a Big Mac! I hadn't had any fast food for over two weeks, and could sure enjoy it tonight! That was my first stop, then across the street to the Flying J. My parking spot was open, thankfully, and we could finally stop. I fed Rider outside on his lead and went in to eat my hot fries and Big Mac...lol. Oh, it's the simple things in life sometimes! ;-)

After eating and relaxing a few minutes, I went online to check out the museum for tomorrow's last leg of the journey. The Ruby Valley Station had been moved to the Northeastern Nevada Museum and I wanted to get pictures of the cabin. Their website stated they were closed on Mondays...What? Closed?! OH, no! I was so disappointed...I stayed on the site to see if there was at least a photo of it. There was only a mention of it, and no

photos...Then, a big sigh of relief...Surprise! It stated that the cabin was in *front* of the museum and *outside*...Woo Hoo! Right on...Now I am heading to bed. We have lots of miles planned for tomorrow: Elko, then Winnemucca!

OCTOBER 26, 2015
WELLS TO ELKO TO WINNEMUCCA

We took our time getting up this morning. I went in to the truck stop to purchase my morning coffee, and got a stout cup to go.

We had a nice drive to Elko. The weather was cool, and it was an all-around beautiful day. Just a few clouds in the big blue sky.

When we arrived at the Northeastern Nevada Museum, it was easy to spot our Ruby XP Station's cabin, as it was right by the entrance of the museum. There was also a beautifully restored stagecoach sitting under the eaves in its own little alcove.

**RUBY VALLEY
PONY EXPRESS STATION**

This small building was originally located 60 miles to the south,
where it served the Pony Express from April 1860 to 1861. It
was moved to this location in 1960.

STATE HISTORICAL MARKER NO. 108
STATE HISTORIC PRESERVATION OFFICE
NORTHEASTERN HISTORICAL SOCIETY

While attempting to take a selfie while holding Rider, a nice lady with several kids, who had the misfortune of not knowing that the museum was closed today, was our blessing. She offered to take a photo of us with the cabin in the background.

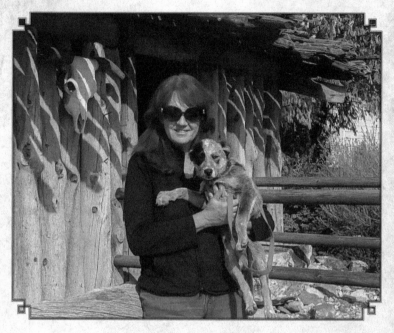

Sadly, this was the end of our journey. Yet...*wow*! What a journey it has been! I only wish I had another week so that we could have gotten to see a few more locations.

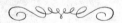

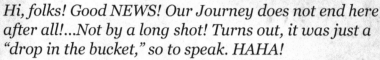

ADDENDUM

Hi, folks! Good NEWS! Our Journey does not end here after all!...Not by a long shot! Turns out, it was just a "drop in the bucket," so to speak. HAHA!

Keep on reading...Thanks to many of you that asked for more...we got to broaden the distance further over the next few years!

Looking back, I have to laugh at my own naivety— one more week wouldn't even come close to the time I needed to complete this journey!

The 2016 Journal starts in Sacramento, California, and spans all the way to Salt Lake City, Utah! These are the two most western divisions of the Central Overland Trail.

Thank you so much for "riding shotgun in spirit" with Rider and me...because of you, we are never alone, and we are happy to have someone to share this adventure with.

May God bless you and yours...and again, we say... THANK YOU! :-)

Love,

Carla and Rider (woof!)

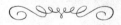

2016 JOURNAL

Beginning Again!

After much deliberation with family and friends, I have decided to add California and most of the Utah Stations to our *journey*. The plan is to leave my dad's here in northern California, where we have been parked for a portion of the winter months, and start our adventure in Sacramento, California.

We will also revisit Nevada, with hopes of finding places we missed last year! With more research, I have discovered that there were ruins at some of the locations where the guidebooks from last year said there were none.

March 1, 2016
Sacramento to Five Mile House to Fifteen Mile House to Folsom to Pleasant Grove XP Stations to Red Hawk Casino, California

We woke up before the sunrise this morning in Sacramento, California. Rider and I stayed the night at the 49er Truck Stop just off Interstate 80, near I-5. It was quite noisy, but we were grateful that we could park there to get an early start today!

(Note [Historical]: In the 1860s, unlike Nevada, the California portion of the Pony Express trail was already highly populated due to the 1849 Gold Rush. The owners of the Pony Express organization contracted with existing businesses—such as boarding houses (that era's version of today's hotels), telegraph offices, Wells Fargo and other stage lines—to provide locations to use for their home and relay stations.)

First Stop: Sacramento Station

Just before 7 a.m., we arrived in Old Sacramento. I wanted to get there to capture downtown while the sun was rising, and before the big city traffic started filling up the streets.

As always, one of my first concerns was where we were going to park this truck with a 26' 5th wheel attached. I had looked online, but only found regular car parking and garages. When we took the exit and turned toward Old Town Sacramento, I spotted a sign that read "BUSES." Of course, if they would fit, we should be able to! As soon as we turned right, following the signs that went under the highway, lo and behold, right at that location there were two—*only* two—RV spots just under that bridge. I was thankful, for sure. And another bonus: there was no *fee* to be paid! Score!

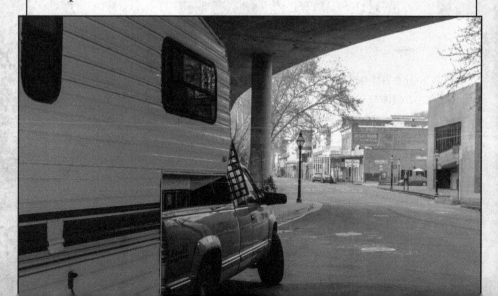

I fed Rider after taking him for a quick walk, and then put him in the RV. Now that he is a bit older, he is some better about not pulling on his leash when we walk...some...but I knew this would be a quick walk this morning, and I would be able to complete the shoot quicker if I didn't have his assistance... :-)

It was a nice morning, around 65°. Only two blocks away, I could see the large statue of the Pony Express rider! Right off, I photographed him, of course. Including a shot of him looking like he was riding in to his destination, the Wells Fargo Building on the opposite corner. The Pony Express rider, Sam Hamilton, left from right here in a blinding rain storm on April 4, 1860, 2:45 a.m., heading toward St. Joseph, Missouri! The BF Hastings Building has a small museum for the Alta Telegraph Company and Wells Fargo Bank & Express. This building was also the location of the courthouse for a time, and more businesses upstairs.

I took a few pictures of downtown...and as I was heading toward the truck, I met two little girls who were dressed in period clothing. I asked their mom if I could take pictures of them, and she said, "Sure!" :-) They had a little brother, also dressed up, but he was very shy and didn't want to come out of the van where his mom was still sitting.

Once Rider and I were ready to head out, I reviewed the maps, looking for the best route to the Pony

Express' first relay stop, the Five Mile House. I used the *xphomestation* website to assist in finding it. It listed two...one was supposed to be by the Alumni Grove on the campus at Sacramento State. We drove through there. Ugh! Not a good idea; school was in session, so there was no parking, nor a way for me to know how to get to the site. The information from my research was very vague, and stated that the site was downstream...somewhere...so we moved on to the next site location listed for it.

Next Stop: Five Mile House Station

The xphomestation website listed an actual address for this next stop, as it is now the site of a self-storage facility. Fortunately, this site was also next to a Home Depot—very easy for us to park!

I went in to the business and introduced myself to the man at the front desk. He was also the owner. I asked him, "Do you have very many visitors come to look at the

monument out front? Does anyone ever come in to ask you any questions?"

He said, "Yes, but only about two or three times a year."

If you didn't know anything about it, you would just walk by and never see it. It is set back off the road a bit. The marker listed a bit of information about the site, and when the first rider came through on that first trip. The address is 7716 Folsom Blvd., Sacramento, California.

Next Stop: Fifteen Mile House Station

I typed in "Intersection of White Rock and Folsom" on *Google Maps*. It took me about five miles off course. (*We all know how that is sometimes!*) I should have just followed Folsom Blvd. from the Five Mile House instead of taking the freeway. But even if I had, I would have still had trouble finding this site.

On the *Google* map, I scanned around, looking for the intersection. Once I found the closest spot that resembled the distance from our last station and these two roads crossing...It appeared there was no longer an intersection there...It was now a cul-de-sac that dead ended where White Rock met with Folsom Blvd. Nearby I could see that there was a 7-11 near the spot in question, so I chose it to get us closer.

I went into the 7-11 and asked them if anyone knew where the intersection was located, but they told me that White Rock goes every which-a-way, and is long. I decided

to go to the end of the cul-de-sac just to look. Nothing but a *brick wall* at the end. But I knew Folsom Road was on the other side.

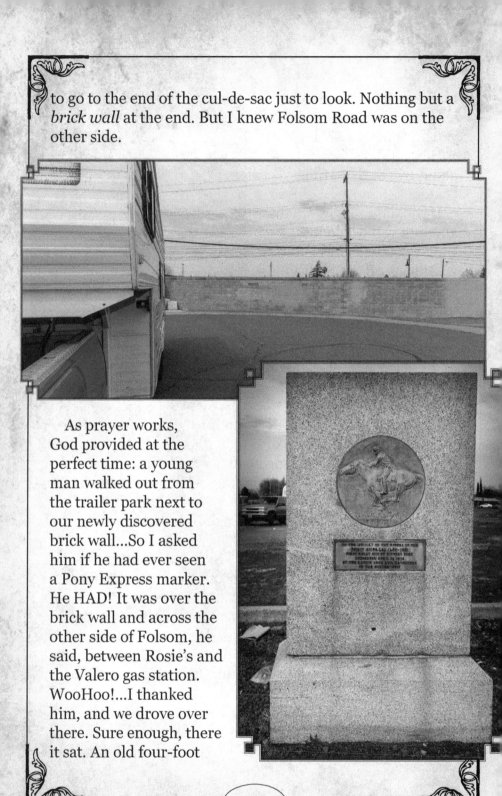

As prayer works, God provided at the perfect time: a young man walked out from the trailer park next to our newly discovered brick wall...So I asked him if he had ever seen a Pony Express marker. He HAD! It was over the brick wall and across the other side of Folsom, he said, between Rosie's and the Valero gas station. WooHoo!...I thanked him, and we drove over there. Sure enough, there it sat. An old four-foot

stone marker. There was trash all around it. A man with his grocery basket of treasures sitting just 200 feet away from it. This is where I started pondering...What would folks from 1860 think of where our society has gone? I cleaned in front of the monument a bit, and took some photos of this 1936 monument to our Pony riders. This marker is in Rancho Cordova, near the corner of Dawes and Folsom.

Next Stop: Folsom Station

By now it was around 3 p.m. We took Highway 50 instead of Folsom Blvd., though you could take it if you wanted to.

The old town of Folsom has a lovely historical town square! There are multiple museums—even a living museum with a blacksmith and more! I met a gentleman at the blacksmith shop, who shared with me about their fine community. He also shared that in 1860 there were four trains that connected here, along with many stagecoaches and freight wagons...He said it was a very productive place!

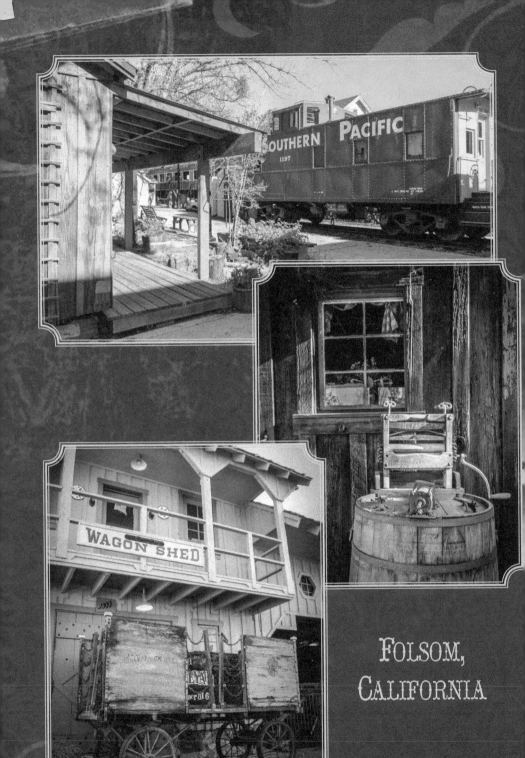

FOLSOM,
CALIFORNIA

GOLD MINING
SACRAMENTO
ASHLAND STATION
FOLSOM FORGE
FOLSOM CAMP

Folsom Museum Display

1860
WELLS FARGO & CO.
ASSAY OFFICE

Pony Express Station

At the end of our visit, I asked him if he could tell me where to find the Wells Fargo Building. He pointed and said it was easy to find. I gave him my business card and then headed off to the museum.

It was late and the museum was about to close, but I paid the $5 admittance fee and went in anyway, then hurriedly looked about. I captured a few pictures of their XP exhibit. I also asked for permission to see out back of the museum.

The gentleman earlier, from the blacksmith shop, had told me that there was a spring back there that had been used to water the livery stable's horses. I took a couple of photos, though it is very different today...You would never know there had been a stable back there.

After the XP had run for a few months, Folsom became the western-most terminal. They no longer needed to go all the way to Sacramento, due to the advent of the train and the telegraph. I will have to do more research to clarify more details for our book.

Before heading back to Rider, I captured a few more shots of this quaint little town. Once I got back to my truck, I found someone parked right

behind my RV. I couldn't get out...ugh! Oh, well, I told myself, it was a good time to take a break anyway. After about a half hour, the person in front of me moved...and good timing, as we were losing daylight, and we had one more stop to go!!

Next Stop: Pleasant Grove House Station
 I had seen a picture of this site in an old book and was excited to hear it was still standing!!! This had also been a stage stop. It is right on Green Valley Road, across from an elementary school...and also by an intersection with a light. I used GPS and my *Traveler's Guide to the Pony Express Trail* to find this one.
 We parked across the street where I could take photos of the large trees surrounding the house.

 The markers by the outbuilding were very cool to me. One in particular, as it was made out of river rock. I shot photos through the fence, then walked to the front of the

house to capture a shot of it. There was a sign with writing on it by the front door. The owner had written, "If you get hurt while on the premises, we are not responsible." I imagine that such a great historic landmark would be difficult for an owner to protect. I found that to be true even while we were in the desert of Nevada last year.

Well, since I was now in the yard, and by the house so I could read the sign, I took pictures from that side of the fence. *Note to the owner of the property...Thank you for taking such great care of this XP and Stage Station! From those of us who love America's history, we greatly appreciate it!*

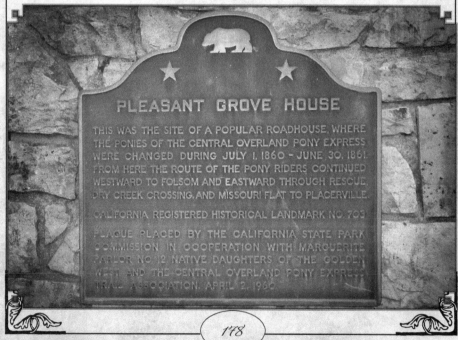

PLEASANT GROVE HOUSE

THIS WAS THE SITE OF A POPULAR ROADHOUSE, WHERE THE PONIES OF THE CENTRAL OVERLAND PONY EXPRESS WERE CHANGED DURING JULY 1, 1860 - JUNE 30, 1861. FROM HERE THE ROUTE OF THE PONY RIDERS CONTINUED WESTWARD TO FOLSOM AND EASTWARD THROUGH RESCUE, DRY CREEK CROSSING, AND MISSOURI FLAT TO PLACERVILLE.

CALIFORNIA REGISTERED HISTORICAL LANDMARK NO. 703

PLAQUE PLACED BY THE CALIFORNIA STATE PARK COMMISSION IN COOPERATION WITH MARGUERITE PARLOR NO. 12 NATIVE DAUGHTERS OF THE GOLDEN WEST AND THE CENTRAL OVERLAND PONY EXPRESS TRAIL ASSOCIATION, APRIL 2, 1960

Now getting close to dark, we headed to Red Hawk Casino. I had read on the *freecampsites* website that you could park for free there. And here I am! What a gorgeous location and resort!!! Wow! I had no idea it was back here, but guessing that it is all pretty new. They must get lots of business, as we are parked next to a multi-level parking garage for cars! I parked in the bus area at the base of it. There were good signs to follow coming in: "Oversized and Buses," with arrows. There may even be a better place to park for RVers, but I won't know until the morning! As I am stopped for the night now...

Lights out!

This morning, did a little computer work. I downloaded all the pics from yesterday on my Mac and the backup drive. When I did, is when I found out that I had shot in JPEG all day yesterday!!! Dang it! Oh, well, they are high quality, but I prefer RAW, as they are even better. Well, at least I discovered it this morning so I could change it!!

As I was leaving Red Hawk Casino, I looked for a better RV-specific parking area and found that there wasn't one. Glad I parked where I did. Also, Security had gone by many times while I was setting up, and they never said anything about me moving. It was nice to see this parking area had good security. They even have a call button for those of you who would like to visit the casino or restaurants...they will come pick you up!

First Stop: Placerville Station

We arrived in town around 9:30 a.m., and the town was a bustle! There were no signs for RV parking, and I drove right down Main Street. I stopped to ask a lady who was walking on the sidewalk if she knew of any RV parking. As she was talking with me, the people behind were hollering at me...*very* frustrating! I moved on and saw a rock wall with what looked like a fireplace in it that caught my eye. It was in the back of a

parking lot. I quickly glanced at the other end of the lot and saw that there was an outlet, too...Cool...So, I pulled in. I just wanted to get a minute to catch my bearings and think of where to park! Also, to get pics of the fireplace I'd seen. (*It actually was an entrance to a historic business.*) Well... this turned into quite an ordeal.

The exit I had seen was chained off with poles...poles that went all the way around the end of the parking lot. I was stuck! At the front of the lot, there were a dozen cars parked as well.

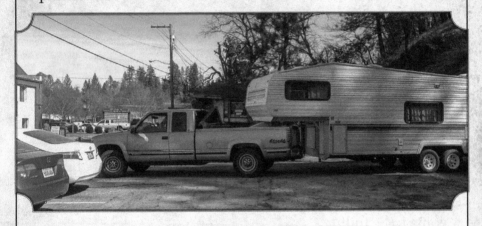

I pulled in as far as I could, to see if I could turn this 40' rig around...forward, backward...repeat, times 10. At one point, a gentleman stopped to offer me his assistance...I was trying to back up and get as close as I could to the rock wall without hitting it...but even with his help, I was stuck. Panic set in for a moment. Then, finally, I realized that I could unhook the trailer, and then hook 'er back up to the truck after pointing the truck in the direction to get out. Well, that was time consuming, but successful. Of course, when I went to lower the trailer, the electric jacks had no power. What the heck?! So, I thought, is it the batteries? Should I fire up the generator to recharge? Or *what*? I decided to grab the hand crank instead. Very slowly, the

jacks came down. While doing so, a gal from across the street approached me and asked, "You're not leaving your trailer here, are you?"

I answered, with frustration under my breath, "No, but why?"

She explained, "In about an hour, this parking lot is going to be full!"

I thanked her for the heads up, and informed her that my plan was to get out of there. Well, I was feeling thankful now...that all this didn't happen then!!! God is good! I prayed my way through this escapade! I got hooked back up, now pointing in the direction to get the heck out... Grateful I have a 5th wheel...Thanked the Lord, then back down Main Street we went.

I spotted a large paved area around a Shell gas station on a corner. I went in and pleaded with the attendant to allow me to park there...lol. Ali was a very nice young man. He first said, "You can park here for a little while," but once we chatted a while about our Pony Express book, he recommended I walk all the way back downtown to the

museum, and not to worry about my truck and trailer! WooHOO!!! So relieved!

My first stop was at the historical monuments on the corner of Sacramento and Main Street, which is near a restaurant. I captured a few photos of them.

Then I walked down to the grand Cary House and decided to go in. This is where I met and talked with Joel. He said that the stage had stopped at the hotel, as did the Pony Express...I had not heard that before, but makes sense. Either way, the Cary House and the monuments are only a few hundred feet apart, so we know that we are at least in the right vicinity!

I captured photos of this BEAUTIFUL HOTEL!!! It was built in 1857, so it was definitely standing when the Pony came through. Joel mentioned that there was a plaque for the famous stage driver, Hank Monk, in the back of the hotel. He took me to the room that looked to be the break room or dining area for today's employees...

When we came back to the front desk, Joel showed me the *Sign-in Register* book from the 1800s. I took a picture of a note from a recent guest who found he was related to one of the signatures in the old book! While they were signing in to stay there, they looked down and saw a family member's name.

CARY HOUSE
PLACERVILLE, CALIFORNIA

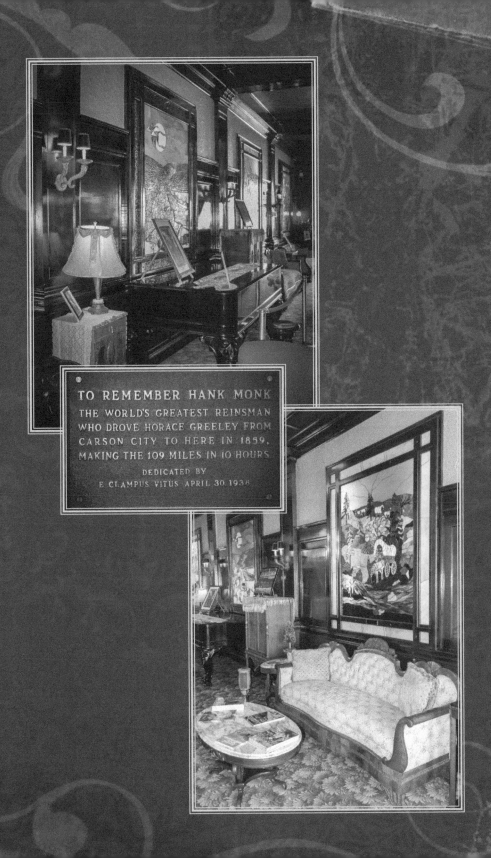

TO REMEMBER HANK MONK
THE WORLD'S GREATEST REINSMAN
WHO DROVE HORACE GREELEY FROM
CARSON CITY TO HERE IN 1859,
MAKING THE 109 MILES IN 10 HOURS
DEDICATED BY
E CLAMPUS VITUS · APRIL 30 1938

Joel also showed me an album the hotel had made with historical pictures, newspaper clippings and notes. It was all very interesting.

He then recommended that I go check out a monument that explained about three men who were hung and buried near the highway. Remember, this town once went by the name of "Hangtown." The monument was directly across from the hotel, down the alley a couple of blocks. He said it was right by the road and an alley parking lot. Not a very prominent location. Joel then recommended I visit the Chinese House behind the hotel a couple blocks, the marker for Snowshoe Thompson on the corner, and then head to the Chamber of Commerce, and the small museum...But, before leaving, of course I got a picture of Joel, standing behind the desk. He wouldn't put on the original concierge uniform; he said that was only done on Halloween...lol.

I walked up the hill behind the hotel, where I found the Chinese House. It was standing as tall and solid as the day

it was built! I captured a few pics, including one of the plaque explaining that it had been restored. The plaque read:

> STONE HOUSE CIRCA 1865
> The last remaining building of the gold rush era Chinese community in old hangtown. Stone house is famous for its historical significance as an old Chinese brothel.
> Restored by John R. Berry — attorney at law
> Architecture and design by Caywood, Nopp, Ward & Associates

 While walking back down the hill just across the street from where the monuments were, I stopped to capture a mural. On the side of a building, there was a mural of Snowshoe Thompson. It was quite a tribute to the man who delivered the mail from here to Carson City, Nevada...on his back...through blizzards in the Sierra Mountains, while walking on snowshoes! He was around during our Pony Express time period as well. :-)

Next, I walked down to the Hangtown monument Joel had told me about and took a couple of shots of it. The plaque read:

> Somewhere here lie the remains of the three unfortunates hanged in late 1849 from the oak tree in the feed corral, after fair trial by the vigilantes.
>
> This incident changed the name of Dry Diggins to Hangtown. Let us not judge them too harshly, for those were the rough days of the great gold rush.
>
> This plaque placed by James W. Marshall Chapter No. 49. E clampus vitus. January 24, 1959

Hmm…Now we know this town has had a third name…*Dry Diggins*. Which was before *Hangtown* and today's name of *Placerville*. Interesting, don't ya think!?

Once back on Main Street, I took a moment to capture the building across the street from the Cary House that read, "HANGMAN'S TREE." I wonder if that was where the corrals were, with the oak tree?

Next stop was the Placerville Historical Museum. A well-built stone structure lined with bricks and metal shutters. I visited with a couple of very nice ladies who volunteered there. I asked them if, once my book was completed, I could provide it for their museum for sale. They said I would have to submit it to the museum's committee, where they would have to review and vote on it. But she thought it would be a nice addition to offer for sale.

This museum was very small. It is located on Main Street downtown. One of the volunteers told me that there was a county-run museum located at the fairgrounds that was much larger. (*I didn't go out there, but got a brochure for possibly visiting in the future.*)

Next, I walked down to the Chamber of Commerce, where I could hear a few ladies talking in another room...I stood around for a while, to no avail...so I just left.

While walking back, I also took more pics of the buildings. This is quite a historical town! But let me tell you...the traffic is like being in downtown San Francisco, with only two lanes!!

Once I got back to the Shell station, I went in to visit with Ali. I bought a snack and a drink—was the least I could do for parking! Found out during our visit, he was also a graphic artist. We exchanged business cards and bid farewell. And, of course, a big *thank you* for his help!

Next Stop: Sportsman's Hall Station

Our next stop was in the town of Pollock Pines, and on the road called *Pony Express Trail*, no less! The station is a large red barn-looking building. I had seen a photo of it in one of my research books...I had hoped it was still being operated as a restaurant, as it was said to be good place to eat, and it was getting close to dinner time!

The terrain is now more mountainous, and we are surrounded by the wonderful smell of pine trees...just divine!

There were nice historical monuments located in front of the building...of course got pics of them before heading

inside. The gals working there were all very nice! They asked me to make myself at home. I shared with them my story, so they pointed out all the historical pictures hanging on the walls. They also shared brief stories of the building. There was even a photo of one of the riders, Bronco Charlie. I took photos of all that I could...including a large map of the XP route that had

a list of the riders written in the corner. I hadn't seen this map anywhere. It was printed in 1935 and drawn by W.R. Honnel.

I learned that the current building/structure was *not* the original. The *original* XP station had been next door, where the parking lot for the restaurant is today. There is one of those railroad rail markers in front of the parking lot, right by where I parked my truck and trailer on the road, sharing that fact.

I enjoyed chicken fried chicken for dinner. It included French fries, a salad, veggies, and bread...There was plenty of food! As I was eating, a nice lady working and passing through the dining area asked how everything was...I told her, "Great!" I had a feeling she was the owner and asked if I was correct. She

said yes, then introduced herself as Amy. I shared with her about my journey, and she left for a minute and came back with a card for the National Pony Express Association. She told me they were located right here in Pollock Pines.

After a few more pleasantries, I asked if it would be okay to camp where I was currently parked. Amy asked me to pull forward a bit more as to not block the restaurant sign, and that it would be fine. Whew! I stayed in the restaurant and visited with some locals, then was out to the trailer by 6:30.

(*Sportsman's Hall Bar area.*)

It has been a very busy and rewarding day!

March 3, 2016
Sportsman's Hall to Moore's Station to Webster's House to Strawberry Valley House to Yank's XP Stations to Friday's XP Station, Nevada

If had to do it again, I would park the truck and trailer *in* the parking lot, as the traffic going by at high speeds was unnerving while trying to sleep.

Got up early and wrote...step one...step two...step three... for EXTRA ADVENTURES while pulling an RV in small towns...due to our chained-off-parking-lot escapade from yesterday. I added a series of photos to the steps, then posted it on social media. Then we were on our way to...

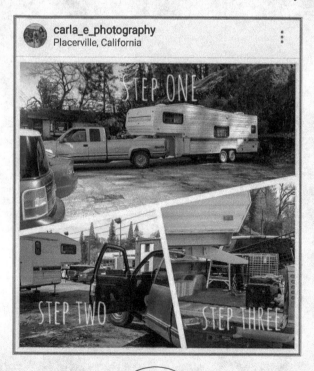

carla_e_photography
Placerville, California

First Stop: Moore's/Riverton Station

Headed out following the Pony Express Road a few miles, then made a right, then a quick left, and we were back on Highway 50.

I had read in the *Traveler's Guide to the Pony Express Trail* that Moore's Station was located just past where the highway was no longer divided. Well, a lot of improvements have been made on Hwy 50 since the book was written. But, fortunately, I spotted a sign on the right-hand side stating that there was a historical marker located 500 feet ahead. I started slowing down. There it was on the left, on the north side of the highway. There looked to be a *large* area to pull into, but I wasn't sure, so I pulled over on the south side of the road to park, then "ran" across this busy roadway.

The only thing left was a monument for the XP/stage stop, and a monument for something else. I took photos, but wasn't sure what it was about, as it was hard to read.

This was a gorgeous location, as it was right by the American River! Once I finished capturing a few shots, I got back in the truck and drove a few hundred feet, just crossing the bridge that was going over the American River...it was a WOW, so I pulled over just past it and walked back to photograph it!

Next Stop: Webster's/Sugarloaf House Station

Well, I am afraid I read the directions backwards and missed this site. The guidebook author had been heading west when he wrote it, and I am heading east...I don't remember even seeing the Kyburz Firehouse, which was where the monument was supposed to be. I thought it was .8 miles east of town, but it was .8 miles west. :-(We had climbed a long, steep mountain at 25 mph in 2nd gear, for about 8-10 miles, to get into the small town of Kyburz, so I didn't go back since it was just a marker. I did photograph the town of Kyburz, though, and a structure that said "Kyburz Station" on it. There was a view of a very prominent rock formation on the top of the mountain just to the west of the town. I got some pictures of it, too...It was very cool!

Next Stop: Strawberry Valley House Station

Following Highway 50 for 9-10 miles, we made it to Strawberry. The Strawberry Grocery Store is on the north side of the highway and is just a few hundred feet east of the monument for the XP station. In one of my research books, there was a picture of a large barn. I assume it is long gone. On the south side of the highway was Strawberry Lodge. A beautiful hotel and resort area. Lots to do there! I photographed both places. They have lots of snow in the winter months and offer skiing, but there was none today.

According to a turn of the century article I read in a *Sunset Magazine,* there are conflicting stories about why Strawberry Canyon is called by the name of Strawberry. One said it was because Berry, the station owner, fed the horses straw. Another stated that before Berry ever had a

place there, there were actually strawberries growing wild. It was all long ago, and we will probably never know which is true. Regardless, it makes for interesting history!

There were TWO routes the XP followed during its run from Strawberry. For the first five weeks, they rode the route to Hope Valley, Woodfords Station, then on to Genoa, Nevada. After those first few weeks of the Pony Express, the riders changed to a new route, which went from Strawberry to Yanks Station (*later referred to as Myer's Station in 1873*) to Friday's Station, and on down to Genoa.

Due to time restraints because of a snowstorm coming, I skipped the first section that had only run for five weeks. The guidebook says it is quite magnificent there, with lots of camping opportunities, as well as some cabins at Sorenson's (*though I don't know if that business exists anymore*); I would recommend a traveler check it out before heading there, due to the other changes I have found!

Next Stop: Yank's Station
We drove 13 miles east of Strawberry into a small town, today called Tahoe Paradise. The guidebook stated that the XP monuments were at the Yanks Hotel. I couldn't find a Yanks Hotel listed anywhere online. I stopped at the Chevron just east of town to ask if anyone knew anything about the hotel or the monuments. Fortunately, one of the station attendees did know something! He said the hotel had been torn down, and now is the location of Lira's Supermarket, which was within a short distance and on the same side of the road.

We drove down there and found that right in front of this very cool log-built grocery store were the monuments. It seems kinda strange to me, that people walk by these

monuments every day while going to do their shopping! I wonder how many of them have ever even stopped to read them and know that they are walking right where horses for the stagecoaches and Pony Express riders were kept and used! We were standing on such a wonderful slice of history!

Leaving California and Entering Nevada

The Nevada side of Lake Tahoe, at Stateline, is the location of Friday's Station. If you have done much research on the Pony Express, you have probably seen a photo of the Pony Express Rider statue at Harrah's Casino in South Lake Tahoe. Though that is a very cool statue, I really wanted to find the XP Blacksmith Barn I had heard about. I read about the station site in some research books, and also heard about it from my FB friend, Bill Mooney, who said he had the privilege of riding right up to it back

in 1993. The golf course manager had met with Bill so that he could ride to the barn in order to complete his journey, following the Nevada portion of the Pony Express trail.

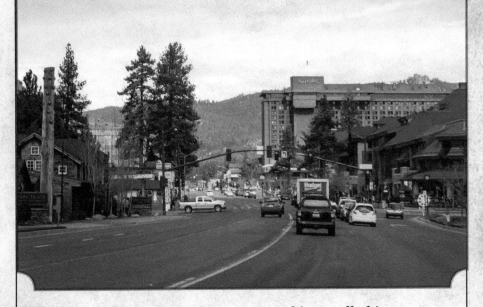

While looking for parking at Harrah's, I pulled in to a neighboring casino that had a large, open parking lot. There was a fella working a dozer, moving old snow and getting ready for the storm tomorrow...I stopped him and asked if Harrah's had a parking lot like this one. He said yes, and pointed me to a back road that would lead me to it. I finally found it and parked. The lot was within a short walking distance to the back door of the casino.

After getting ready to head in, a security officer drove up and told me I couldn't park there. He apologized, and was very courteous. He offered to lead me to another parking lot that was behind Harvey's Casino on the other side of the strip. While we were discussing parking, I also asked him about the location of the large statue of the XP rider,

and he said, "Oh, the one all the drunk people try to ride on Saturday nights?!"

I said, "That's probably it!"

He told me that the statue was at the entrance of Harrah's, just off the strip, and I could easily walk to it. He also told me I must register at the office and tell them what I was doing and how long I would be parked in their parking lot. His name was Mike (or Mark—*sorry, my new friend, I can't remember!*).

Of course, I picked his brain about what I really wanted to find, and that was the barn on the private property. I asked him if he knew who I could call for permission. He recommended I ask at the desk in Harvey's; he thought they would probably know.

In Harvey's, I went to the registration desk, introduced myself, and gave them my business card and license plate number. I asked the man at the desk about the barn, and he sent me to Candace at the concierge desk. She was a sweetheart, and very helpful. She said it was probably the same owners of the snowmobile rental site, as she thought that was the same lot. She gave me their brochure with their number on it so I could call for permission.

I called, but had to leave a message.

I knew where the snowmobile site was, as I had driven past it twice while finding parking. First, I crossed the street to photograph the XP rider statue and monument markers, then I walked up the highway toward the snowmobile business.

Next Stop: Friday's Station, Nevada Side of Lake Tahoe

It was a bit of a hike, but made it in short time to the snowmobile rental place. I introduced myself to the two young men that worked there. Told them what I was looking for...They pointed at the location behind them and said there was a driveway and that I could drive right in from Highway 50. I told them I had left my truck at Harvey's. They said there was a gate behind their snowmobile track and that I could walk to that. Of course, it was covered in snow...I said, "I don't know...maybe I will walk around."

Then one of the young men offered to give me a ride on the snowmobile! He said, "Just hop on, I will take you to the gate." Woo Hoo!! I had never ridden one before. It was a short and quick ride, but still very cool! He dropped me off at the gate and wished me luck.

As I was going through the gate, a fire department pickup went past me. I also noticed there was a full-sized fire truck sitting in the drive by the large house up front. I wondered if this was now a fire station. I had heard it was part of the golf course.

At first, all I saw were white, pristine buildings. Some old, and some pretty new looking. I photographed them all as I walked through this park-like setting...then I saw it! There it was!!! The LOG STRUCTURE I was looking for!! It had a new roof, and was sitting by a pond...snow here and

there around it. What a gorgeous setting! I got lots of pics of this building, the area and its views. I was blessed to get to see it. Feeling very thankful!

When leaving the site, I had to walk along the highway on a small sandy path. There was a crosswalk across from me, but there was so much traffic, I didn't chance it at first. Finally, there was a break, and I ran across. I walked back up the road I had driven on to park in the back of the casino...this was quite a jaunt, and I was a bit winded from the altitude.

I was thankful to get back to the RV and Rider...so I took a break. Then I noticed I had missed a phone call and had a voice message. It was the owner of the snowmobile park. His message said he wasn't the owner of the location of the barn. Oops, but I had already gotten the pictures...Now what?* I will have to try and find the right connection.

*(Update: The barn is located on property owned by the Edgewood Golf Course. The family has owned the property since the late 1800s. I have corresponded with their representative, and am VERY thankful to them, as they have given us permission to publish the photos!)

After a break, I pondered where to go next. With the bad weather coming in quickly, I decided to head back to my sister's in Sparks, Nevada. I have some business to take care of there. Also, I will be able to go visit some of the nearby stations, with just my pickup...

My friend, Bruce Martin, is flying in on March 22nd to join us on part of this adventure. When he arrives, we will be heading across Nevada and Utah. I will be glad to have company for a few reasons...one of them will be to visit some stations I wasn't comfortable doing alone last year.

I am excited for the next part of our journey!!

March 10, 2016
Sparks to Genoa to Carson City
XP Stations to Sparks

Today my sister, Suzanne, great-nephew, Bennett, and I drove over to pick up my niece, Ashley, who lives in Carson City. I asked my sis if we could go over to Genoa real quick, once we picked her up... She likes to visit the Pony Express stations, too, so she said sure.

Next Stop: Genoa XP Station

It was a beautiful day—around 70°—and the Pony Express blacksmith site is now a very nice, well cared for park...Mormon Station Park. In my journal from last year, you will have read that I was there for a few days, and mentioned the museums and the like. Today I was wanting to get pictures of "Snowshoe Thompson." My first visit there, it was my first Pony Express station...I was thinking I would try not to get distracted too much with other history...But since being there and doing more research, I have found he played a *very* large part in getting the U.S. Mail through, during and *before* the XP!

I found I hadn't liked the view of the Mormon Station in my earlier pics, and changed some angles around that I hope you will appreciate more than the earlier pictures (*that you will never see now! Haha*). Photographed the life-size statue of Snowshoe...some with my niece and her son, too...One may make the book, of my cute little two-year-old great-nephew, as he was fascinated with the statue and is pointing at it in the picture as if to explain about it... :-)

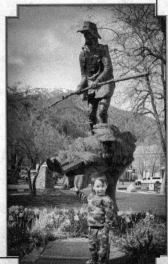

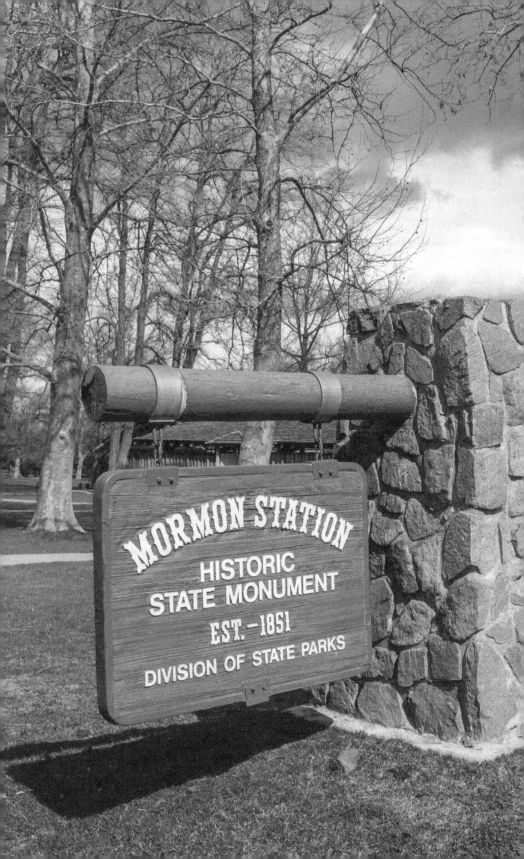

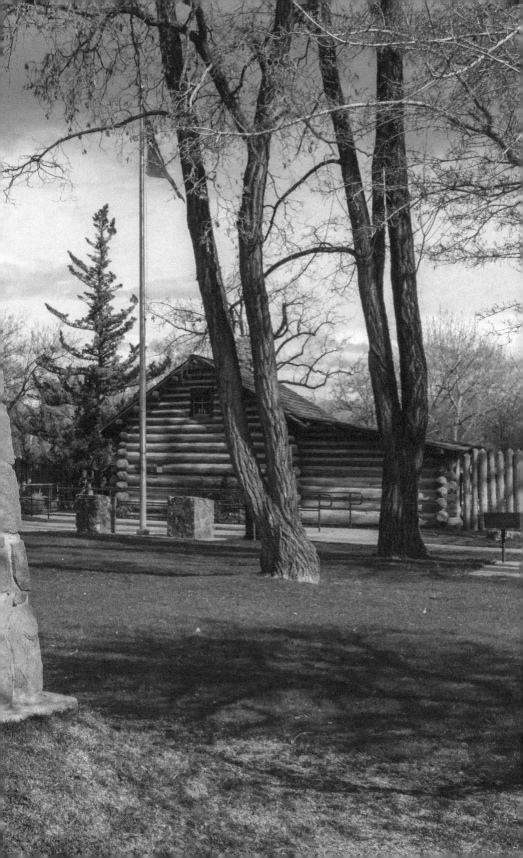

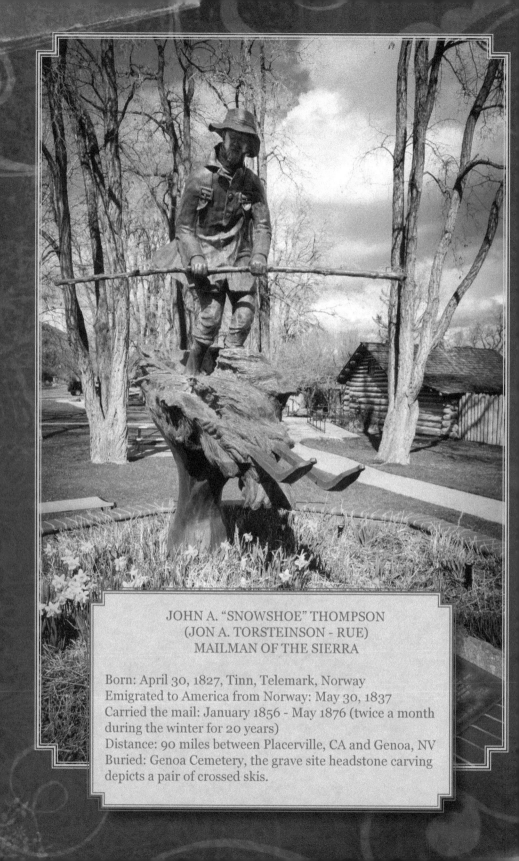

JOHN A. "SNOWSHOE" THOMPSON
(JON A. TORSTEINSON - RUE)
MAILMAN OF THE SIERRA

Born: April 30, 1827, Tinn, Telemark, Norway
Emigrated to America from Norway: May 30, 1837
Carried the mail: January 1856 - May 1876 (twice a month
during the winter for 20 years)
Distance: 90 miles between Placerville, CA and Genoa, NV
Buried: Genoa Cemetery, the grave site headstone carving
depicts a pair of crossed skis.

Traversing the mighty Sierra Mountain ridges on a pair of homemade "long" skis and using his single pole for balance "Snowshoe" braved 20 to 50 foot snow depths, snowdrifts and blizzards - the mail must reach its destination. "Snowshoe" carried a mail bag weighing 50 to 100 lbs strapped to his back. He carried crackers and dried beef for food. Drank melted snow from his hand, and rested only when necessary during the three day trek from Placerville to Genoa. The mail was Genoa's only contact with the outside world during the long winter months.

"SNOWSHOE" THOMPSON - A TRUE HERO OF THE WEST

Sculpture: Town of Genoa Historian:
Don Budy Text by BJ Rightmire

Next Stop: Carson City XP Station

Last year when in Carson City, I was pulling my RV and knew that it would be difficult to try and find the XP location *and* a place to park...so I had planned on going later. Today is later!

With all of us in my sister's Jeep, we headed downtown to find where the XP station once was. One of the guidebooks states that it is just an empty parking lot.

We made a nice morning of it. Ashley knew from the description I gave her where the site would be there in Carson City. It was located directly across from the Legislative Building. We found it. There it sat...*nothing*—

just as the book had said. An empty parking lot with just a few pylons and concrete slabs.

Suzanne parked, and I got out to take photos of as many angles as I could. Trying to create something from this barren lot and make it picturesque. When done, I got back in the Jeep.

We made a lap around the back street, one block off the main drag. There was an old building in the back of the lot, but we thought it looked more like the early 1900s from the structure materials. But as we made our way south on Curry, we could see the back of another old building/bar; it looked more like our 1860s era. Ashley said it was a historical building that she has always thought would be cool to restore. Suzanne parked the Jeep

behind the building. I walked and photographed all the way around it. There was a historical marker on it that showed it would have been standing in the day of the XP! Ashley and I walked down Carson Street to look at the other buildings that were near the XP site, and I shot a pic looking north. Then I looked down...there were these brass plates in the sidewalk for the Kit Carson Trail. The plates had various things etched on them: one was of Carson's profile, and there were others with different symbols...but the one right in front of the XP site was a horseshoe! So I laid down on the sidewalk with my camera and shot a low LOW shot of the brass plate with the Legislative Building across the street in the view. Sometimes creativity is a necessity, not a luxury, especially while trying to capture history that isn't visible today.

We then drove north up Curry about a block and saw a few old buildings and the back side of a very cool refurbished old hotel/restaurant/bar called *Firkin & Fox: A Historic Landmark, Restaurant and Pub*. It was on a one-way street, so we passed it and went around the block so we could park on the street to get a couple pics. I had my sis drop me off at the corner across from the hotel. As I was getting out of the Jeep, I turned around and went, "*Whoa!* Sis! Look!" There was the historical marker for the Pony Express! Right on the corner of Carson and 3rd in front of a quaint little restaurant called *Pop's*. I photographed it and tried my best to get the hotel across the street in my pics between the busy traffic. (*Carson Street is the main street of Carson City, and it is very busy!*)

On the XP marker, it stated the stables were located just west on the NE corner of Curry (Ormsby) and 3rd Streets. We drove around for quite a while trying to find that street, and couldn't find but sections of it, and they weren't connected to Ormsby. Finally, I *re*read what the marker said...the street was now Curry, the one we had been on... oh, bother! Sorry, Sis!!!

We found the corner, and it was a paved parking lot, full of cars...not very pretty pics... but right across on the other corner, while lost, we had seen a sign

in a window of a building that read, "Original U.S. Stage Depot - 1873." Maybe they continued to use our "parking lot corral" for their horses?

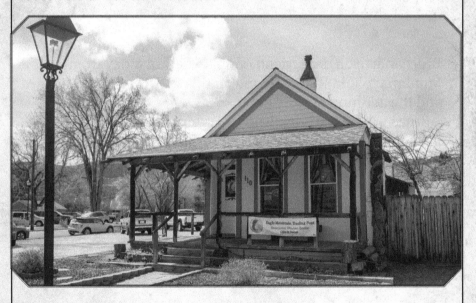

That was our last stop for the day. It was time to head back to the house.

This evening, I am working on the fun part of owning your own business—my annual bookkeeping work... prepping for filing my 2015 taxes. Oh, what fun!

There were a lot of travels last year; this will probably take me until my friend Bruce joins me! Let's hope not!

For now, I will be putting off any journaling...I don't think you want to know my day to day on filing taxes. See ya when we hit the road in a couple of weeks!

MARCH 22, 2016
SPARKS

Bruce Martin, a dear friend of mine, flew in today from Montana to join Rider and me on this REDO of Nevada, and the addition of Utah.

Bruce will be traveling with us through not only that portion of the Pony Express, but I will be driving him all the way back to his home in Grass Range, Montana. We have scheduled a couple of brandings for me to shoot. And while on our way north, I want to swing through Wyoming and the Grand Teton National Park, and Yosemite if possible! But for now...let us focus on our current adventure—the Pony Express stations!

MARCH 23, 2016
SPARKS TO FORT CHURCHILL
TO FALLON CHURCHILL FAIRGROUNDS

With a bit of rearranging to make room in the RV for Bruce and his gear, we finished loading up, then we hit the road!

I have already got what I need for Genoa, Carson City, and Dayton, and there is supposedly nothing at Miller's Station...so we headed straight for Fort Churchill first thing this morning.

First Stop: Fort Churchill

There were a couple of questions I still had about things I remembered reading while I was there before, but couldn't find any literature on. It was information about the cemetery, so we stopped there first. I had remembered something about the soldiers being moved from this cemetery...In front of the gate of the cemetery, there is a small box with a button on it. When you push it, "Taps" begins to play...then there is a man's voice, which gives a brief description of this site. Also, there is a small marker with some information.

Here is the information we confirmed while there this time. The plaque reads:

> Congress appropriated $100 for the removal of the soldiers' graves from the post in February 1885. Crowds watched as a procession of local militia companies, Civil War veterans, legislators, state officials and a brass band marched through the streets of Carson City to the Lone Mountain Cemetery.
>
> This cemetery was also utilized by the Samuel Buckland family when the post was officially abandoned in 1869. Samuel Buckland bought all the salvageable materials from the post for $750.

Samuel Buckland, along with his wife and children, is buried here. Many of their children died very young, according to their tombstones. The 1800s were very hard times for the little ones.

Bruce has never been here, so we visited the museum and the cannons/rifles they have under cover and fenced off outside. Then we drove around the fort for him to see how large this site really was. Still amazes me!

When we left the fort, we drove over to Buckland Station, only to find it closed again...ugh. We got out anyway, and walked around the large station house. There are public restrooms in the back as well.

Next Stop: Fallon, Nevada—to Walmart for supplies. While there, we also grabbed a couple Big Macs to have for dinner.

Then we drove to Churchill Fairgrounds to park for the night. They have water and electricity at the RV sites for $15/day. There is a dump station, but not at the RV sites. (*You may remember that I stayed here last year as well.*) If you are traveling with horses, they also have stall rentals, too! Dry camping is $7/day.

I planned on us staying here so that we could leave the trailer in the morning. Highway 95A runs right next to the fairgrounds, and our next XP station was supposed to be about 14 miles south of the Highway 50 and 95 intersection. This time, I was not taking a trailer out there, and this was a great place to leave it!

We dropped the trailer, and I was glad to see that the check-out time was 1:00 p.m. That should give us enough time to run out to Carson Sink and back today.

Our first stop, though, was back to Walmart! I never could find my binoculars in my storage, and then I kinda forgot about it, but knew I really needed them from last year's experiences. Fortunately, Bruce asked if I had any... so, back to Walmart!

First Stop: Carson Sink/Sink of the Carson XP Station

From Walmart, we drove out to the Carson Sink area. This site is very iffy on its location directions. One of my guidebooks, the 40-plus-years-old one, stated to drive to corrals off a dirt road, park, then walk a mile and a half to the site, where we would find "very indistinct adobe walls melting back into the earth." Another newer book, about 15 years old, said there was a yellow marker on the XP trail, but not worth the time (lol). So, following a mix of both of their directions, we gave it a go.

Our destination was to be about 12 miles south of Churchill Fairgrounds, on 95A. We passed by the road we were thinking was the correct one, as one of the books said it was near a canal, and we wanted to get a better view of the surroundings.

We drove out a bit further...saw the canal, but the road next to it was not looking promising, and there was also a gate. Keep in mind, we are on a two lane highway that heads to Las Vegas, and it is very busy with folks going by at high speeds. Hard to make a dash off the road in sand.

While we were driving by, Bruce did see something shining in the area we suspected, and we decided to head to that spot...somehow. So, we went back to the better gravel road, which is probably the Smith Road that was listed in the *Nevada Guidebook*. We drove about half a mile off the highway heading west, where we saw other vehicle tracks that led off to the left (north)—not a road, just tracks. We followed them on to the salt flats for about a mile. I was a bit squeamish, but Bruce said it was solid enough...he was right. (*Thank God!*) Once we got to where the sagebrush was thick, we stopped and walked the rest of the way.

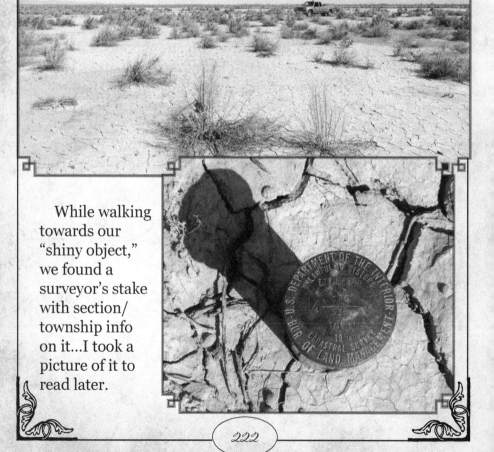

While walking towards our "shiny object," we found a surveyor's stake with section/township info on it...I took a picture of it to read later.

We made it to our shiny object. It was a dumped evaporative cooler...haha. BUT, as luck would have it, it was on the road next to the canal! Once we were on top of the canal road, we were able to see that it had a very large, impassable washout, so it was a good thing we didn't try to come in that way with the truck!...AND standing on top of this road, we could see a yellow marker! So, I thanked the evaporative cooler and we kept walking.

Once we arrived, we found that there were three markers at the XP site: Tall silver XP marker, Overland Stage and an Emigrant Trail. We searched for the short walls of adobe, but we could only find rocks that may have been the cornerstones. Also, Bruce found a broken-off wooden post that had a half circle of large rocks around it. Was this part of the station? Or just a corner post for a section/ township? (*Looking back, I wonder if it was a telegraph pole?*)

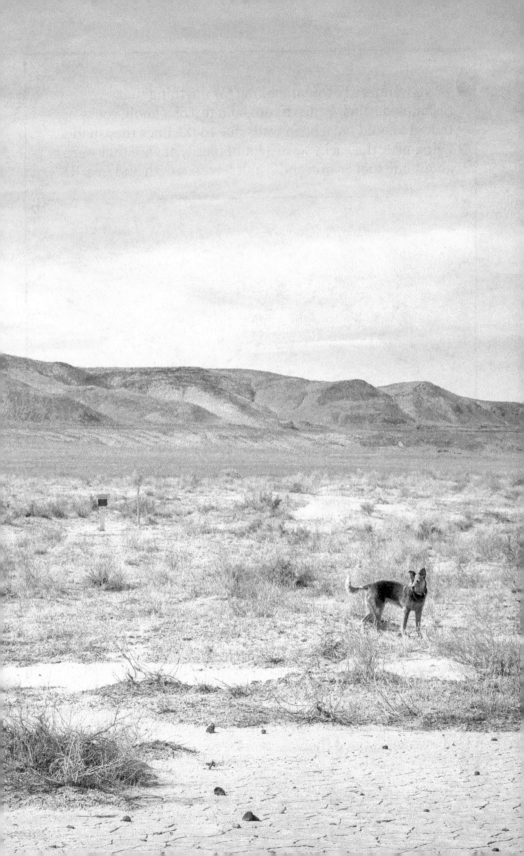

We wandered around looking for anything that resembled ruins. Bruce found, at a top of a knoll, rocks he thought could have been walls due to the lines they made. Lying near the rocks were a lot of pieces of wire that were about one foot to one and a half feet in length and in a "U"

shape. This place was said to be pretty much a mini fort... and this is it?! So sad to see there are no remnants more than a maybe/could be.

On the ground, there were a lot of snail and mussel shells everywhere, and they really made the area sparkle. We found a few possible brick pieces, but hard to say.

My find for the day was one square head nail!!! Bruce found a stone with chipped edges, like you find on arrowheads. After an hour or so, we hadn't found much. I am glad we got to see this site, though, as there is so much history at it. One interesting account is in regard to the men, describing how they built the station. J.G. Kelly, one of the men, stated there were no trees or rocks to build a

station. They had to build it out of adobe bricks that they had to make using the mud from the lake. In order to get the mud to its proper consistency, they had to stomp on the mix all day with their bare feet. After a week or more of this, Kelly described the state of their feet like this: "They were much swollen and resembled hams."

I captured photos of Bruce by the markers, and he in turn returned the favor. Rider was in a lot of photos... lol. He enjoyed running around this site. He even found a bone to chew on to entertain himself.

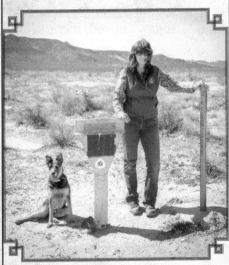

After the mile and a half hike back to the truck, we headed to Churchill Fairgrounds to pick up the trailer. It was about 1:15 p.m. We had had a successful morning.

We hooked up the trailer, packed up, dumped it, filled it up with water...then off to get propane at the Big R Stores.

Then I remembered that Bruce had noticed early in the morning that the vent over the couch was coming off...We went back to Walmart. My RV doesn't have a roof ladder, so I had to purchase a ladder so that he could fix it, then we took the ladder back for a full refund. Hey, it worked! Got

to think out of the box sometimes. Bruce had tried climbing from the inside while standing on the dog crate...lol...but there just wasn't enough height! Besides, I didn't want him to flip off of it, and coming back down would not have been easy.

Next Stop: Sand Springs XP Station

Though I had been here before, I knew Bruce would really want to visit this site... especially after no ruins at his first XP site at Carson Sink. Also, I wanted to get some distant shots here, of the full station.

It is an easy access site, now that I knew I could pull my RV all the way up to the gate! (*Last year, you may remember, I walked the road in, as I wasn't sure if I could turn around.*)

We signed in the *You Were Here* book and read the posted signs.

You may remember from my 2015 journal, but in case you don't: The interesting thing is that the guidebook I used, printed in 1976, stated there were no ruins at Sand Springs. Well, fortunately, at the library I also had read a book written by the University of Nevada, Reno, archeology students, that in that same year, the students found and dug out this entire site! It had been completely buried

in sand. From my last visit, just about five months ago, I could see how this would be true...the rooms had a lot more sand in them since that last visit! I wonder if there are volunteers that keep moving the sand back out.

As I was shooting from above, on a knoll, Bruce had been walking around the site. He called out and asked if I had seen the gun port in one of the walls. I couldn't remember if I had photographed it last year, so went inside to shoot it...So, having a bit of fun with it, and Bruce still being on the outside, I told him to stay still...I was going to "shoot" him through the gun port...lol! I did, and I think they looked pretty great, if I may say so! He is a great model, too. :-)

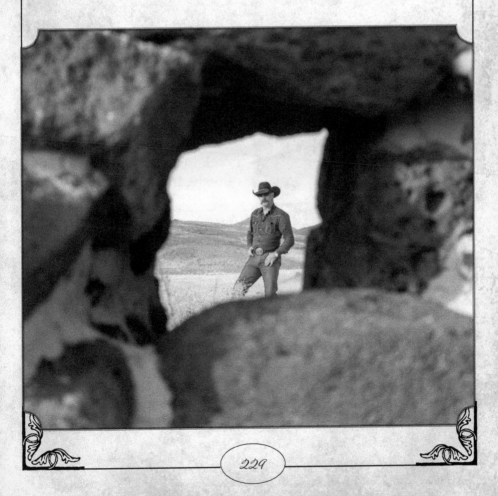

Next Stop: Middlegate XP Station

This station is located just off the old highway that parallels Highway 50. You can see it from the road, and there are signs. Middlegate was an XP and stage station.

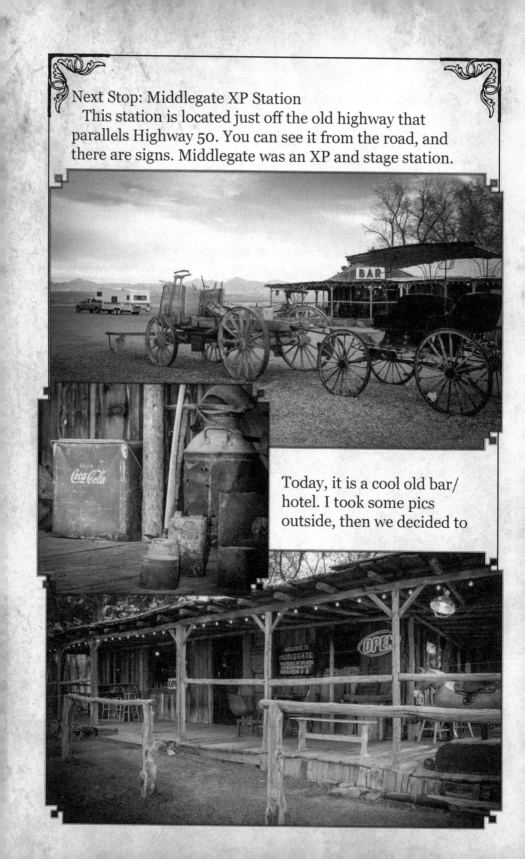

Today, it is a cool old bar/ hotel. I took some pics outside, then we decided to

enjoy our evening by going inside to have a couple of beers and dinner. We met many nice folks: Mike the bartender; the gal who made us a great Reuben hamburger, recommended by Mike; and Sky, a nice young man who was off

work tonight, but who worked as the cook…he is the one who encouraged us to go inside while I was shooting outside—he said we had to buy one of their great burgers! We met a couple who said they were "rock hounds" and spend their summers all around the area here. After some good visiting, and a couple of shots of chilled Fireball…we camped in the parking lot for the night. Mike had said that it was okay to do so *(before I had anything to drink).*

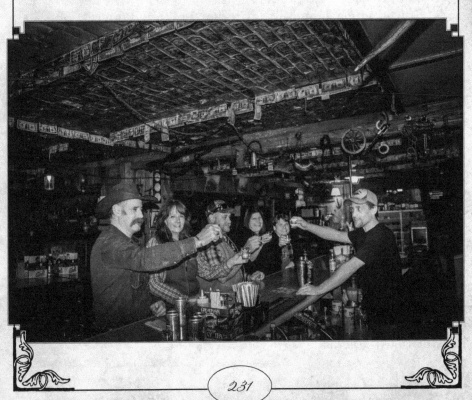

Not feeling so great this morning...lol! I have a drink about once a year anymore, but I had fun! And now paying for it. So...this was spent as an easier day, and rest, as we hiked a LOT yesterday.

Next Stop: Cold Springs Telegraph Station

After leaving Middlegate, our next stop was Cold Springs. We parked where I did last year at the Telegraph Station. It is a nice gravel pullout, and not in anyone's way. There is a paved lot down closer to the hotel/stage ruins, but lots of folks pull in and out of it all day long to read the historical landmark sign located there.

It was a nice, leisurely day today. I planned the rest of the Nevada portion of our trip on my *Nevada Atlas* map and made lots of directional notes for the next stations. Bruce put together the BBQ grill we got at...can you guess??? Yep, Walmart!

With his success from a million pieces being assembled of the new BBQ, we had steaks, and I made fried taters and cream corn for dinner! Very nice! When by myself, dinner would probably have been one of my go to's:

peanut butter sandwich, peanut butter cheese crackers...
Vienna sausages...or cereal...lol. It was nice having a friend
to enjoy a real meal with!

This evening I waited on the sun to get low in the sky,
then we walked down to the hotel/stage ruins and got a
few shots. This time I took my stepladder to photograph!
The ruins near the road are all enclosed within a seven foot

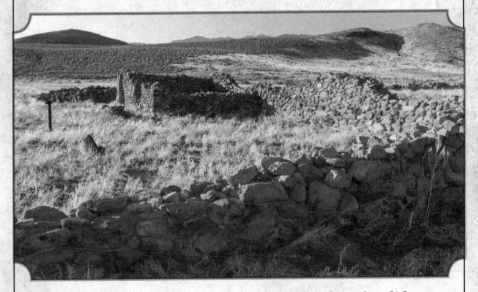

chain link fence with barbed wire on top. Though I did my
best last year to shoot through those pesky diamonds, the
ladder worked much better!

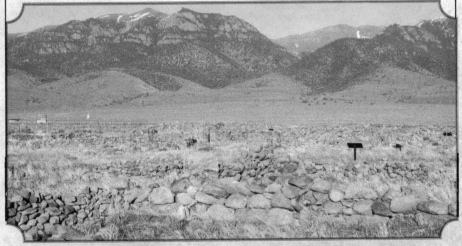

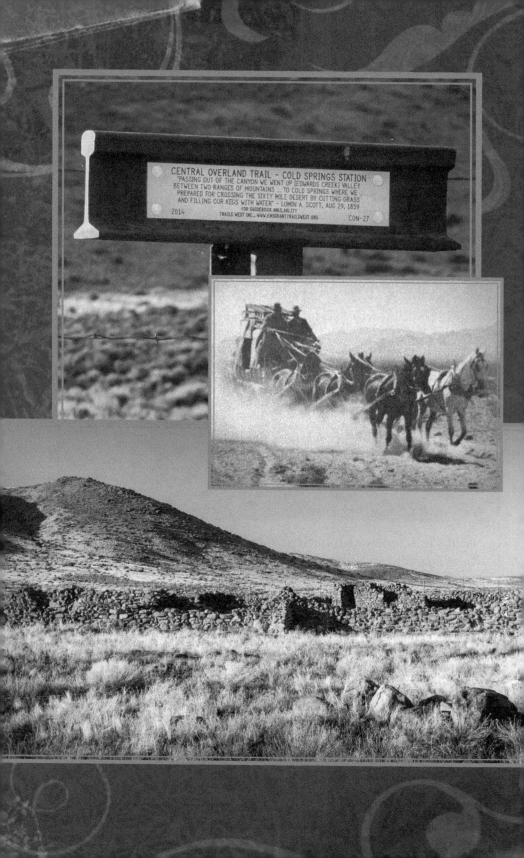

CENTRAL OVERLAND TRAIL – COLD SPRINGS STATION
"PASSING OUT OF THE CANYON WE WENT UP [EDWARDS CREEK] VALLEY
BETWEEN TWO RANGES OF MOUNTAINS ... TO COLD SPRINGS WHERE WE
PREPARED FOR CROSSING THE SIXTY MILE DESERT BY CUTTING GRASS
AND FILLING OUR KEGS WITH WATER" – LUMIN A. SCOTT, AUG 29, 1859.
2014
FOR GUIDEBOOK AVAILABILITY
TRAILS WEST INC., WWW.EMIGRANTTRAILSWEST.ORG
CON-27

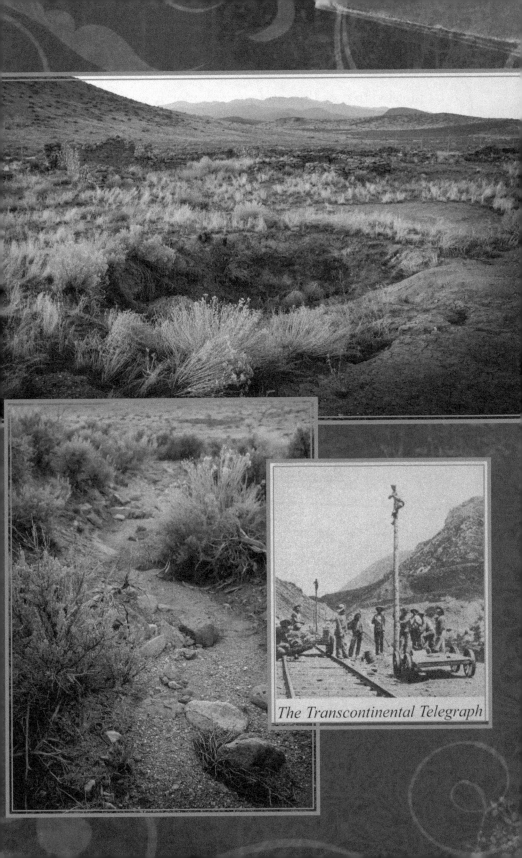

The Transcontinental Telegraph

I hurried to race the sun from completely setting before I made it back to the telegraph ruins. They have a regular ranch fence (a barbed wire 4-strand fence about 50' from the ruins) which surrounds the seven foot chain link fence around the ruins. Last year I couldn't find a place to get through; this time I took time to find a spot to crawl under the fence, about 200' away from the site. I shot the creek bed that ran along the side, and with my handy ladder, shot all the way around these ruins. I used the ladder to hold up the barb wire as well, when crawling under it.

As I was finishing, I turned back towards the trailer and noticed the spectacular evening glow on the mountainside...I shot in the direction of the XP station that sits a mile and a half up on that hill. The shot has a lone tree in the middle, and the XP ruins are right above/behind that tree. All three of these sites are *very* large in size compared to other ruins we have visited! One of my favorite sites by far! :-)

We are camping at the Telegraph Station tonight.
Night night!

March 26, 2016
Cold Springs to New Pass to Jacobsville XP to Smith Creek XP to Bob Scott Campground

This morning I worked on uploading pictures to my computer (*I put them on my computer only for a short time, until I can get them on my large drive at home*) and also my back-up drive I carry with me...Then we enjoyed wonderful steak sandwiches for breakfast...the luxury from last night's leftovers...then we were back on the road!

First Stop: New Pass Overland Stage/Hotel & Store

This was NOT an XP Station. (*I skipped this spot last year, as I had no reception and it is off the road a mile and a half and behind a rock mountain.*) I had a better idea of the location this go-around and had GPS'd it for the road that led to it. The satellite views on *Google Maps* sure come in handy!

When we got close, I slowed down. Fortunately, there wasn't any traffic, so we could, and found a pull-off when we thought we were close enough to park. Bruce got out and walked over to the knoll by the pullout area, and when he got to the top he called back to tell me the road was right there/here! Lo and behold, we were at the entrance. Though a four-wheel drive could access this road easily, we walked, so as not to have to disconnect the trailer. It was a pleasant walk and a beautiful day, anyway.

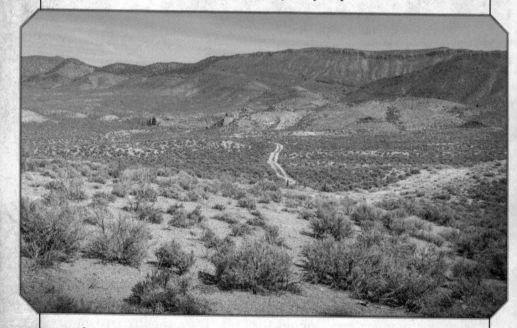

The ruins are hidden behind the rock mountain. We found them to be still very intact, considering their age!

There was a ravine where it looked like a seasonal creek ran alongside the road. The store ruins were located on the north side of the road and creek. That made me wonder if there was a bridge here at one time.

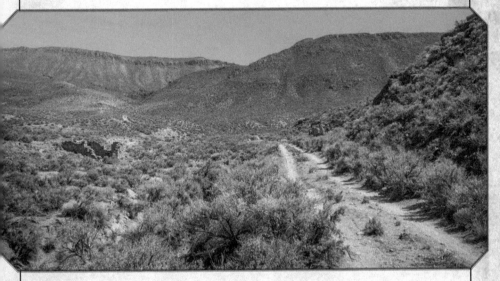

The hotel was right on the south side of the road. These ruins were awesome. I love to find ruins where the fireplaces are still standing...and the hotel's was still standing tall, though leaning just a bit. These ruins were all rock, and probably had the willow/sod roofs at one time—nothing now, though. They could have even been wooden—like many other sites, it could have been removed for another structure, or possibly used for firewood?

I took almost 300 pictures at this site! We spent an hour walking around. I found a few tin cans, as is usual for these old type ruins. Most of the cans were just to the east of the hotel. There were three sunken three-foot round divots behind the hotel. Not sure what they were from? Outhouses, maybe...probably?

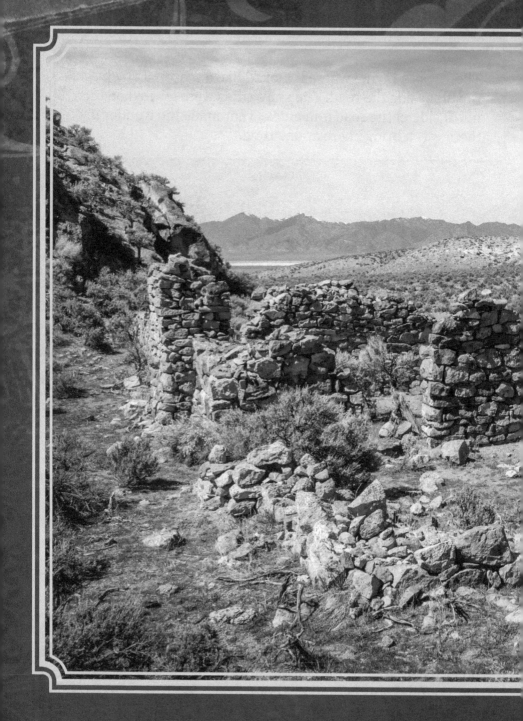

"NEW PASS HOTEL"

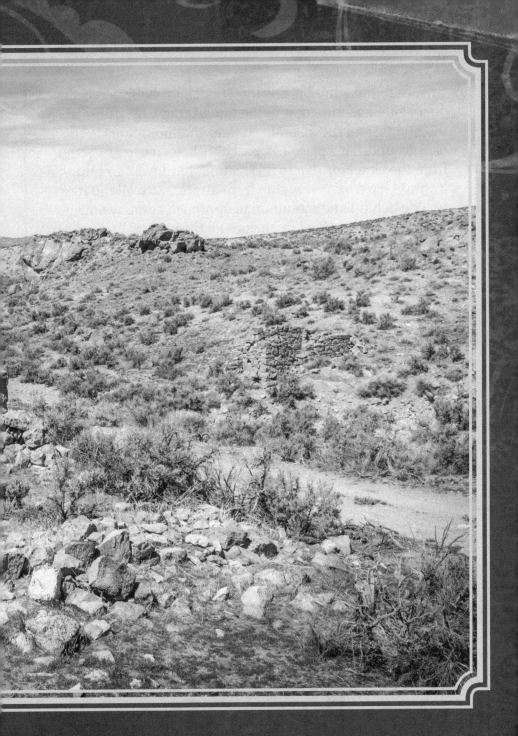

"NEW PASS STORE"

Bruce found a fire pit nearby. Though probably a recent one, I shot a picture of it in the foreground with ruins in the middle and the distant salt flats and mountains in the background. This place has probably been more protected from the elements due to its location, but I wouldn't think it would have been very safe from attacks with all the rocks to hide behind and mountain to approach at many angles.

The road we walked in on goes all the way around back to the highway, though we didn't walk the whole thing...so not sure if it was washed out...so beware, and make sure before driving it yourself.

Next Stop: Jacobsville/Reese River Station
(*Note [Historical]: Surveyor Lt. Simpson and his crew camped here before this was ever an XP stop.*)

I stopped here last year, and Rider and I did a selfie with the historical marker, but did not see any ruins to speak of. This year, I gave a better look by hiking for several miles in an arc around the historical marker. I captured the views in a circle, but to no avail; found no remnants of any kind of buildings or even any rocks, as the marker had suggested there were. Only a couple tin pails...not sure what they were, or if they had anything to do with anything that I was looking for, but took pics of them anyways. Then I headed back to the truck where Bruce and Rider waited.

There is a sign for the Lincoln Highway here as well. I photographed the two-track road that ran parallel to today's Highway 50, not knowing if it is—perhaps— the tracks of that first continental highway.

Next Stop: Smith Creek XP Station

This site takes some time to get to from Highway 50. From Hwy 50, take Hwy 722 southwest, turn right on Smith Creek Ranch Road, then go about 14 miles to the ranch. We drove through what reminded me of a slough near the ocean. Lots of water on both sides of the road, though not full; there was more than I expected in the desert!

Just before we would have reached the Ranch Headquarters, on our left, we found a Pony Express rider cut-out on top of a fence post. It was located just before the white corrals and loading chute. From the Ranch Road, you could easily see the XP rock cabin even before we got to the metal cut-out.

There was a nice pullout to the right, where we left the truck and trailer. We walked down to the cabin. It was fully intact, with a recent rock/willow/sod roof. You could tell where they have added on to the original structure, comparing it to the other pictures I have seen of this site in books...also, they have moved the fence further away from the cabin, as if to make more of a yard around it.

In front of the cabin, there is a storyboard with some historical information and riders' names on it.

It appears as if this site is now being used as a cow camp. There was a BBQ grill, and even kayaks, in the back of the cabin, along with solar panels for power. Times sure have changed, haven't they?!

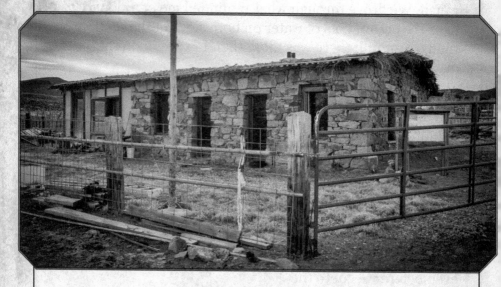

We took lots of pictures here of the cabin and the view!!! The view was spectacular. There was lots of water in the area, and hay was being grown all around the valley.

Driving out, we were visiting and still reminiscing about the site. Bruce especially liked this one, compared to the others we had seen this trip so far. Well, while visiting, Bruce noticed we were heading due south...oops... somehow, we missed our turn that went between the waters where we had had it on both sides of us coming in. I looked at the satellite map on my phone, and he was right, so we turned around and found the connection to get us to the correct Ranch Road. So, be aware of your surroundings, friends! :-o

We made it to Austin about 7:00 p.m. Fueled up and headed to Bob Scott Campground, where we are camped

for the night. (*Same place I stayed last year.*) We were going to try and make it to Spencer's Hot Springs, but it was just too late.

Oh, well...tomorrow we will!

MARCH 27, 2016
BOB SCOTT CAMPGROUND TO SPENCER HOT SPRINGS

We enjoyed a nice bowl of cereal for breakfast, then headed out of the campgrounds. From our campsite, I had spotted a historical marker just across the highway, so we went back to read it before moving on...On leaving the campground, I noticed it was supposedly closed...oops! If traveling through, and you find the gate to the campground closed, you could also stay at the large pullout area across the road where this historical marker is located.

The marker was about the surveyors who have passed through here. Those looking for passes for the stage and railroad. Lt. Simpson's name was listed as passing through here, too.

Spencer Hot Springs

This was only for pleasure and has nothing to do with the XP. But who knows, maybe once they retired they came back and enjoyed them, too?! Last year, the gal at the Austin courthouse had told me I should go to them. But being alone, I told her I best not, and just stayed at Bob Scott's.

It was a long, dusty road to the hot springs, but not really too far off of our course. Once we reached the hot springs area, where we were to pull off to the left, we parked and walked around to find where one could take a dip. We found a water trough being used to capture the water. On the side of the tank, there was a four inch pipe with hot water coming from the spring. Only part of the water was coming in to the tub, as there was a rock in it to control the flow in order to keep the water from getting too hot. The hot springs temperature is said to be 140°. The trough was about 95°.

When we were walking toward the tub, there had been a naked man getting out of it...I pointed and asked Bruce to slow down, so we didn't embarrass him (*or myself*). By the time we walked around the dune, he had his shorts on.

We talked to him for a few minutes about the springs. He

said he visited here often, then gave us directions for using the unusual rock set-up. Primarily, he told us we could adjust it if we wanted it warmer, but not to overheat it for too long. (*There were markings on the pipe that stated, "HEATS UP FAST, AND COOLS OFF SLOWLY." So, I'm sure that was what he was referring to.*)

There were a few pools below this trough. All, including the trough, are slimy, but who cares...just rinse off when you are getting out...lol. After we had a nice nap and snack, we changed and went to enjoy a good soaking...a time to wash off the desert's sand and soothe our aching muscles.

The view from the tub was gorgeous...sitting in a tub of hot water, looking out at a large basin of desert with snow-covered mountains in the background...Oh, and one plastic pink flamingo looking on as we relaxed! (*Only bummer...I did not get a photo of this view, as I left camera at the trailer!*)

When walking back to the trailer, we met a nice couple, Joe and Jane. They were from Alaska, and on their vacation. Joe shared that he is a commercial fisherman. We talked about my project and about their journeys. They were very nice folks who also love history. Jane shared that she was currently reading a Nevada desert history book about folks who came through here in wagon trains. We both agreed that as tough as it is driving through the desert, we couldn't imagine what it was like for them in wagons!

There are NO facilities here: no drinking water, no bathrooms. There is only sand and hot water. So make sure you bring whatever you need along with you!

We camped here for the night. I fried up some hamburgers and opened up a can of pork-n-beans. We fired up the generator to charge up, and enjoyed watching the rest of the series I have on video...*Lonesome Dove's* "Streets of Laredo."

Take note: it was windy most of the time we were here. Kinda like getting sandblasted a bit. Park accordingly. We could have probably turned around to point toward the south, but we survived—it was only for one night.

March 28, 2016
Spencer Hot Springs to Eureka through Blizzard to Ely Prospector RV Park

I got up and went out to get a picture of the hot "trough" and was so disappointed to find a storm was heading in and I couldn't see the snow-covered mountains at all. Also,

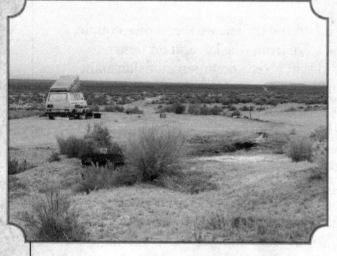

there were people soaking; so, not wanting to disturb them, I took a picture of the area, and not the actual trough. I guess I will have to revisit someday. :-)

We could feel the weather changing. It was getting to be very cold, and before we were finished loading up, snow began to fall. We got off the sandy area just in time. We drove out the gravel road, and by the time we were back to Highway 50, the snow was coming down pretty good.

With the snow coming down so heavily, sadly we had to SKIP these scheduled sites: Hickinson Petroglyphs, Dry Creek (*which I really wanted to hike in to—but no way in this weather*), Sulphur Springs, and Diamond Springs.

We drove right in to the town of Eureka without stopping anywhere. The snow was now a few inches deep, but we decided to visit the store and a couple places on the main road. We had planned on staying at an RV park on the south side of town anyway.

The small town grocery store was like stepping back in time. The store was in an old, original building from the 1800s mining days. There were old cupboards with canned goods, head mounts all over the walls, and a tin ceiling. We strolled around, admiring this relic for quite a while, while searching for a few things we needed to pick up.

Next, we walked under the covered walkway towards the saloon. There was an empty store with a very unique uncut slab ceiling in it. Bruce had seen it before; I hadn't. Then we went in to the saloon and took pictures there. This was a cool old bar. One room had a large dance floor, with a nice stage, the bar in the middle, and then

a café connected on the other side. We got a few pictures inside and had some fun with them. Got Bruce behind a door made like an old jail door that was in the dance hall area.

Lastly, we headed down to what I really wanted Bruce to see...the historic Opera House. Bruce plays cowboy/Western music, and I just knew he would really appreciate it! He did...

We met Patti Peek, the coordinator of the Opera House. She was very gracious and gave us a tour. First, she pulled the 1932 screen down for us to see, and then took us back stage and down the hallways. You may remember from my visit last year...these walls are COVERED

with autographs of all the artists who have performed here, starting from the 1880s! Patti explained that we were lucky that the Opera House was even open today, as the only reason they were was due to a water meeting today.

Patti told us this building is pretty much a community hall at times for local chapters of all kinds to meet up. There is a room downstairs, too, for birthday parties and the like. (*But we already knew that, didn't we?! Remember? This is where the kid's town treasure hunt started last year. :-)*)

Bruce might even get a gig out of it when all is said and done. Patti told him to get ahold of her in July to hear about the schedules.

We thanked Patti for her hospitality, and then headed back to Rider and the snow-covered truck and trailer.

Next stop was to the edge of town and stop for the night at the RV park...

Bruce asked me if I wanted him to drive...(*I might as well admit it...I am a chicken little driving in the snow!*

I have done it often enough, but I do NOT like slippery conditions, especially pulling a trailer!!! Beings that Bruce is a Montana cowboy...DUH... of course I wanted him to drive!)

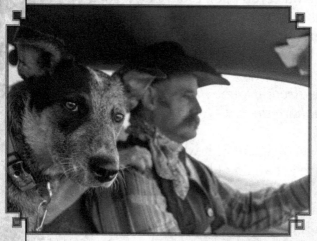

I said, "Well, if you want to, that would be great." (LOL...*Whew... thankful!*) From the look on Rider's face in the photo, I think he agreed, "Mom, he's got this." HaHa!

Well...the RV park was the plan, anyway. I knew that the park was coming up, and at the same time was showing Bruce the old mining camp that was across the street from the rest stop. Well...we looked back to our left, and we could not tell where the driveway was for the RV park. The snow was already too deep, and we missed it.

We searched for a place to turn around, to no avail. Everything was covered with snow...we couldn't see the sides of the road well enough to tell if it was safe to pull off on or not...and didn't want to take a chance of getting stuck off the side of the road. So, we had to keep looking for a clearly safe turnaround.

By the time we spotted a safe place to turn around, we were already 20 miles out of Eureka. It was really snowing hard now, and windy as heck.

We crossed three or four mountain passes. Sometimes in white-out conditions. There were a few reflectors off the sides of the roadway, but they were not always visible. NOT FUN!!! There were some tracks on the road that Bruce

followed for a time. I can admit it, I was pretty stressed about then, and was trying my best to not show it. I was so thankful Montana man was driving! I would have just pulled over and gave up...haha. I am sure I would have kept going, but I wouldn't have been doing well, especially in the no visibility situations.

Coming up on the fifth or sixth pass, we were in a minor incident. We had just come over the crest of the mountaintop, so we were going slow—maybe doing about 20 miles an hour...and all of a sudden, there they all were... STOPPED. There were about four or five cars in our lane! Bruce slowed down, but we couldn't slow down enough to not run into them...we had to go around them on the left, into the westbound lane. Once we were over there, there was an SUV, also pointing east, with her back-up lights ON!!! What the...?! Now we are sliding at about three to five miles an hour...Bruce said, "Sorry, but I am going to hit her." Then, ever so slowly, we slid right into her, or she backed into us...hard to say.

In front of her about 200' was a semi truck who was stopped, facing us, in the westbound lane. I think he was stuck, and probably the reason why all the others were stopped? God only knows. But why the gal was in the wrong lane, stopped, with reverse lights on? Unless she went around the traffic so as to not hit them either? In these kinds of weather conditions, things can happen that we don't understand.

After my truck connected with the gal's SUV, she got out for a second, then she got back in her vehicle and

pulled forward through the opening between both lanes of stopped traffic (that was there the whole time)—so not sure why she had stopped to begin with?! We pulled around behind the big rig and the traffic he had stopped so that the folks heading east could get by. I gave Bruce my insurance information to exchange with her. Since he was driving, I never got out. This was not a safe place for anyone to be outside...so they made it brief. We told her if she liked, she could meet us at the Sheriff's Department in Ely, as we would go there to report the accident as soon as we got in to town. The poor gal was in a rental car and on vacation with her kids.

At quick glance at the scene, we knew that we lost my license plate and bent up my bumper, but there was no damage to the radiator or even the grill we could see... thank God! She reported that she couldn't open the back door of the SUV, but her vehicle was also operable.

We drove for another hour and a half in white-out conditions, with the wind blowing the snow sideways...We were in a *blizzard*!

You may be wondering why we didn't just stop somewhere? Well, on Highway 50 in this part of Nevada, there are no pullouts and barely shoulders, if any. On this side of Nevada, we were in mountainous terrain. If there was a road to turn off on, we didn't know what would be down it, and then we could have another problem altogether if we blocked a road. We had to keep going.

The road disappeared often, then suddenly you would be able to see the single reflective markers one on each side of the road. Fortunately, my GPS map was still working, though there was no phone service, so that we would know when a curve was coming up and how sharp it would be.

Praise the Lord, and thank you, Bruce, for your experience with this kind of weather and road conditions. We made it safe and sound into Ely!

Even here in town, the visibility was still very low. You could barely see the buildings on the other side of the sidewalks, and hardly even the roads. I GPS'd the White Pine County Sheriff's office, as Bruce wanted to stop there first to report the accident and get a report filed.

We had to drive about five miles an hour. We passed a lot of sedans that were stuck along our route, and even a few crazy people who were dumb enough to be walking on the road in the tire tracks!

Anyway, we made it to the Sheriff's Office, and I bundled up to walk across the parking lot...the wind was still blowing the snow sideways. Once inside, we received a very friendly greeting from Sergeant Penny Jo Robison. She couldn't help but chuckle as she watched us blow in the door.

We reported our incident and visited a while about the storm and the local going-ons from it. A few minutes later, another deputy came in, soaked clean through, from him being out rescuing folks on the roads. His name was Dave Monroe; he was a very nice young man.

After introductions, he and Bruce went outside to photograph the front of my truck for the damage. Officer Monroe asked for the registration (*because we lost the front plate, and the one in the back was covered in snow and ick*). While Bruce was digging it out of the glove compartment, Rider (*you know, my puppy*) decided to jump out of the truck! Fortunately, he had seen me go in to the building, so that is where he ran, too...and I had just happened to look outside and saw him running around! I let the bugger in. The officers loved him, and he sure loved all of their attention, too!

When they came back in, we all visited for a while about Officer Monroe's day and how the schools were all shut down for today and tomorrow. Before we left, I asked them if we could add them to my photo collection. And they obliged! Hey, this is all part of the adventure, though I know Bruce wished it hadn't been.

Officer Monroe mentioned that our picture with Sergeant Robison may be worth something even more in the near future, as she will be on the ballot

for sheriff this year... Well, we sure are pulling for her! What their small crew must go through to service this large area, especially in a storm, has to be very difficult. God bless them for their service!

Well, back out into the storm we went...heading for the Prospector Hotel/Casino/RV Park. Again, we passed a few cars stuck in their own tracks, as we chugged along. We made it to our destination without incident! Praise God!

We found a pull through and went inside to register. We were told that we couldn't park there, though, as it had already been assigned to someone else. Bruce moved the truck one more time...then plugged it in. At this point, we both took a swig off some Fireball...LOL. This has been one hell of a day...With the weather, I registered us for

two nights' stay...We got our keys for the pool and hot tub, and side door to enter the hotel...then we went to the hotel restaurant, Margaritas, to have a hot meal.

Wow! Such a relief to be stopped after the day we had. I wasn't even driving, and was so stressed from the road conditions. Bruce handled all of it like a champ! Even Rider was glad to have his dinner and relax...We watched a couple funny movies tonight...Then—night night!

MARCH 29, 2016
ELY PROSPECTOR RV PARK

This morning I woke up off and on, and finally got up to make coffee about 10:30. Bruce said he slept well...I know I slept like a rock. Knowing that we were not going anywhere today was nice after yesterday's stressful drive.

Today was a great day to get caught up on my Facebook comments and messages, along with other computer work. The Prospector Hotel and Casino offers free internet connection all the way out here in the RV parking as well. (*If you have other needs for work, they have a courtesy office you can use with a computer and printer by the registration desk.*) We were glad to have phone reception for the first time in a few days, as well.

It was nice to be able to enjoy a little civilization before heading back out into the desert. The next part of our journey will be on roads that are dirt and gravel, so we might as well enjoy our down time while they take their time to dry up. I pray they are passable when we head back out.

MARCH 30, 2016
ELY PROSPECTOR RV PARK

Today was another relaxing day. I hooked up the TV so that we could watch some local channels, and then we enjoyed a movie tonight.

The snow is slowly melting away all around us, though it is still cold at night. We haven't been able to hook up to the water or dump the tanks yet, as the connections are still frozen over.

Bruce made dinner—spaghetti(!)—while I did laundry in the hotel. After dinner, while we were waiting on the dryer, we enjoyed the hotel's hot tub and swimming pool! Nothing exciting today...but enjoyable down time.

(I highly recommend staying here if you are traveling through. The hotel has rustic decor, including a wall with Will James' story, hallways with Western artwork and photography, and much more! The restaurant served great food as well.)

MARCH 31, 2016
ELY PROSPECTOR RV PARK TO UH-OH
TO NEVADA RAILWAY MUSEUM
TO SCHELLBOURNE REST STOP

We got up at a leisurely pace this morning. There was no need to hurry, as we were still waiting on the snow to dissipate. I remembered I had rubbing alcohol in the bathroom, and tried to melt the snow off the sewer connections. It worked! (*After we also chiseled around the edge.*) We got it dumped, finally. We also filled up the

water tank. Then we cleaned up our area and got things ready to roll.

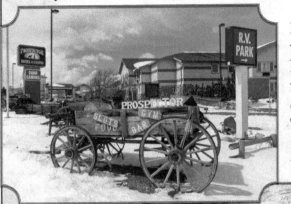

Before leaving, I walked around the outside of the hotel to capture a few photos of their outdoor artifacts. They have some pretty cool old wagons and even

an old log cabin right by where we parked. I got Rider in a few of the photos, then posted a note with some of them on my FB page.

As I was readjusting stuff in the back of the pickup, I found trouble. BIG TROUBLE!

When we were in the accident the other day, we couldn't see much with all the snow, other than that the front bumper was bent. Well, now that the snow had mostly melted out of the back of my truck, I could see that the trailer was damaged pretty bad. Right where the 5th wheel hitch was bolted on to the trailer, the sheet metal had torn away and all was shoved about eight inches forward!

I called out to Bruce. After showing it to him, he said, "Not good!" We pulled to the front of the Prospector to ask them if they could recommend a welder. The lobby clerk gave me a few numbers, and fortunately I found one just

down the street who said they could get to it today. Thank God we found this out before leaving town! Thank God, we made it all the way to Ely! Good thing we had to go slow with the weather when we came across the passes into Ely—it could have been really bad with one quick stop or turn.

We took the trailer to the shop, and they said they could fix it up. Also, I asked about the 5th wheel plate, as it was bent up, but he said it was still sound.

We dropped the trailer off and decided to take our time to do a little sightseeing, as there was no need to sit and watch them work on the trailer. Our first stop was to a local Western store. Bruce found himself a real nice Palm hat for a great deal.

Then we walked to Anderson's Store, as the welder had said they make great sandwiches and burgers...He was right; the burger was great! :-)

Now back to the shop to see how it was going...they had just finished! $275 fix...ugh. But so glad it is done! We were very fortunate to find an available welder on such short notice!

After picking up the trailer, we went to the Nevada Northern Railway Museum. I chose not to go in, since I'd been there last year, but I did pay for Bruce, since it was his first visit.

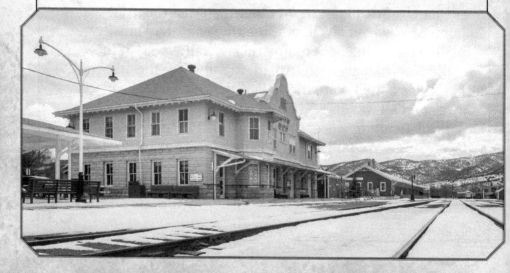

While Bruce enjoyed the museum, I walked around outside taking photos of the station in the snow. Quite a different look than last October...also, I could walk out onto the tracks to take some photos from the center of

them...There were no trains out, so took advantage of that! Of course, I wasn't allowed to even walk out onto the tracks while here last time, as the steam engine was idling on the tracks! I was bummed that the train wasn't running, though, as I sure

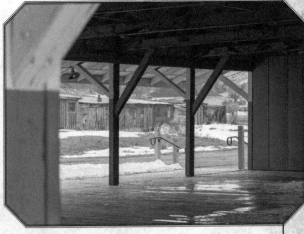

enjoyed it last time, and wanted Bruce to get a chance to ride as well. Oh, well. We spent about an hour and a half there.

Before leaving town, we of course stopped to get fuel and refill the propane, and then we hit the road.

Next Stop: Schellbourne Rest Stop

We found the same parking spot as I had last year available...it is a nice end spot, away from all the truck parking. After backing in, I put Rider out on his lead to enjoy some sunshine and eat his dinner. We went inside and shared the leftover spaghetti and salad.

Tomorrow, we will wait 'til things warm up a bit, and then be heading up to Egan Canyon! I am excited, as this site has a story of the two station keepers being held captive by 80 warriors...

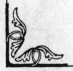
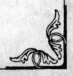

April 1, 2016
Schellbourne Rest Stop to Egan Canyon XP
to Cherry Creek to Schellbourne Rest Stop

This morning was chilly, but we were grateful that the sun was out!

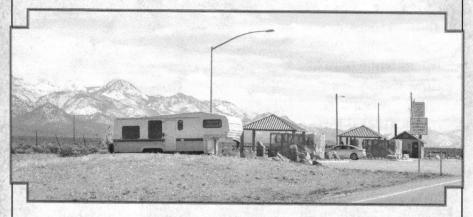

We dropped the trailer and noticed there was another RVer who was parked across the way from us. Their trailer was unhooked also, and I wondered if they were doing what we were? Then the next time I looked, I noticed the hood was up on their new Dodge pickup...then I recalled seeing them last night with their hood up. I walked over to see if there was anything I could do to assist them.

I met Dan and Ruth, a very nice couple traveling up to see friends in Cherry Creek. Dan said that his dash light for one of the injectors was on. They had spoken with a NHP (Nevada Highway Patrol) officer last night, who had called in a tow truck. They were still waiting. They asked if I had phone service, and I told them I had it off and on. It literally depended on where I was standing. They said they couldn't get out at all.

I loaned them my phone to call Good Sam's. After a considerable amount of time on the phone trying to help

"Cheyenne" figure out where they were…to no avail (*she just couldn't get it?! I have had trouble when calling them too, and dropped 'em for it*), my phone finally died, because it took so long. I was frustrated for them, as I told this Cheyenne person that SHE didn't need to know where they were, since the Ely tow truck service would know exactly where they were…Also, if I found this spot on my *Google* GPS search…what the heck was the problem locating it?

Fortunately for Dan and Ruth, they had their friend from Cherry Creek coming to just follow them back to Ely, with hopes his truck would make it okay.

While we waited, I shared with Dan what I was working on with the Pony Express, and he said that his profile picture on his FB page was him standing next to the large sheet metal art of the XP Rider here at this rest stop. He asked me for my card and said he would be looking forward to purchasing one of my books when it came out. I gave him a card and said that I would love for him and Ruth to follow along on our journey on Facebook, too!

After their friend showed up, while we were visiting, he told us that the road up to Egan Canyon may be muddy. He said that with my truck being a 4x4, we should be fine, and that we probably wouldn't even need to use it. He was iffy about us going through to Utah, though. He recommended coming back in the summer…lol.

Next Stop: Egan Canyon XP Station

With guidebook in hand, we headed out. The road to the first turnoff was in pretty good shape. The road leading up into the canyon had some snow

still on the ground, and was slippery in places...for the most part, though, the ground was pretty firm, and we had no troubles at all.

I have read that this part of the trail coming through the canyon was a very popular ambush road. It was said that the rock outcroppings and the willows were perfect for hiding and attacking the riders as they passed through. So, once we were in those willows, I stopped to photograph them. The sides of this canyon looked exactly as had been described. Now, all I see is a stunning canyon, but I am sure the riders may have not seen it that way, with constant concern of being killed!

Once we made it to the Egan XP station, there were good signs where the road splits...The road that continued up and over to Ruby Canyon was completely covered in snow. I decided that I had driven far enough, and I parked the truck off the side of the road.

From there, I walked around the site. I really wanted to find the Fort Pearce Cemetery, where I had read

there was supposedly an XP rider buried there along with three cavalry soldiers. I knew from the guidebook it was supposed to be just about a half mile or so to the northwest...I think I walked further than that, though. When I got to what I thought was about a half mile up the road, there was nothing yet. I climbed up on a knoll to see if I could see anything. I saw several wood posts standing in the distance, and hoped that it was the site...I went back to the road to walk, as I was in over a foot of snow. The road was slick for walking, as it was partly frozen as well. I was so thankful I didn't drive, as I was sinking just walking on the slush.

There were a lot of other tracks in the snow—maybe cows, horses, deer? After going a few hundred yards, I spotted an area that had a marker in front of it. It looked to be about a half acre that was fenced off. Woohoo, I made it! You could plainly see the wooden picket fences around each of the four graves. At the entrance, it noted that there is a dispute of who exactly was buried here, but it read that the before mentioned was probably the case. I spent a while there and took lots of pictures. It was strangely beautiful with all the snow. I said a prayer over each of the graves, and then headed back towards the truck where Bruce and Rider waited. (*Out of respect, I never take Rider into any cemetery.*)

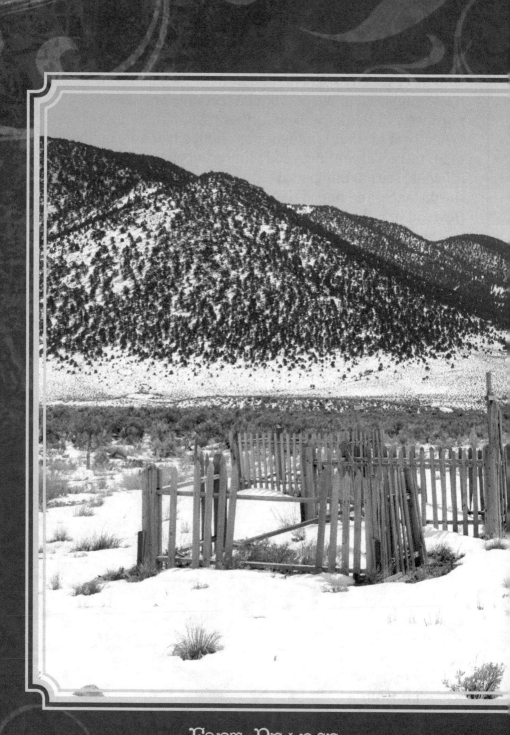

FORT PEARCE

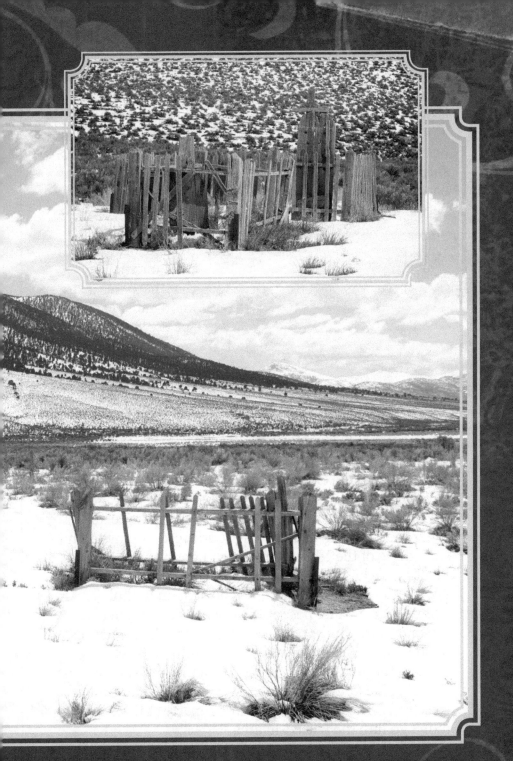

CEMETERY

As I was heading back, I was paying attention to the hills around the area. From my research, I knew about a story of a rider who was said to be riding in to this station, and as he came around the large mound, he spotted 80 warriors surrounding the station. Upon seeing this sight, he went back to get the cavalry that he had passed earlier that was between Egan and Fort Ruby.

He had explained the site location pretty well, mentioning that there was a large knoll and you couldn't see the station until you got around it... that is how he saw the warriors without being seen. I believe the knoll I shot from all angles would have to be the location he was speaking of. I even climbed on top of it to get a look around, and then went down to the elevation I believed the XP station must have been.

While I was out looking for the cemetery, Bruce and Rider took the other road going southwest, hoping to find something of the XP station. When I got back, he showed me what he had found of a rock monument with a steel post coming out of it. There was no sign on it, though. Also, he had seen a white post out in the fenced area; maybe it marks something about the XP station? I got pictures of both. Also, I photographed all around the fenced area. Though the snow sure made the area picture worthy—just stunning, actually—it sure wasn't conducive to finding any rock walls. The area is on private property at that, so we didn't go into the fenced-in area.

Heading back down the canyon toward the rest stop, we did see a few remnants of the mining that had started here right after the Pony had ended. There looked to be perhaps an active site as well, just above the XP site, as there was a tent camp. I captured a few pictures of the sites. One of the sites had a boarded up opening in the base of the mountain. You know, like the ones we see in the movies...or, for those of us over 40, in the *Lassie* series. No, we did NOT attempt to go in!

We were enjoying the beauty all around, and I was taking pictures of the road coming out, with a shot of the valley going across to Schellbourne Station/Schell Creek, when I spotted a deer...then two, three, and then about sixteen! I stopped and got pictures of them. Even changed to my 300mm lens in hopes of getting some clear shots of them. It appeared as if one doe enjoyed being my model, as she was patient while I captured her many times. The herd moved up the rocky area and to the top of the crest. It was so awesome.

Then, when I was about to close my door to leave, I noticed we had parked right next to an XP marker...lol! This is twice now this has happened to me this year! Once in Carson City, and now here! I got back out, and shot this marker with the view of the mountains and valley.

Heading back out of the canyon there were two ways you could go. Bruce asked if I would like to take the road going to Cherry Creek. I hesitated, due to fuel...then agreed it would be nice to see the historical mining town.

Next Stop: Cherry Creek

Cherry Creek was a mining community right after Egan Canyon had been one. The town now has many ruins and

CHERRY CREEK AND EGAN CANYON

The town of Cherry Creek before you was part of a network of mining districts that operated in the nineteenth and twentieth centuries, including the Gold Canyon district in Egan Canyon, five miles to the south.

Peter Corning and John Carpenter helped start the town of Cherry Creek when they staked the Tea Cup gold claim in 1872, resulting in a boom and the development of a town. At the town's peak in 1882, it boasted a population of over 1,800. While production fluctuated, Cherry Creek continued to produce gold and silver ore into the 1940s.

Egan Canyon to the south was part of the 1855 route established by Howard Egan and the Mormon Battalion, and surveyed for use in 1859 by the U.S. Army. By 1860, the Pony Express placed a change station at the west opening of the canyon. Between 1861 and 1869, Butterfield's Overland Mail and Stage established a station here that grew into a small temporary town.

In 1863, soldiers from Fort Ruby discovered gold in the canyon, leading to the creation of the town of Egan and a mining district. By 1865 there were three stamp mills in Egan processing ore from the district. Like Cherry Creek, to the north, Egan boomed and busted into the 1920s before mining ceased.

remnants left behind...along with homes of those who still reside here. It is a very small town with dirt roads, and one

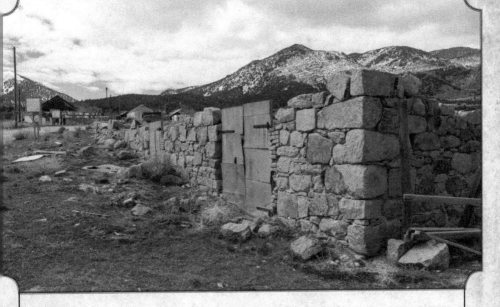

paved road that leads in and out to Highway 93. I got quite a few pictures. While shooting, I met a young lady who looked very sad. I asked her if she was okay...she explained that her grandfather had just passed away and that she had lived with him. I gave her my condolences and told her I would be praying for her and his family. She thanked me, then continued on to her destination. (*I started to leave this out of the journal, but decided in honor of the people who live in this small town, I should share that there are folks who live their lives here; it is not just an old ghost town. I honor and respect it as their home.*)

I headed back to the truck...then we were on our way back to the Schellbourne rest stop...

I am whooped; been a busy day hiking in the snow. I laid down for a bit, then ate a snack and laid down again. About to make some dinner, but wanted to write this up first.

Bruce just told me that the sink is broken...I got up to check it, saying, "What the heck? No!"

Once I got up to look, he said, "April Fools!" Oh, boy! LOL, I forgot today was April 1st! Funny guy—glad the sink is okay...haha.

Happy April Fool's Day!

Tomorrow, we are heading out to very desolate areas... We will be finishing up Nevada and heading into Utah.

APRIL 2, 2016
SCHELLBOURNE REST STOP TO SPRING VALLEY TO ANTELOPE SPRINGS TO EIGHT MILE TO DEEP CREEK XP STATIONS TO IBAPAH, UTAH

We hooked up the trailer and were ready to roll early this morning...we headed east out of the Schellbourne rest stop, and up the dirt/gravel road. I had stopped at Schellbourne Station last year, so this morning I only shot the log cabin that was lower in the valley from the road. Some research

states that it was the old XP station; others only mention that the station was a log cabin.

As we drove by, I pointed out to Bruce the rock walls of the old buildings that we could see from the road.

Next Stop: Spring Valley/Stone House XP Station

Our next stop was going to be Stone House, also called the Spring Valley Stage and XP Station. I enjoy looking around this location.

The XP station is said to be the old log barn/building near the corrals. I got lots of pics...again! LOL, as can't help myself—just love these kinds of buildings and corrals! Even shot a few of Bruce and Rider. :-)

Now driving towards Antelope Springs...we saw some antelope and a few mustangs in small groups. Not sure if they were all of one band, or multiple bands? Many of them were too far to get pictures, but I did try to get a few. We'll see later on the computer if got them well enough to share with anyone!

Next Stop: Antelope Springs XP Station

My last visit here, I had no luck finding the log cabin that was said to still be standing (some fifty years ago) in one of our guide books. It was said to have been used for the XP station near the springs. I wanted to make another heartfelt effort at finding it. We dropped the trailer at the turnoff on the main road and headed back up the two-track road once again.

This time I knew where it *wasn't*, so we took some other trails and drove further up the road. Bruce was driving so I could get a better look around. We took a driveway off to the left (south) just below the reservoir. This reservoir has to be the location of where the spring is located...we drove about a half mile up the new road, where we met up with

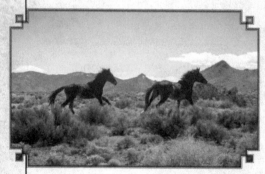

a couple of mustangs! This time they were very close...and for some reason, the whimpering of my whiny puppy who spotted them seemed to fascinate them and caused them to stick around with wonder. I think they were

probably wondering what the heck was in the truck to make such noises! I would imitate them here for you now, but I don't think I could come up with how to express them in writing...heehee. I'll let you use your imagination!

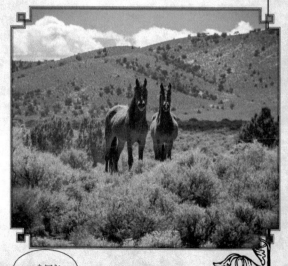

Even off to this new direction there was still no log cabin, so we turned around and went up the north side of the reservoir, then back to the main two-track road we came in on. A short distance up, we saw the (what has now become the typical) railroad rail marker of Trails West, Inc. I missed it last year! It read that this was the location of the Antelope Springs Station. I got out and walked all around, hoping to find anything that would show me where a log cabin may have been. Nothing...nothing but a few rabbits. One that made me jump, right after he came out of his hole! "Pesky wabbits!"

Once I had captured enough photos of the view, we headed back to pick up the trailer. I was rejoicing that we at least found the marker for the site!

While trying to back up to hook up the trailer, I did a rookie move and let the clutch out too slowly and the truck died...Yep, I accidentally killed it trying to go slow...Well, for some reason, she didn't want to start back up. I tried a few things, then just gave her some time to cool down. We went to rest for a few minutes, hoping that was all she needed. (*For some reason, with no rhyme or reason, this truck has some issues once in a great while, where, once it gets warm, it will not start.*) Nothing, not even a try.

After a siesta, we tried again, and thank ya, Lord, she started up! We hooked up...and were back on the dusty trail!

Next Stop: Eight Mile House XP Station

As we drove towards Utah, headed across the grand Antelope Valley, we saw a few more antelope running and watching us as we passed by.

One of the research books I had on this next station stated that the site was just outside of the Goshute Reservation, and along a trail next to the border of the reservation fence line. It was to be about half a mile or more off the main road. It was said to be only the location, as there was nothing left of it...so instead of unhooking the trailer and driving down to it, I shot a picture of the vicinity from the main road to show where they claimed it was, with two Antelope on this side of that fence line.

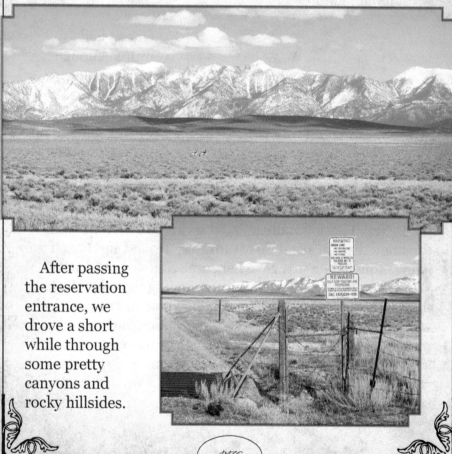

After passing the reservation entrance, we drove a short while through some pretty canyons and rocky hillsides.

Upon approaching some trees and buildings off to the right (south), there was an old log cabin and barns on the side of the road just behind the fence. We stopped, and I started capturing shots of them, as I thought it was pretty cool.

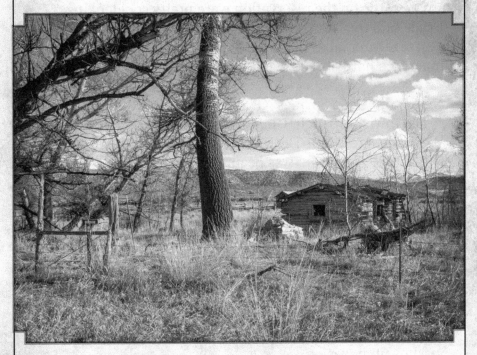

Well, after a bit, I spotted the sign! Another one of those Trails West, Inc. signs that are made out of old railroad tracks. It read that this was the site of the Eight Mile House location! Saaaweeeet! Though there are discrepancies of which location is accurate, I got photos of this one to put in my book...as it is much nicer than just a view of sagebrush at the end of a fence line like the other possible location was. This one is much more tangible!

I respected the fact that it was on private property, and only shot from the fence line. A gentleman was pulling out of the nearby ranch house and shared a big smile and a hearty wave as he went by...I am grateful to have found this

station! It is another one of those awesome coincidences, as I have mentioned before...where as I step out of the truck unawares...to find a clue to the site in question only a few feet away...Love it!

The cattle on the reservation were pretty cool looking; Bruce said they looked like they were Corrientes. This desert terrain takes many acres to feed one cow, so they must be a hardy breed.

Next Stop: Deep Springs XP Station

The town of Ibapah, Utah! Good-bye for now, Nevada. We made it to Utah! The terrain here, as well as on the Goshute Reservation, was beautiful. The further we went, there seemed to be more water and irrigation. The valley was covered with green pastures, and there were historical ranch houses and barns.

As we were entering Ibapah, we found the CCC (Civilian Conservation Corp) marker for Deep Springs! Well, wouldn't ya know it, it was on a magnificent spring! Surrounded by deep, lush grass, with water a-plenty...and there were old buildings and barns nearby. The sun was just behind the marker, so not sure how well it will show up in my photos... these markers are old and dark, made of brass.

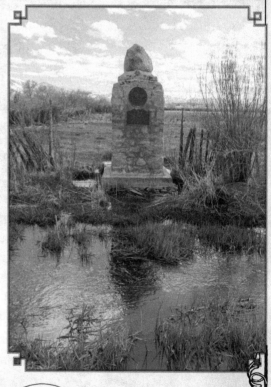

(When I called to check the trail through Utah with the BLM there, the man told me that many of the markers had been stolen off of the monuments, due to them being made of brass, and they hoped to someday remount new ones with a substance that was not so valuable...hoping they wouldn't be stolen again.)

As you drive into Ibapah, for those of us who have never been here...we were never really sure if we were already there, or just on the outside of it...

After leaving the monument, we turned left, and off to the right there were a few cool old buildings, including a granary shed. I captured some photos of a cabin standing

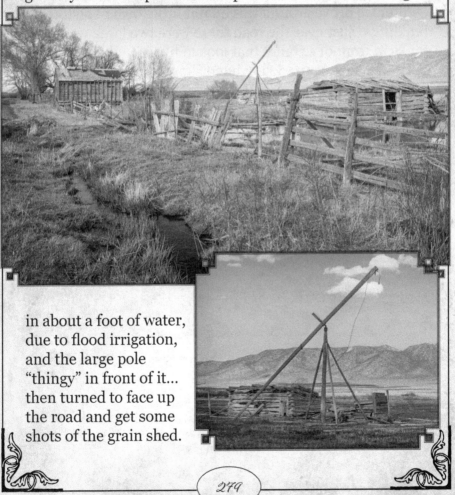

in about a foot of water, due to flood irrigation, and the large pole "thingy" in front of it... then turned to face up the road and get some shots of the grain shed.

Once the road turned from gravel to pavement, we were in town. Just off the main road you could see a school. While looking straight, there were a few houses and some trailers.

One of my guidebooks, 15 years old, said there was a gas station and a cool shop with souvenirs for the Pony Express. Well, we were soon to find out, that was only true until about six years ago. We were down to a half tank of fuel, and had a lot of miles to go to the next place that had fuel, which would be much closer to Salt Lake City. I always carry gas cans, but was concerned it wouldn't be enough. I judge on the error of too much, never too little!

After we drove around this quaint little town of historical buildings...just near the road there were two large water tanks in front of a trailer that looked like it could be the RV park. Then we saw faded painted signs on the tanks that read "RV and Propane." I went to go knock on the trailer

door, but once I stepped up to the top step and looked in the window, I could see it was not an office—and no one lived there, either.

There was a dog watching me nearby, so I figured someone must live in the house next door. The dog

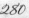

followed me. I knocked on the door and a gentleman answered. I introduced myself and asked where could we get fuel and a place to park the RV for the night.

He introduced himself as Clint Downs, and then proceeded to tell me that the nearest gas station was in Wendover, and is quite a ways northwest of here. I explained that I was working on a photography book on the Pony Express and wasn't heading that direction; we were following the Overland Trail. I asked about the ranch over by the school, and their large tanks...did they have gasoline, or were they all diesel? He said diesel...

Then he told me about the Parker Ranch. It was five miles back from where we had just come in. I said I appreciated that they "might" sell us fuel, but it would be nice to know for sure before we drive 10 miles round trip and find that they don't have any or aren't at home... He said, "Oh, sure, come on in; I'll call them—they are my cousins." Then he introduced me to his wife, Winna. She and I sat down and shared about my book and about the Pony Express' history here in their town.

Clint called about the fuel and spoke to Rachel, his cousin's wife. She said she had gas and said to come on back to their place. Clint described the place, and I remembered it well, as there was a small cabin at the entrance of the ranch and it was meticulously well maintained. Bruce and I had admired it while driving by.

Clint said after we got our fuel to come on back and we could plug in to one of the RV sites next door...as he owned it...I said, "Very good! Thank you. It will be nice to plug in this evening." It was getting to be about 7:00 p.m.

We drove back to the Parker Ranch. As we were pulling in to the drive, there were children playing, and there was a woman walking from the house towards the large tanks of fuel. Rachael was the sweetest lady ever. She said that they paid $2.50/gallon for the gas, and that's all she

wanted in return. I gave her $60 to top it off...told her how truly thankful I was for her generosity...I expressed to her that it sure will make the next leg of our trip a lot more pleasurable knowing that we now had plenty! I gave her a card and told her about the XP book project. We waved to the kids and bid Rachael farewell.

(*In the future I would recommend folks take extra fuel, and NOT expect to find fuel in Ibapah. The Parkers were gracious to help, but they are not a fueling station ;-)*)

We went back to Clint's place to park. They have a nice grassy area to park, with full hookups. Clint said that many hunters camp here in the fall. He hasn't advertised, and did ask if I would make a notable mention of their RV camping in my notes/book. I said absolutely! I am sure if anyone like myself was out this way, they would be as happy as we were to find a nice place to camp with power/water/sewer! (*Please, call to confirm that the RV park is open before driving all the way there.*)

As promised, here is the information:

WEST DESERT RV
Owners: Clint and Winna
Downs
435-234-1134
Ibapah, UT 84034
Mail (not physical address):
HC 61 PO Box 6066

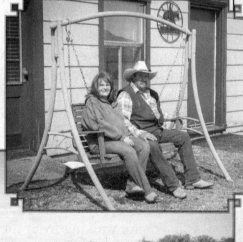

While visiting with us, Clint said that he knew a local historian who would probably love to meet us. He said he would give him a call and see if he could come down and visit in the morning. About a half hour later, he came back out to tell me that *Jed* would love to, and would be here at 8:00 a.m. I said, "Very cool...I will be looking forward to it!"

This has been a pretty awesome day. So thankful to have met some wonderful people...and gotten fuel...and now a nice campsite...

Lights out.

April 3, 2016
Deep Creek to Canyon to Round Fort to Six Mile House to Willow Springs to Callao to Boyd's XP Station

We woke up early, as we knew Clint and Jed would be over to visit by 8:00. I was looking forward to meeting with them.

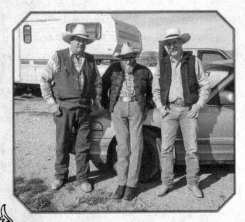

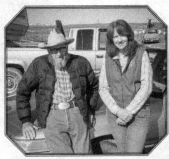

I believe our visit with Jed and Clint was an important part of our adventure, as we learned

283

not only from the historic sites, but also from their wisdom
and the stories handed down. I am so glad we got the
opportunity to meet and visit with them. I believe these
colorful details add to our understanding of the history
of the Pony Express stations surrounding Ibapah, Utah, I
have included a recap of our visit with them below.

*Disclaimer: Please keep in mind, while reading my
conversations with Jed and Clint, that I had to go off
my notes while typing this up, and some things may be
out of order or lacking detail. Sorry if some things seem
confusing, but I wrote them down the way I understood
them to be. These are NOT recorded as facts, only as a
report from Jed's and Clint's words, not mine. Thank you
for understanding.*

Jed, a 97-year-old gentleman and local historian, pulled
up in his grey sedan. Though he had a walker, he asked
for no help, and got out to stand up to speak with us. After
niceties, he began to share his knowledge and memories of
his youth. Jed has cowboy'd all over the west. Nevada to
Montana, he said. He has broken many a bone, from horse
wrecks, he told us. He has also survived all his siblings, and
told us he never smoked a day in his life. Him and Bruce
exchanged about places they had cowboy'd the same. Also,
Jed told us that just three years ago he rode in the National
Pony Express Association's Annual Re-Ride, somewhere
between Eureka, Nevada, and Ibapah, Utah! At age 94?!
Wow, now that is noteworthy! And then some!

Clint and Jed shared with us the local history about the stage and XP route, and the buildings in the area. They stated that at the end of town where the CCC monument is located, was not the actual site location for the Deep Creek XP Station, as the site was half a mile from where we were at today, at Egan's cabin. They told us about the next few stations we would be seeing as we follow the trail further into Utah: we were to turn and follow the Overland Trail and at the end of the first canyon there would be a monument for Canyon/Burnt Station on the right, the site location would be back to the west from it about a ½ mile or so...there are two sites called Canyon, the second one is about two or three miles past that first monument, you will see a sign for Canyon Station that takes you to the round fort structure...then, in the small town of Callao, there is a station on Don Anderson's place called Willow Springs... and then the next, would be Boyd Station.

Clint shared with us that he is related on his mother's side to *George Washington Boyd*, who built Boyd's Station. Boyd came here with Major Howard Egan. Egan went to Brigham Young (who at that time employed Boyd) and requested that Boyd assist him to work for the Pony Express. Boyd built Willow Springs and lived there. Then he built Boyd Station, his namesake.

Clint also told us some stories about a few of the local XP stations. He was given this information by a Goshute woman:

> Eight Mile Station was attacked and the cook killed. An XP rider rode up and went on to Deep Creek for help, but by the time he got back, the cook was dead.
> Burnt Station and Spring Valley. The Goshute tribesmen went out to hunt. They saw the cavalry heading toward their camp

in Spring Valley. Since all that was there were children and the old left behind, they thought nothing of it. When they got back from their hunt, they found all were slaughtered. They retaliated at Canyon Station—the one they call Burnt Station now—by killing the station keepers and burning it down.

Clint said that these stories can be found in articles by Jessup, of the *Tooele Transcript Bulletin* (newspaper), about seven or eight years ago.

Jed's family roots are from Scotland. They traveled out with Brigham Young to the Salt Lake City area in Utah. His great grandmother walked from St. Louis the whole way. She was pregnant, and said the oxen-pulled wagon was too bumpy a ride; it was easier for her to walk. Jed's grandmother, Elizabeth Hunter, walked alongside her mother. She was 11 or 12 years old at that time. Once his great grandmother arrived in Salt Lake City, she delivered twins! Jed stated that they were also somehow related to the famous marshal, Porter Rockwell, who was once the bodyguard of Brigham Young.

Jim Weaver, Jed's grandfather, homesteaded in Utah.

Jed (Gerald) Cook, was born on September 16, 1918, in Lehi, Utah. I laugh as I type this, but hey, it is what HE said, so I am sharing it...He said, "After my first bowel movement, they moved to where the Parker Ranch is now."

Jed was married for 44 years to his wife, Joyce. They had two girls and two boys: Joycelyn, Marilyn, David and Les.

Remember the cool little cabin I mentioned yesterday at the Parker Ranch? Where we had to go back for fuel? Well, that is the same cabin Jed said he moved to after that first bowel movement! Later the family moved to Major Howard

Egan's cabin. Jed's sister, Mary, was born in that cabin! Howard Egan's cabin was once one of the Pony Express home stations, and later became a telegraph station.

Jed said the cabin was located on the Old Ferguson Place, which now belongs to Richard and Erin Knight. (*He talked to us like we would remember whose place it used to be, like many of us do when we have lived somewhere a long time.*)

Also, on the Knight's place, is where the Sheridan Hotel is located. Jed stated the Sheridan Hotel founders were a family who had come from Ireland. This building is still standing tall and complete.

Addendum: July 2017
Since writing this journal, I have had the pleasure of meeting Jed's daughter, Marilyn Linares, on Facebook. She has reviewed the above information, and I have updated any corrections in details or names she gave me. Marilyn has written a book about her father's life. Sadly, Jed passed away recently and will never see this journal or the XP book completed. Thankfully, due to his daughter's work, HIS legacy will live on. It is now available on Amazon under the title Jed: The Memoirs of Gerald Cook, Legendary Cowboy and Storyteller of Deep Creek.

After we visited for over an hour and took some photos with Jed and Clint, Jed took us over to the Knight's place to visit and take some pictures. When we pulled in, I went up to the house and knocked on the door. Only a couple of dogs came out to greet me. It was too bad no one was home.

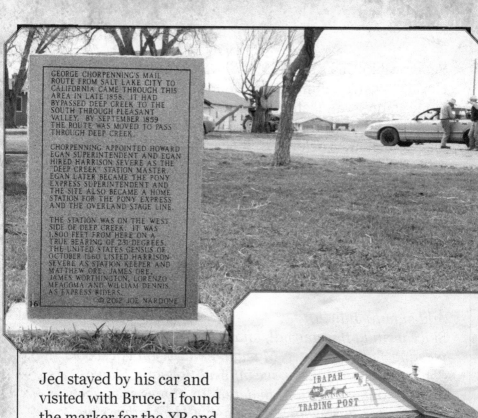

GEORGE CHORPENNING'S MAIL
ROUTE FROM SALT LAKE CITY TO
CALIFORNIA CAME THROUGH THIS
AREA IN LATE 1858. IT HAD
BYPASSED DEEP CREEK TO THE
SOUTH THROUGH PLEASANT
VALLEY. BY SEPTEMBER 1859
THE ROUTE WAS MOVED TO PASS
THROUGH DEEP CREEK.

CHORPENNING APPOINTED HOWARD
EGAN SUPERINTENDENT AND EGAN
HIRED HARRISON SEVERE AS THE
"DEEP CREEK" STATION MASTER.
EGAN LATER BECAME THE PONY
EXPRESS SUPERINTENDENT AND
THE SITE ALSO BECAME A HOME
STATION FOR THE PONY EXPRESS
AND THE OVERLAND STAGE LINE.

THE STATION WAS ON THE WEST
SIDE OF DEEP CREEK; IT WAS
1,800 FEET FROM HERE ON A
TRUE BEARING OF 231 DEGREES.
THE UNITED STATES CENSUS OF
OCTOBER 1960 LISTED HARRISON
SEVERE AS STATION KEEPER AND
MATTHEW ORE, JAMES ORE,
JAMES WORTHINGTON, LORENZO
MEACOMA AND WILLIAM DENNIS
AS EXPRESS RIDERS.
16 © 2012 JOE NARDONE

Jed stayed by his car and
visited with Bruce. I found
the marker for the XP and
took a couple of shots, then
photographed some of the
surrounding barns, corrals,
the old Trading Post Store,
and the Sheridan Hotel.

There was a
pretty tough-
looking dog tied
up to the hotel,
so I didn't get
too close.
 Then I walked
out to the fence

line to shoot in the pasture where Jed showed us where the XP/telegraph cabin was located. I did not go out there, since there was no one home to ask for permission.

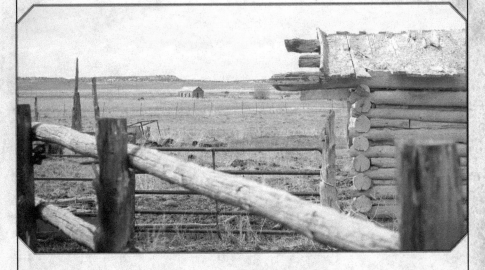

This whole place was great and just oozed with history!

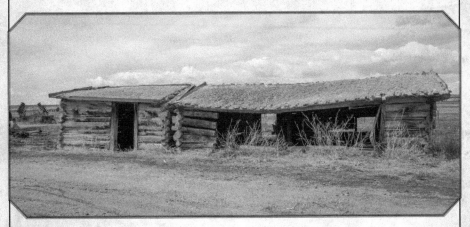

After quite a few shots, I went back to visit with Jed, and to thank him so much for his time. It was such an honor to meet him.

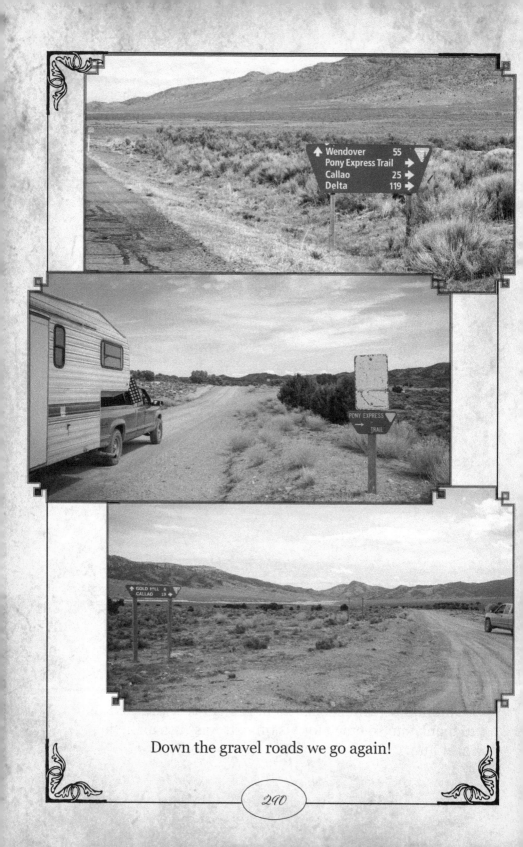

Down the gravel roads we go again!

Next Stop: Canyon Station/
Burnt XP Station

There was a large monument—a CCC monument—quite a ways off of the road, and on the other side of a large wash. (*It is just under the right side of the sign in the photo.*) So large a wash, I wondered if the XP riders would have used it as their trail in the summer months. Less likely to be seen riding inside of it.

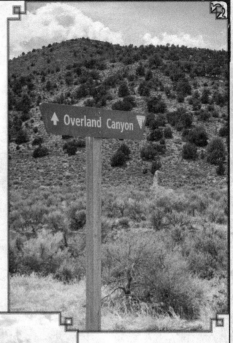

But then again, it wouldn't have been very easy to get out of if there was any trouble. I took several pictures of this wash, as it was quite remarkable to me.

This was the original location for the Canyon Station, which was renamed after the Indians had burnt it down.

Next Stop: Round Fort/Round Station/Canyon Station

Located with a great view at the top of the hill, with an overlook that went on for miles and miles.

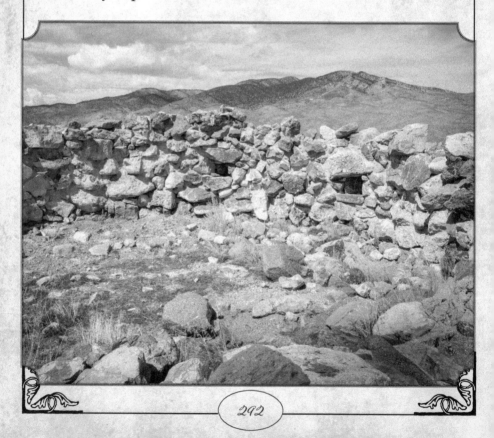

The time frame for this site proves it was not used for an XP station. It was built in 1863 for the Overland Stage. The Pony Express ended in 1861.

We got out and signed the guest book. Then we walked around this site for a while. The ruins were fenced with a gate, so you can go in. It was quite unique, being a round fort. Though "fort" to me sounds large, this site was not. The rock walls, with gun ports, were not very tall either. We found a few tin cans—one was a sardine can—and some blue glass fragments. Folks had put some of their findings in the Sign-in-Box. I took photos of our findings to record them.

Next Stop: Six Mile House/Mountain Springs (as Sir Richard Burton called it)/Willow Creek (*The Pony Express Stations in Utah*, page 63)

About seven miles from Round Fort, we came up to a ranch on our right-hand side. There was a sod-roofed building in back of the ranch behind some tanks. I do not know if it was the actual XP/stage station building, though.

I captured it as best I could, considering the distance from the road.
 This location is in question of being an XP site. I believe if Sir Burton hadn't mentioned it, no one would have thought it to be one.

Next Stop: Willow Springs XP Station

Just before reaching the Bagley Ranch, which is where Willow Springs site can be found, I shot a few of the old homesteads along the road. This town feels as if it is still in the 1800s.

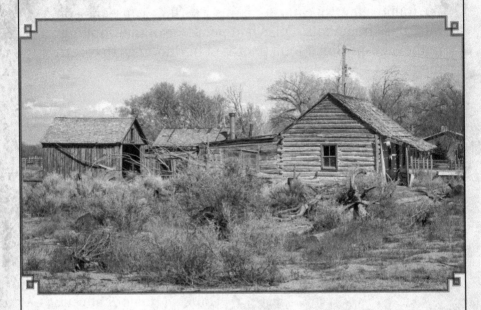

Bagley Ranch is six miles from Mountain Springs (or 13 miles from Round Fort). Don Anderson owns the Bagley Ranch, and it is on private property. Clint and Jed told us to go on in, as they are real nice folks. We didn't see anyone about, so we didn't get a chance to meet them. Clint had said something about a personal museum on the ranch. Maybe someday I will get back that way again, and get a chance to ask, and hopefully see it.

I shot a couple of old ranches on the road before we got to Bagley's, then got photos of the XP monument that stood in front of the ranch entrance. There were a few old-looking buildings at the end of the drive. Could one of them have been the actual station? Not sure today.

Next Stop: Callao town pics!

I couldn't resist capturing Callao for its great historical cabins and homesteads! A Western photographer's dream town!

Still not sure what it* is, (the "thingy" like the one in Ibapah by the cabin in the water), but I have shot a few of them out here: They look like wooden cranes? Were they possibly for pitching hay? Or what?

*(*After asking this question later on Facebook and showing the photo of the one in Ibapah, I found out it is called a "walking beam." They were used for a multitude of things, including drilling shallow wells. A mule/horse was used to do the walking for providing the power necessary.*)

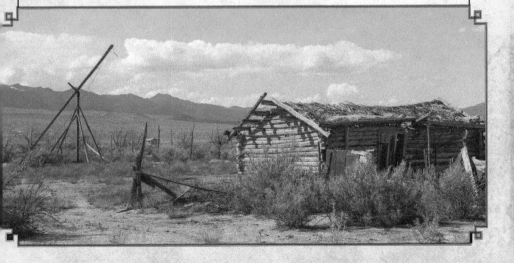

 After nine miles of driving in the desert, toward the mountain range, we came up to the ruins, on our left.

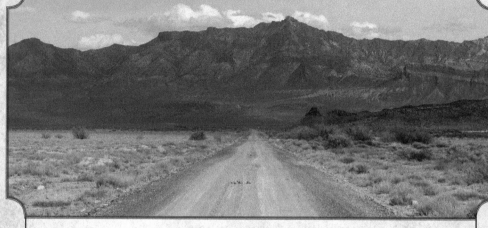

 The rock walls and markers were protected by a chain link fence with a walk-around pole entrance. Then, around that fence, there was a larger area fenced off with three strands of barbed wire.

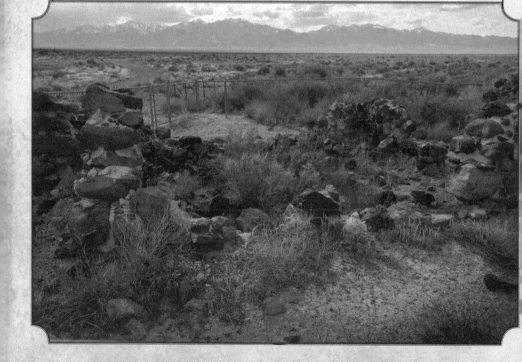

There is a nice pullout here, and as it was getting to be evening, we decided to camp here for the night. Clint had told us that it would be a good place to stop for the night. Remember, this station was built by his relative, George Washington Boyd, for the Pony Express. How cool it must be to be related to a man that lived here and built this site!

The XP steel post at this station has "Butte" on it.

This is a quiet and peaceful desert oasis for weary, dusty travelers. Even though we are blessed with all the amenities while pulling a 5th wheel, you can still feel the distance between you and civilization.

After dinner, I went and just sat in the ruins. Listening. Feeling. Trying to imagine how it felt, as I sat right where they did, to be a station keeper or a stock tender, to have lived and worked here. Did they ever get time to enjoy their surroundings? Or were they always on alert for what could happen? I can't help but hope that they had some time to sit outside and enjoy this same view I was looking at...while resting beside their tiny rock home. I imagine them praying to God for their protection, just as I do every day, praying for our safety, while visiting this...very large...mysterious... desert. A place in the world that seems to have been left alone by most of humanity.

I strolled back to camp and captured my musical friend, along with my wanting-to-be-musical puppy, in the vastness of their desert surroundings... They entertained me and the coyotes until the sun disappeared. One photo is of the two of them howling together...haha.

It was a relaxing evening after such a long day!!

April 4, 2016
Boyd's to Fish Springs to Black Rock to Dugway to Riverbed to Simpson Springs to Government Creek to Lookout to Faust to East Rush to Camp Floyd Cemetery

Today was a really...REALLY...LONG day, with a LOT of stations, so hang on to your hat! Here we go!

 Utah's super gravel highway makes for a dusty, yet for the most part, a pretty good road to travel on. Though, at times, you do get a lot of "washboard" patches for that reason. I have lived for many years on a gravel road, and when people travel down them at high speeds, it causes that washboard effect. I suppose it is still much better than worrying about getting stuck in the sand or mud! We just have to slow way down, so as to not shake and rattle everything out of the cupboards in the RV, or tear it or the truck up.

Next Stop: Fish Springs/Fresh Springs/Smith's Springs (*after the station keeper*) XP Station

Fish Springs is 13 miles east, from Boyd Station. As we drove along the main road, we could see the large reserve off to our left. Before reaching the entrance, we come upon another Utah monument. Though there was no plaque, we imagined it had to be their marker for the Fish Springs XP Station.

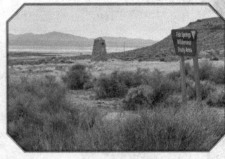

A short distance more and we turned down the road leading into the reserve. We found a sign stating we were now on the old Lincoln Highway and the Pony Express Trail.

We headed toward the grove of tall trees; that is where you will find the XP site. On this road and off to the left, we came upon the XP silver stake marking Fish Springs. Near the picnic tables there is also an Overland Stage marker.

Today, there are no structures left, but there was lots of metal and broken glass along the forgotten highway. These items could have been left from any time, recent or historical.

This site is a marsh. The reeds were so thick, I could barely see in the water. This location is where there was mention of "circular holes of warm spring waters with little fishes a-plenty," when the XP station was here. Hence the name, I am sure.

This historical site is now surrounded by the beautifully protected Fish Springs National Wildlife Refuge. 10,000 acres (*of the 18,000 acres total*) is marsh land. If you are a bird watcher, I would suggest you plan on arriving early and spending a whole day here. I wasn't looking for camping while here, but I would imagine you could find information about this location very easily on the internet.

Next Stop: Black Rock XP Station

While driving eastward, you will find the station site on the left-hand side of the road. It is easy to spot the location, as the name describes it pretty well. Also, the CCC monument stands tall out front. The brass plaque has been stolen.

While standing at the end of where the black rock protrudes toward the west, you can almost see the Fish Springs Refuge. The view from here goes on for miles. There were no remnants here that I could find. I walked all the way around the large rock looking for clues of where the station could have been, all the while wondering where would I have wanted the station to be, near this big rock. There is a large, flat area just to the east that I walked all over...looking for a straight line of rocks or anything that would resemble a foundation. Time has removed any sign of the station.

I did capture a few bones that I found, with the long distant views of desert in the background. It seemed appropriate for the feel you get while here.

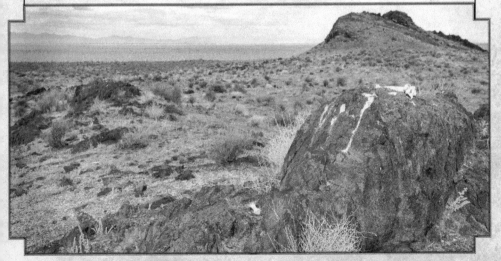

Next Stop: Dugway XP Station

Well, we missed it.* The xphomestation website only stated it was a mile off the roadway. Yet my guidebook states you could drive to it, but that there were no markers at the fork/turn. It would take you about 1.5 miles off the main road, then another .8 miles off that road on a two track, to get to the monument. The station was recorded as a dugout at the time it was being used.

After we left Black Rock, we turned left, following signs. For a few miles, there was nothing, then more nothing—no roads in the distance, no markers, no nothing. I started to wonder if I had messed up on my mapping somehow? Oh, what a relief, when we spotted one of the concrete XP trail marker signs just off the side of the roadway! Whew!

At this location point, we stopped and I took photos of the area with the marker, looking back towards Black Rock. Also, captured my truck and trailer on the roadway. At least you will be able to see, with these photos, what the rider's view looked like in the area of Dugway. Boy, I sure cannot imagine riding full speed at night across this

open landscape. But then again, following the stars would probably be a blessing, compared to keeping an eye on a faraway bluff, mountain, ridge line, or ???

*Addendum
After careful review of The Traveler's Guide to the Pony Express book and my travel photos:
I have discovered that we had NOT missed the Dugway turn at the point where I thought. The guidebook was really hard for me to follow at times, as he would write directions in the paragraph while describing the scenery. Also, he was traveling in the opposite direction than we were. I am more of a Step #1, then #2, kind of person. Anyway, upon further review, I realize now that the Dugway turnoff would have been AFTER Dugway Pass, NOT before, when heading east as we were.
I had photographed a sign that I spotted while we were on the Dugway Pass. It read:

> CENTRAL OVERLAND TRAIL - DUGWAY PASS.
> Course nearly southwest across desert to Short Cut Pass. "Through this pass Chorpenning and Company, the mail contractors, have made a road, but it is so crooked and steep as to scarcely permit our wagons to get up it." - Capt. James H. Simpson, May 5, 1859.

This sign/plaque was erected in 2013, quite a few years after the guidebook I have been using. Looking back at my photos, we could have found Dugway Station, if I had known, but at that point I thought we had missed it, and was off to the next station. Dang it!!!
I will confirm what Lt. Simpson stated about the pass to be correct: it was very crooked and steep...and, I will add, narrow. At one point on the pass, we had to stop to allow another vehicle to come up, before descending. And just think, this is over 150 years later!

Next Stop: Riverbed XP Station

Now we are in a low area of a valley. This looked to be an old riverbed; hence the name, I am sure. You can see up ahead where the road turns toward the left and up a hill. But before you get to that, you can see the CCC monument, sitting off to the left of the road a ways in the field. I asked Bruce to pull the truck around while I walked to it. Once I got to it, I realized there was a single-lane road that led up to it, with a circle drive; it was just large enough to swing a car or pickup around, and then head back down that same lane back to the main road.

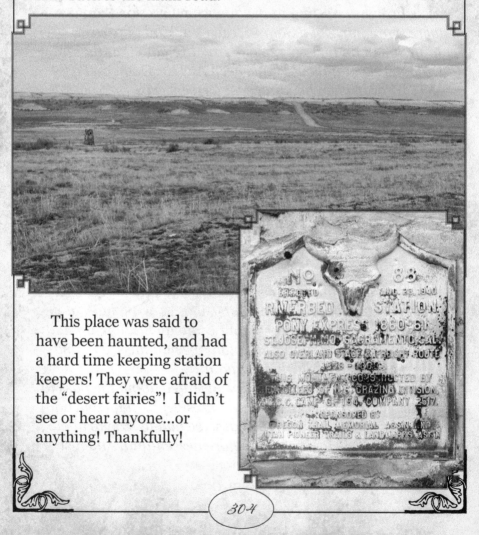

This place was said to have been haunted, and had a hard time keeping station keepers! They were afraid of the "desert fairies"! I didn't see or hear anyone...or anything! Thankfully!

This is a gorgeous location for a station. And so far, would be my pick to live at! As you drive through the desert, you start heading for a hillside spotted with trees... yes, TREES! Haha! And green grass!

There was activity all about, at, and near the station. It was as if we were back to civilization. Not a lot of folks, but there were enough to tell us that this place was probably pretty popular for those coming from east of here.

At this site, there are two stone structures. One is a structure of the Pony Express Station, rebuilt by high school students in the 1970s.

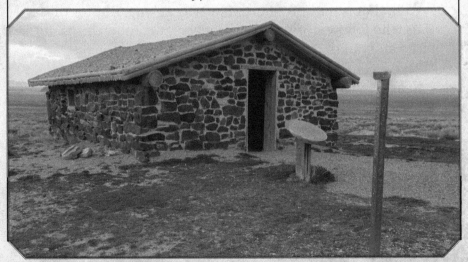

The other is a cabin across the road that had a sign in front of it that read:

> STONE CABIN. Alvin Anderson used stone from the abandoned Pony Express station when he built this cabin in 1893. It was intended for his wife, who died in childbirth before she could live in it.

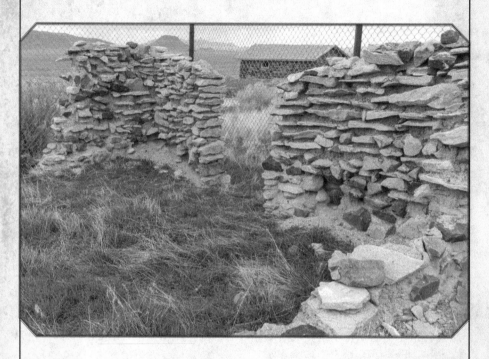

Well, that is nothing short of heartbreaking. But for those of us who follow stories of the pioneers, we know this is not a rare story of that era, sad to say.

Nearby, there is a nice campground. Also, there were some interesting man-made caves just over the ridge below the rebuilt station. I walked down there and took a few photos of them. They were made from rock and carved into the hillside. In order to preserve them, it appears someone has made concrete roofs for these rock-formed caves. As I

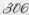

circled around them and took another path back up the hill towards the station, I came across this sign:

> Archaeological resources are fragile and irreplaceable. The Archaeological Resources Protection Act of 1979 and the Federal Land Policy and Management Act of 1976 protect them for the benefit of all Americans. Please don't erase the traces of America's past.

Just above the station site, up on the hillside, you can see there is another cave, but not man made. We did not take the time to go up there. I did ask someone who had, "What was in there?"

He said, "It wasn't very deep, and there was nothing inside." I do not know more than that.

I would have enjoyed spending more time here and camping, as I really enjoyed the views and the trees. But the weather was looking like it was going to rain, so we moved on.

Next Stop: Government Road Junction

It has been recorded that the site was possibly an XP station. It was a telegraph station for sure, though. I found the historical marker that was just before, yet near, the Junction Road sign that had this information:

Lookout Pass: 7 miles, straight...
Dugway: 10 miles, left...
Erickson Pass: 11 miles, right...

The historical marker read:

> CENTRAL OVERLAND TRAIL - GOVERNMENT ROAD JUNCTION
> "From Point Lookout we drove six miles and left the Telegraph Road. Took the left hand fork and drove to Government Springs for dinner, concluded to camp here. Good grass and water. Fifteen miles today." (Government Springs is located 3.5 miles to the south of this point) James McNabb Colwell, August 30, 1865

I have to agree about the good grass. Most of the drive from Simpson Springs to this point has been rolling hills covered in green grass. Just beautiful.

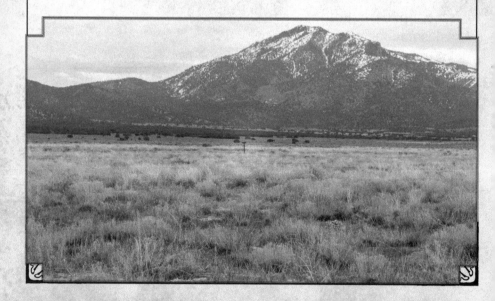

Next Stop: Lookout XP Station

We continued along the grasslands for just a few miles, then we started to climb up the hill. The road became very winding, and there were pinion pines on both sides of the road. Once we got close to the top of the pass, there was a CCC monument for the XP station, just off to the left-hand side of the road.

As we were coming up on it, there was what appeared to be campgrounds off to the right side. After reading the signs, we found that this area was an All Terrain Vehicle Park with areas for riding. Though primitive campgrounds, they were nice.

We stopped and parked near the CCC monument. It, too, was missing the description/name brass plaque.

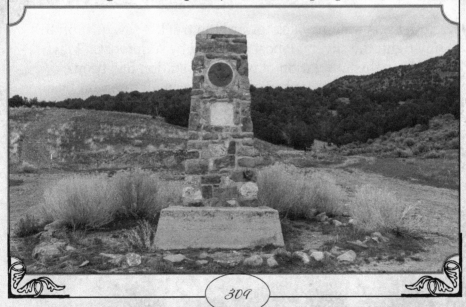

On the same side of the road as the monument, there was a bit of a road that led up to a fenced-off area behind it. I thought maybe this was the site of Miss Libby's dogs' graveyard I had read about. She and her husband, Horace Rockwell (Porter's brother), lived at the station for a while after the XP had ended. I have read how she loved her dogs like they were her children. After photographing the fenced-off area, I found that it wasn't the doggy graveyard; it was a spring. It had been fenced off for protection from, and for, the ATV riders.

As I was walking back toward the truck, I saw, just off to my right, the silver XP post standing by some rocks. Maybe this was the foundation of where the station had been? Though it actually looked to me like a small reservoir basin, and it was just below the spring.

I then headed back toward the truck and crossed the main road. There was another dirt road on the other side. I could

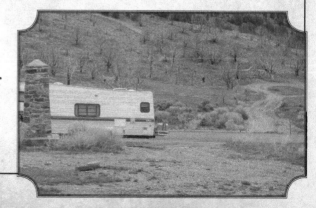

see that it led to what looked like adobe/rock ruins, just inside the trees. It reminded me of the Alamo. (*Been there many years ago when in elementary school.*) I thought maybe this was the station ruins, and not the rocks across the road, as this appeared to be much more substantial.

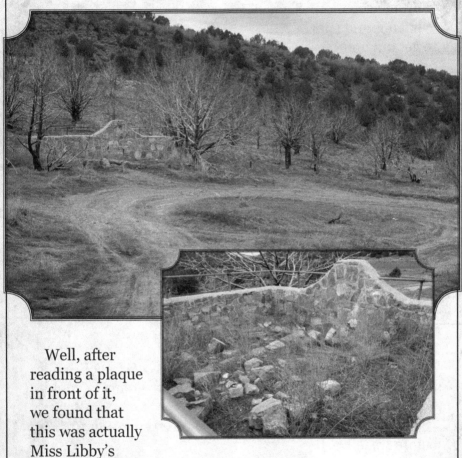

Well, after reading a plaque in front of it, we found that this was actually Miss Libby's dog cemetery! Rumor has it, there are also a couple of emigrants who are buried in there, too.

Seems strange to me that the dog cemetery has been so well taken care of, and even has the *Sign-In Book* at it, and not the XP station site. Go figure?!

Next Stop:
Lookout Pass -
Not XP station,
but Central
Overland Trail
 6,192' elevation.
What a grand spot
to get out and
enjoy the view!
I captured the
storm that was
heading towards
us. Along with the
sagebrush and the
rustic fences.

The traditional Overland sign read:

> CENTRAL OVERLAND TRAIL - LOOKOUT PASS
> "We struck the stage road in 5 miles. Good water
> here. Drove on to the summit of Point Lookout.
> Here we nooned and drove 1 miles farther to water
> and camped."
> Albert Jefferson Young, August 9, 1862

This sign was also posted in 2013. Some IDIOT shot the
bottom and bent up where it stated Albert's name. I could
hardly read it...stinkin' goons!
 I got a photo of Rider tied to the Lookout Pass sign
before we left. :-)

Next Stop: Faust Station/Rush Valley/Bush Valley/
Meadow Creek

Down the mountain we went, leaving Lookout Pass.
Before us was an amazing view of the Salt Lake Valley.

When we got to the
bottom of the mountain
pass, we drove a short
while, then we came to
the end of the road at a
stop sign. Just before it,
there was a *Pony Express
Local Tour Route* sign
posted.

We turned left (north
on 36) for only a short ways. Then there was a sign pointing
to turn right, to go to FAUST...We turned and parked.
We were at the intersection of Highway 36 and the Pony
Express Trail. I knew from my research that there was a
monument near here.

Once I got out, it was easy to see the CCC marker
located just across the highway. I walked over there to
capture some photos of the monument. This was also an
interpretive site with displays. And surprise, surprise! The
monument had both markers still intact!

"NO. 53. FAUST STATION PONY EXPRESS"
showed proudly beneath the Pony Express Rider/Map and
the three founders' round
plaque.

It was so nice to see one
as it was the day it was
placed, from the 1930s! I
am thinking it is because
there are a few ranch
houses nearby, maybe
the stinkin' varmints who

steal 'em are concerned that they may get their butts shot at if they tried to steal this one!

The interpretive displays located by the monument were very informative: information about the riders, "Only the Finest Horseman," "Expedient Delivery." And there was more history: "The Crowds Cheered On..." (*There was even a brief tidbit of a story from Mark Twain about his coach ride in the summer of 1861—about his seeing a Pony Express rider approaching, waving, and passing them by.*)

Next Stop: East Rush Valley XP Station

Well, the pavement sure didn't last long. After a short drive on the road heading to Faust, we were back on yet another gravel highway.

As we were searching for our next station, the clouds were coming to life with color. The sun was starting to set behind us, and the glorious twilight hour was beginning to glow over the valley. There were brilliant shades of orange and deep purple...We pulled over a few times so I could capture the cloudy sky with the mountains as their canvas.

Upon reaching the next CCC monument, off to our left, we found this location was apparently too remote to keep the varmint thieves away. It had been damaged and the description plaque stolen. Only the top round plaque remained.*

The sun was still illuminating the rain clouds with exquisite colors...it was stunning. Though there were no remnants or ruins left at this site, I captured the sky with the monument in the foreground. I sure hope one of my shots will share with ya'll what we witnessed!

(*See Photo on Page 316 & 317. :-)*)

*(*Later found on the Utah BLM website there was a photo—submitted by the public, I am guessing—with the*

plaque intact; it was a Centennial plaque, though, and not a CCC. The plaque is hard to read, as some jerks had shot it up, but it showed the name as "Rush Valley" and stated that it was also an Overland Stage stop until 1869.)

Next Stop: Camp Floyd Cemetery

It was dark by the time we reached Fairfield, where Camp Floyd is located. We tried to find a place we could pull off the road to park near the Stage Coach Inn, but there wasn't any that would allow us to get completely off the road enough for my comfort.

So, we decided to try our luck at the Camp Floyd Cemetery. We turned around and headed back to find it. Fortunately, at the end of the driveway in, there was a large paved parking lot right in front of the cemetery. We pulled up close to the fence and backed up to the edge of the pavement that neighbored an empty field.

I was comfortable with the thought of parking here...until Rider started growling and barking towards the cemetery... while I had him outside by himself on his lead. It gave me a few chills, I have to admit...Then I brought him in and shook off my thoughts of where we were sleeping.

We had a light dinner tonight...now everyone to their corner. We are all whooped. This has been a long day, for sure!

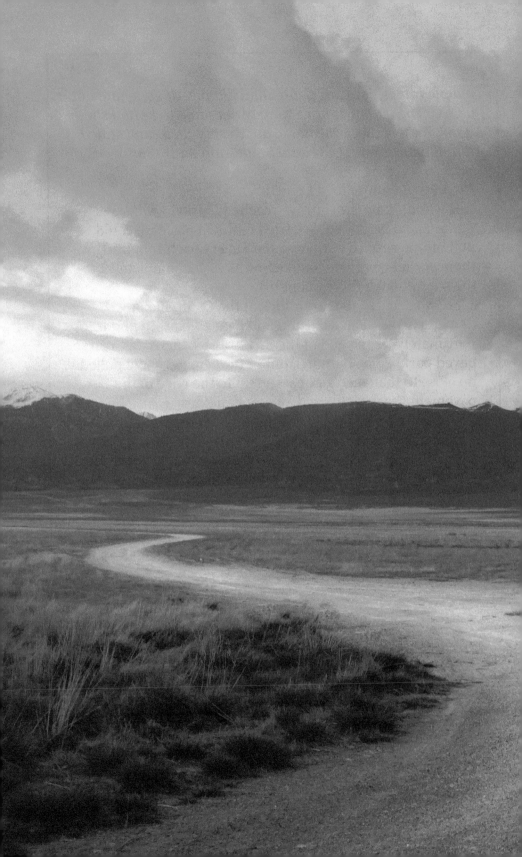

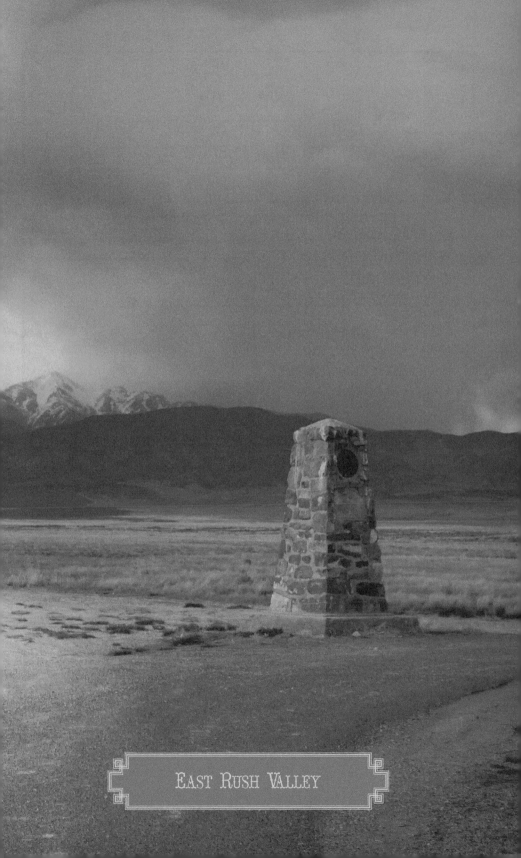

EAST RUSH VALLEY

April 5, 2016
Camp Floyd Cemetery to Camp Floyd to Joe's Dugout to John Hutchings Museum in Lehi

I got up before the sun and threw on a heavy sweatshirt, as it was a bit chilly this morning. Then I headed out through the open wrought iron gates to enter the cemetery. It was still near dark, and a good time to reflect, and just absorb, where I was standing.

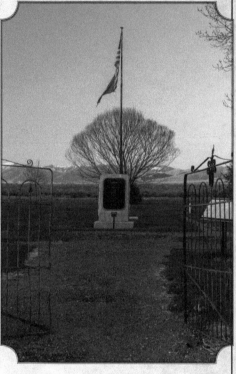

I slowly walked around the graves, paying my respects for their service. As I photographed the stones, I prayed for their families left behind, who may not even know they are here. ALL the graves are marked "UNKNOWN."

The interpretive board lists names of soldiers who are believed to be buried here, though it doesn't list what grave is whose. I am sure that is why they are marked "Unknown."

A short time later, as the sun was just starting to peek over the horizon and illuminate the grounds, I continued to photograph as much as I could.

As you enter the cemetery, right near the middle, there is a large concrete monument with a very weathered black plaque on it. The structure is near the base of the flag pole.

There is no date on the monument. It reads:

> In Memory Of The Officers, Soldiers and Civilian
> Employees of the Army in Utah.
> Who Died While Stationed At Camp Floyd During
> The Utah Campaign From 1858 to 1861
> Whose Remains Are Interred In This Cemetery.
> Erected By The War Department

Right under that large monument, there was a smaller, much more recent plaque that read:

> UTAH HISTORIC SITE. CAMP FLOYD.
> Camp Floyd was established in 1858 by order of President James Buchanan. During its three years of operation, Camp Floyd was the site of the largest assembled troop concentration in the United States prior to the civil war. No buildings remain in this area from the encampment, but the site was listed on the National Register of Historic Places in 1974.
> Marker placed in 1988

Upon finishing my morning outside, I went back to the trailer. We had our breakfast, and were off again!

Next Stop: Camp Floyd/Fort Crittenden and XP Station

The location of the Stagecoach Inn State Park, its museum, and the livery stable for the XP are all within a few blocks of each other in the town of Fairfield, Utah. Also, they are just a few miles drive from the Camp Floyd Cemetery.

We pulled up and parked near the wooden fence, just off to our right coming in to town, and by the museum. There was a large CCC XP monument out in front of the museum. Alongside of it, there was another monument that made mention of a Pony Express rider who had delivered orders to Col. Philip St. George Cooke in May of 1861 to abandon the fort and return to Fort Leavenworth.

At the entrance of the museum is a souvenir shop with trinkets and a selection of books. I was excited to find a book titled *The Pony Express Stations in Utah* by Patrick Hearty, photos by Dr. Joseph Hatch. Oh, how I wish we would have had a copy of it before entering Utah from Nevada!

I paid for us to go into the museum. This museum is located in the only building left of the fort; it had been the commissary. We visited with the volunteer, and I got a card

for the museum. We then watched a video of the history of the area about the Mormon settlement and the Utah War. Then we walked around, and I snapped a few of the museum displays. The museum is very well designed and attractive.

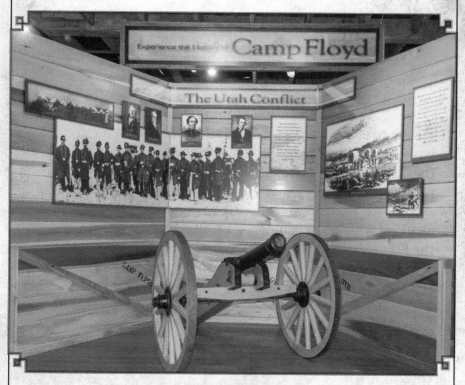

Okay, as you know, many stations we have been to have had a name change for one reason or another, whether it be in reference to its region or the name of the station keeper or an event, like being burnt down. I have to say this one's name change has the most unique and historical reasons I have heard! For that reason, I am gonna share it here in my journal as well, and not just in the photography book. One of the markers inside declared this, and a display outside also made mention of it. (*I am only sharing the part which references the name change.*)

The inside display reads:

> ...John B. Floyd joined the Confederacy and was accused by the Union of fraud and malfeasance. He and others had used the Utah War for Confederate objectives...

The outside monument reads:

> ...When many persons defected to the South including Sec. of War John B. Floyd & Gen. Albert Sidney Johnston, he (Col. Cooke) changed the name of the Post to Fort Crittenden Feb. 6. 1861...

Well? What do you think? I think that was a pretty good reason to change a name! No matter what side you would have declared yourself, I think we can agree that changing the name of a Union fort, from a Confederate soldier's name, would be understandable.

After we were done reviewing the books in the lobby and chatting with the volunteer, we walked across the street to the Stagecoach Inn. Our new friend joined us after a while

and showed us around. One of my favorite treasures in the inn was the replica of a mochila they had on display. Not only was it a replica of the mochila, but the saddle underneath it was a replica of the skeleton saddle they used. It was a lightweight saddle built just for the Pony Express and meant to only be used with the mochila!

The maker's mark on the skirt of this saddle:

"No. 10 - Platte Valley Saddle, Kearney, NE - (C) 1988"

The Stagecoach Inn has been meticulously restored, and is very well cared for. Great work, Utah, on preserving your history! Our History! Thank you!

Upstairs, there was a room that had a hole in the wall... it was from a gunshot! A guest at the inn was said to have been cleaning his gun, and reported that it was an accident.

I am guessing due to the growth of the inn during its busy days...caused it to have a bit of a strange floor plan. You could see where they had added on, as there were some outside windows that were now in a hallway.

Famous Visitors:

- British explorer Sir Richard Francis Burton traveled by stagecoach from St. Joseph, Missouri, to San Francisco in September 1860. He provides a description of his journey in his book, *The City of the Saints, Across the Rocky Mountains to California.* (*There is a picture of him on the wall, too. The first time I have seen what he looked like, as I have read plenty of his gruff writings about his journey.*)

- Mark Twain recorded his visit in July 1861 to the recently abandoned Camp Floyd in his book, *Roughing It.* Twain and his brother, Orion, traveled by stagecoach from St. Joseph, Missouri, to Virginia City, Nevada.

After finishing our visit to the museums, I walked over to where the XP station had once stood. Today, there is a lean-to/shed/barn standing on the location, by a grass yard and the paved parking area for a private residence. They have a beautiful, large white dog, who liked being in my pics...lol.

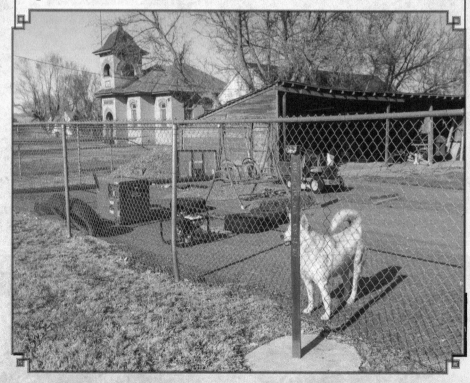

I cannot verify or deny if the barn is original, but the location is most accurate, as there is a silver XP marker sign stating "Fairfield" on one side and "Stable Site" on the other.

Nearby, there is a brick "District School" house, and it, too, is a historic landmark. I photographed it as well. Even though it didn't come along until 1898, it was still noteworthy to me.

Next Stop: Joe's Dugout

Following the GPS coordinates found in *The Pony Express Stations in Utah* book that I just purchased at Camp Floyd, I photographed the hillside I am to believe was the location of Joe's Dugout. The dugout was kept by Joseph Dorton. It was said that nothing was left. What was amazing is that at this site they dug a 350' well! But to no avail: they never found water, and it had to be hauled in from Utah Lake.

My Picture #806 (*seen below*), just on the ridge line about where you can see the top of the house on the far left, is where I think the above-mentioned book states was the location of the well and station. But this is a guess, as we are going by the photo they posted in their book.

Next Stop: Lehi to Visit John Hutchings Museum

After leaving Joe's Dugout site, we found a Subway sandwich shop and Bruce bought dinner.

After we finished dinner, we headed to Lehi, to the Hutchings Museum. We knew that it would be closed, as it was near dark when we had dinner, but we were hoping we could find a place to park overnight nearby. We were fortunate, as the street that ran behind the museum had a city parking lot with lots of room. There were no signs stating we couldn't stay overnight, and there was no fee to park. Yay!

The only problem with parking here: there was no grass nearby for Rider. I have to walk him to a rock garden in the back corner of the parking lot. He isn't too keen on it, but he is making do...lol.

Good night!

April 6, 2016
John Hutchings Museum
to Rockwell's to Trader's Rest to
Salt Lake House XP Stations to Truck Stop

John Hutchings Museum opened at eleven, so there was no hurry this morning to get moving. That was a nice change, as we have had a few very productive long days recently.

When we woke up, I was afraid that we might be surrounded by cars parked all around this long train... There were only a few cars, and they didn't park near us. I was happy for that. Even though we weren't in a hurry, I didn't want to be blocked in.

We signed in to the museum right at 11:00. This museum had a large variety of historical memorabilia: There were dinosaur fossils, native indigenous people exhibits, different wars' artifacts, a Wild West room with quite a few relics, rifles and hand guns, and stage line and Pony Express exhibits with photos of some of the stations. In that same room, there was also a large exhibit regarding Orrin Porter Rockwell. There was a whole wall about him, and even a mannequin dressed to look like him. You may remember he was Brigham Young's bodyguard, who later became a Deputy Marshall. He was said to have been feared by many. (*You might remember— he was also related to our friend Jed Cook, our historian in Ibapah.*)

I captured photos of the inside and the outside of the museum. There was an interesting cabin outside that had quite a history. It was originally built by John Austin in 1868, as a family home. Later, it was moved to different ranches and used to shelter calves. Now today, at its final resting place, it is a display at the museum.

After soaking in all the knowledge we could handle, we walked back out to the trailer to have lunch. Then we hit the road.

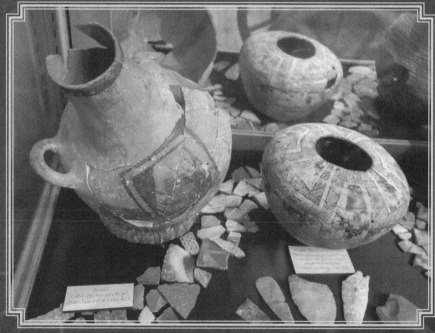

ORRIN PORTER ROCKWELL

"A LEGEND IN HIS OWN TIME"

Museum Display, Hutchings, Lehi, Utah
Research Only, by Carla S. Photography

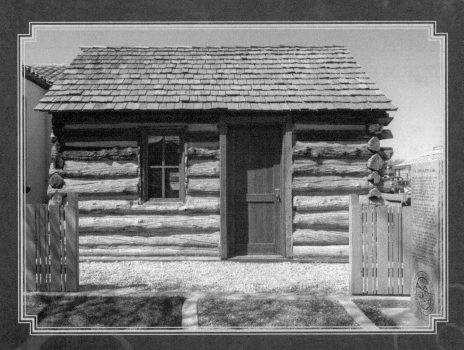

Next Stop: Rockwell's XP Station

This next station was said to be near the highway and the Utah State Prison. There was so much construction going on, we couldn't find the location. Even with the GPS. After taking a few pictures of where I believed it to be, we moved on to the next station. Ugh.

Next Stop: Traders' Rest/Travelers' Rest XP Station

This time I also looked at the "National Historic Trails - Auto Tour Route Interpretive Guide" that I downloaded on my computer. It gives the address for this station. I googled it, and we went right to the intersection where it was supposed to be. OH BOY, we are IN town, now! The busiest corners of shopping you could imagine. I had to circle around a bit, then finally spotted it on the corner of the intersection.

It was right near the sidewalk. Fortunately, we could pull through and park at the mini mall that it was next to. I tried to be creative shooting a monument in town. This was a lot like being in Sacramento again.

By the way, at this point, I am driving; Bruce is not too keen on BIG city driving. I can't say that I blame him! But I am okay with it.

Next Stop: Rockwell's XP Station...

Yes, you read that right. Once I got out the computer at Traders' Rest and looked at the guidebook online, I looked up Rockwell's, too. It had more descriptive directions of where to go. It stated that you could park in the Park & Ride parking lot and walk to the monument. I had remembered seeing the Park & Ride, and told Bruce, "Sorry, but we are going back!" He sighed...lol.

The highway was getting to be very busy, as it was around 4:00 p.m., and folks were getting off work. Also, the construction zone was making it even tighter to get around. Oh, well...I found my exit, AGAIN, and this time took the first right, where I could see the Park & Ride lot. We pulled in, and I sighed in relief to be stopped.

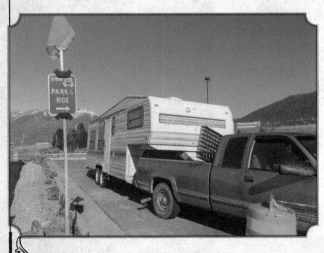

Now to find where this marker was. I prayed with all the construction going on that it hadn't been MOVED!

We ran across the street and went to the

other side of the K-rail. Once we were on that side, we could see the old road. You could tell it wasn't often used anymore. We followed it, and now I was getting excited! This has to be where it is! I continued heading down this old road, and boy was I happy when I did see it! It was off to the left, and it was one of the original monuments... Sweet!

This monument is one of the ones that have the oxen skull in the middle on top...it read:

> No. 48. Erected Oct. 13, 1934. ROCKWELL STATION.
> About 1000 Feet Due West Prominent On The Overland Stage and Pony Express Route 1858 to 1868. Kept by Orrin Porter Rockwell. This Monument Was Constructed Of Stone From The Old Station.
> Adult Aaronic Priesthood Group Of East Jordan Stake And Utah Pioneer Trails And Landmarks Association

On the skull head you can read, "Official Marker Utah Pioneer Trail and Landmark Association," written in cursive.

On one of the other sides of the rock monument you can see where there had been a plaque (*I am guessing the Pony Express rider plaque?*). On another side, there was nothing. Then the last side had the plaque of the three founders, which was placed during the Centennial of the Pony Express.

There was even a bench here for folks to sit and relax— ponder, I would say—for those

of us determined enough to find this historical marker. The view is not so relaxing today, though. Your view is either the state prison or the busy highway. There is grass growing and trees still standing around the monument. A little oasis in the midst of a booming city.

This site was also Rockwell's home and business: The Porter Rockwell's Hot Springs Brewery Hotel.

I am so glad we went back and found this monument, and grateful that the city has left it for us to find!

Next Stop: Salt Lake House*

This next site was to be at the old Tribune building. I had an address, but the address didn't work in *Google Maps*. There was supposed to be a granite monument there. There was no place to park, and I couldn't find a building with a monument in front of it. There were no signs, either. I took photos of the area that I thought it was in, but to no avail; I found nothing. It was tough trying to drive and shoot, though, since there was no place for us to pull over. (*After reviewing my photos, I am very disappointed.*) Nor did I know of any place that I would feel safe leaving the trailer, as I didn't want to get a ticket or have it towed.

Well, GPS worked to help us find a truck stop, at least. We parked on the street next to it, as I was hoping that would help keep the noise down from the trucks going in and out all night.

Addendum
I have since acquired the GPS coordinates of the Salt Lake City monuments/markers from a website found online: waymarking.com.
This is a site where the public can post coordinates and photos of historical landmarks, and they are verified. From this site, I now know that there is also a larger-than-life Pony Express Rider statue in town, too.
If I can, before the book is published, I will go back to capture them. This was an epic fail on my part. I just assumed that I would have no trouble finding monuments in such a big city! Seems the middle of nowhere works better for me!

April 7, 2016
Salt Lake City to Jackson Hole, Wyoming

There was a Denny's right by where we parked last night, which was nice, as we had breakfast there this morning. The strangest thing about our breakfast? We ran into the fella who patched up my 5th wheel in Ely, Nevada! How coincidental is that?!

We left the Pony Express trail (*for Rider and me, only temporarily*) and started heading north to do a bit of sightseeing on our way to take Bruce home to Montana.
Tonight we are camping near Jackson Hole, Wyoming. We are parked off the main highway across the road from a

gun range, in a pullout. Hey, it's FREE and we have a nice view of the valley below.

Tomorrow, the plan is to visit Jackson Hole, and then the next day photograph the Grand Tetons! I am so excited!!

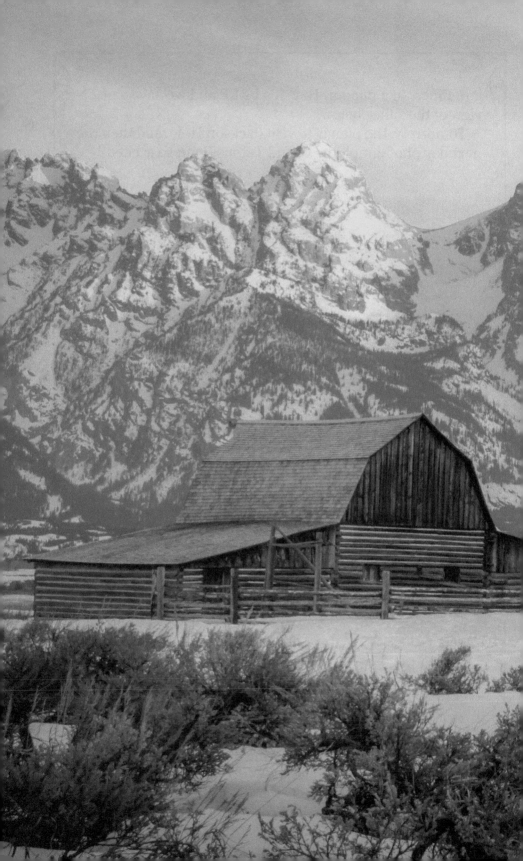

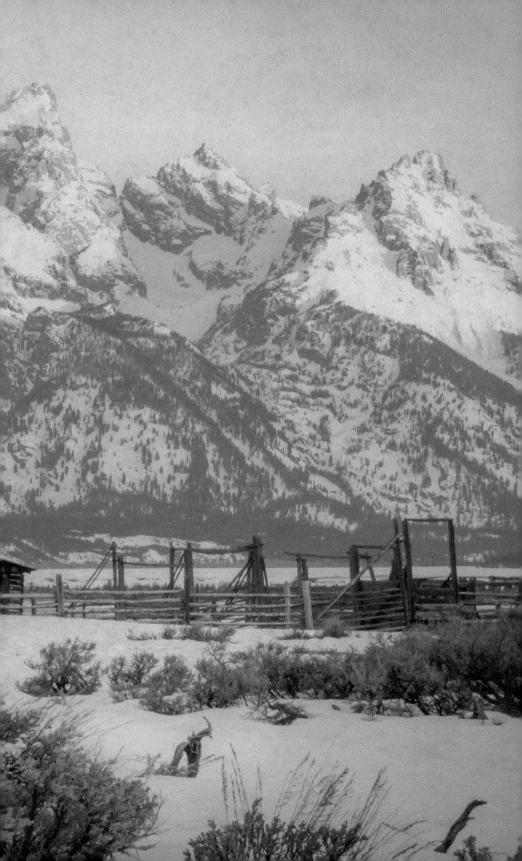

NON-Pony Express Adventures
through the spring and part of summer...

SPRINGTIME, 2016

After completing our last stop in Salt Lake City, we headed north, to the Grand Tetons. I have dreamed of visiting and photographing that area for as long as I can remember. It was truly a DREAM come true.

After enjoying the park, we headed north to take Bruce home to Montana. On the way, we had to go through western Wyoming, as Yellowstone National Park was not yet open. On that route we found some bison along the side of the road and pulled over to capture them. Was funny, as Bruce had just said that soon we should be seeing some, then moments later—there they were!

Bruce knew of a road that took the back way to Spanish Peaks. It went right by the Turner Ranch. I shot the beautiful views, the ranch house and an old abandoned cabin.

Bruce's daughter, Jen, and her family live in Great Falls, Montana. We went by their home first before taking him to his home in Grass Range. While there, we visited the Falls and the Charles Russell Museum. This, too, was another

dream come true. Russell has always been my favorite artist...*ever*! Because of his talent, for sure, but mostly because I know that he lived to see the things he painted... and he painted them so beautifully. The only bummer about our visit, we could not go inside his house or studio,

as they were being remodeled while we were there. I photographed the outside, and Bruce took a photo of me in front of the cabin that was Russell's studio.

 While in Grass Range, I shot the branding I had scheduled to do. I then scheduled another one after meeting some nice folks at that first branding...
 While visiting in Central Montana, Bruce* and his family were great hosts, with showing me all around. With their expert guidance, I got to see many of the areas that I had not been able to visit on my previous trips there. I am very thankful to them and all those folks I met while I was there.

*Addendum
I asked Jeni Weir, Bruce's daughter, to write up a little something about her dad to include in our book. She obliged, and I am honored to share it with you here. Also, a photo of Bruce dragging a calf to the fire at the Hanging T Ranch.

Written by *Jen Weir*, about her father, Bruce Martin:

"Dad came into the world on November 24, 1959. He was born to Clint and Sharon Martin up on the Montana high-line in Havre and was a ranch kid from the word go. As soon as he was up and moving, you could find him astride a horse. By age 5, he was outworking the hired hands stacking square bales right alongside Grandpa.

When he was just 8 years old, Dad put his hand in the riggin' of his first bareback horse in Bridger, MT. This

triggered a love affair with rodeo that he still holds today. For the next 27 years, Dad rode bareback horses and competed in other rodeo events all across the country and up into Canada. During one very impressive stint, he covered 748 broncs in a row! His career was cut short when he broke his neck after being rear-ended by another vehicle.

In addition to rodeoing full time, Dad also helped run Martin Construction with Grandpa Clint while also operating his own cattle ranch in central Montana. Once his riding days came to an end, Dad took up judging rodeos. He judged for the Northern Rodeo Association and the Nationals Senior Pro Rodeo Association for over 10 years. To fill in the gaps between rodeos, Dad also worked as a cross-country truck driver for several years.

While Dad's bareback riding days are through, he still loves to sit a horse and does as often as he can. You can bet he'll be ready to help out every spring when the neighbors start dragging calves to the branding pots.

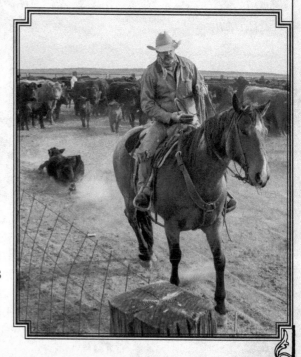

Besides his love for rodeo, Dad also has two other passions in his life – leather work and playing

guitar, which is what he fills a lot of his time with these days. Show up to his house anytime and there's a good chance you'll find him building a pair of chinks, a belt or halter in his leather room or strumming his six-string.

Lastly, Dad's greatest love of all – his kids and grandkids. He has helped raise four pretty great kids, if I do say so myself. His oldest, me, was born in '85, my sister Jessi came along in '86, Chase was born in '88 and the baby of the family, Cedar Spur, arrived in '96. To date, he's up to nine grandkids all of whom adore their Papa Bruce, always asking him to play his guitar."

Thank you for sharing, Jen!
Thank you Bruce, for riding along on the Pony Express journey! :-) God Bless ya! Til our trails meet again...

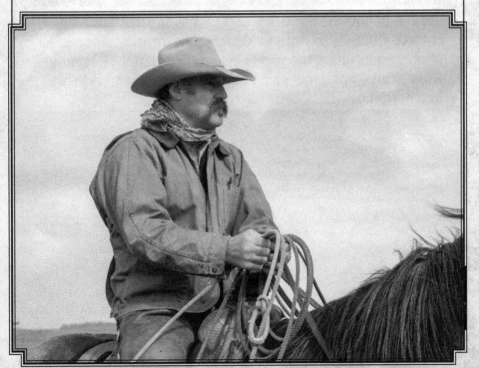

SUMMERTIME, 2016

Next, I went on to the states of Washington and Oregon to visit friends.

 I stayed on in Oregon for a while at my friend Larry Enbysk's ranch. He invited me to photograph the Helix Rodeo, which I obliged.

 Then he invited me along to do some day work moving cows to summer pasture in Meachem, capturing some great photographs along the way. This is where I met Mike and Russ Evans. Mike was nice enough to allow me to ride his horse, Dollar.

Next, I had the pleasure of attending a gather/sort/
shipping weekend at Hat Rock, right on the Columbia
River. Magnificent area to be on horseback! Thank
you, Larry, for loaning me Petey to ride for that photo
adventure!

I got all the ranch and rodeo photos from here edited and
uploaded to my website for folks to purchase. Also made a
couple of ranch videos that they loved and purchased.
It has been one heck of a year so far! Very thankful!

August, 2016
Redding, California

Back to Northern California to park and sit still for a bit.
I have a lot of photo organizing and editing to do for our
Pony Express Photography Book!!!

The Pony Express Adventure Continues!

October 22, 2016
Redding, California

After a respite from travel, giving me time to work on the book these last two months (*editing photos mostly*), it was time to get back out in the field. In my research for my writing, I found that there were a few stations I would like to go back and get that I either missed last time or didn't know where they were. Upon getting research ready to find them, I stumbled across a website dedicated to historical markers: *waymarking.com*. Actually, it was a link that is on the xphomestation webpage...lol. I had never noticed it before, as I have always gone straight to their list of XP stations/sites mentioned. Well, lo and behold, there were some of the missing site locations. With GPS coordinates!

The sites I am going back to in California were the original stations used during the beginning of the Pony from April to July, 1860. From the Fifteen Mile House (*today located in modern day Rancho Cordova*), the XP followed a more southerly route. Then, after July, their trail moved north.

With this new research found and logged, we are ready to go! Heading out in the morning for another "On the Road Adventure"!

We will be ending up in Reno to stay with my sister and her family, so no RV this go! Just Rider and I in our pickup!

October 23, 2016
Redding to Old Town Sacramento to St. George Hotel to Five Mile House to Mormon Tavern to Duroc House to El Dorado to Diamond Springs to Webster's to Apex Inn in Lake Tahoe

I had hoped to get an early start, but wasn't feeling up to par this morning. A long day spent preparing typically causes me to have a restless night. Wondering if I logged it all correctly, going over it in my mind over and over...Ugh! So, this morning I decided it was okay to take my time. I enjoyed my coffee, sat with my dad and his wife Julie, and visited for a bit. I shared with them about our plans for this journey and for the day.

9:30 a.m.
"Rider, load up! Let's go!" We were off, and heading toward Sacramento. About a two and a half hour trip through farms and ranches. Northern California is beautiful. The valleys are for farming, and the hillsides are for ranching. There are only a few road signs to read, and not much else to view on this leg of the journey.

Next Stop: Old Town Sacramento
Just after 12:00 p.m., we pulled off the "J" Street Exit to go into Old Town Sacramento. Well, today is Sunday; it is a beautiful day, about 75°, and Sacramento is a city of just under 500,000 people. Hmm, can you picture it? Circling the historical brick roads, round and round we go, looking for a parking spot. Well, we lucked out after our patient circling and timed it perfect when a SUV was leaving. I mention SUV, as I am in my extended cab Chevy long bed, and it needs some elbow room when we park.

Fortunately, I was able to back in, too. We were in a pretty great central spot to the two places I wanted to photograph here. I put money in the meter, and Rider and I took off towards the pier. I met an officer and asked him if he knew where the monument marker for the *Antelope* was located. Mentioned to him about my book and visited a minute. He pointed me in the direction; it was about a block. We walked down the wooden sidewalk and turned toward the docks and spotted the marker.

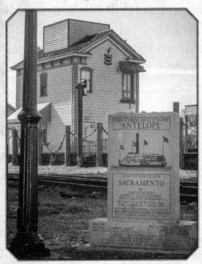

The *Antelope* steamship was how the mail for the Pony Express arrived from San Francisco on that first day, April 4, 1860. I could not find any information anywhere concerning her current whereabouts, or if she was even still around. The marker will have to suffice. I also captured the steamship office and a paddleboat that was at the dock, just for fun.

Now a few blocks east of the pier, near the statue of the Pony Express, I was looking for Pony Express markers on a rock wall. Somehow I didn't see them last time, and

wanted to capture them today as well. Before getting to the statue across the street, I noticed that the Wells Fargo Museum in the ol' Hastings Building was open. We went in and asked the ladies, who happened to be dressed in 1800 period clothes, if I could bring Rider in and take a few pictures. They said sure. (*Poor Rider, this city action was overwhelming him. He did great, and we did the "stay" command a lot to comfort him so he would know what was expected of him.*)

In the museum, there was a small model of the *Antelope* steamboat. I captured it and a few other things about the Pony Express. We didn't stick around long, as the place was full of visitors and it is a small room.

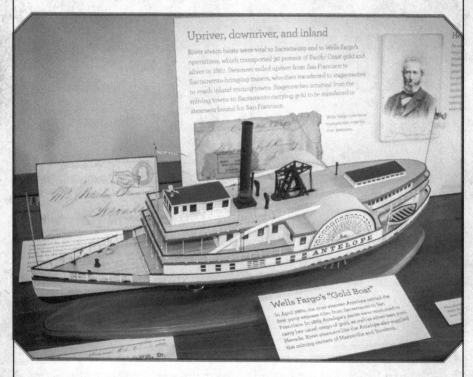

Upriver, downriver, and inland

River steam boats were vital to Sacramento and to Wells Fargo's operations, which transported 90 percent of Pacific Coast gold and silver in 1867. Steamers sailed upriver from San Francisco to Sacramento bringing miners, who then transferred to stagecoaches to reach inland mining towns. Stagecoaches returned from the mining towns to Sacramento carrying gold to be transferred to steamers bound for San Francisco.

Wells Fargo's "Gold Boat"

In April 1860, the river steamer Antelope carried the first pony express rider from Sacramento to San Francisco. In 1869 Antelope's decks were reinforced to carry her usual cargo of gold, as well as silver taken from Nevada. River steamers like the Antelope also supplied the mining centers of Marysville and Stockton.

We then crossed the street, where I took another quick shot of the statue with the Pony Express rider just for

fun. I can't just walk by it! About 150 feet from there was the rock wall with the monument markers. Got 'em, and even a few with Rider laying on the bench just in front of them.

Boy, was he ready to get back to the truck...kids squealing at him while we walked on the sidewalks, ladies acting like he was a monster and gasping when they looked down and saw him...lol. I guess they weren't used to us country folk, either...LOL.

(You can find more information about Old Town Sacramento on their website. I have provided the link for you in "References.")

Next Stop: Historical Marker for the St. George Hotel

With our new GPS coordinates to lead us, we circled around the one ways and wrong ways...then, in not much time at all, we found it. Fortunately, we even found a parking spot right near it, too!

Joe Nardone, a historian for the Pony Express, has found and continues to work at finding these historic locations. After finding them, he coordinates with the local communities to place these historical markers. He started placing In Search of the Pony Express monuments in the 1990s, and continues to do so today along the trail.

The monument here is in regard to the St. George Hotel. Here is where men brought their applications to be reviewed, hoping to be hired for this great adventure. On the back of the marker, etched in stone, is the ad that was run in the paper looking for

the daring young men. Today this marker is surrounded by the skyscrapers of California's capitol city.

Next Stop: Five Mile House

University of California...I typed in the GPS coordinates and headed to the Five Mile House marker that is located on the campus. Fortunately, today is Sunday, so the parking lots were empty, and there was no need to pay for a parking permit. A short walk, and I was there at the old 1960s Centennial marker. You may remember that I have already captured a Five Mile House marker by a storage facility on Folsom Boulevard. Historian Joe Nardone reports that that site was the actual Pony Express station during its time of operation. He claims that this one was no longer in service as of 1856. That would have been several years before the Pony began.

I wonder why the Pony Express Centennial Organization believed that this location was the site during the Pony? I can only share what others have reported. I am not

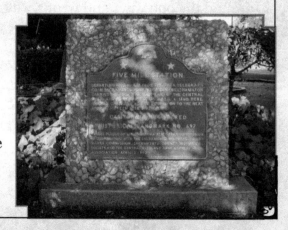

claiming one over the other. To be equitable, I will provide photos of both in the "Remnants of the Pony Express" book. :-)

Next station would be the Fifteen Mile House. I have already captured it; it is in Rancho Cordova.

Today we followed the southern route that was taken during the first few months that the Pony began.

Next Stop: Mormon Tavern
Well, I am so thankful I found the coordinates for this site. I drove right past it last time. When you see the photos, you will understand why. There are two ways you can get to it. I recommend the way *Google Maps* took me for safety reasons. The marker is about three to four feet off the Caltrans right-of-way fence. You could pull off the

freeway, as there is a pullout wide enough. But as a former Caltrans employee, I have to say: Don't. It is not a safe

place to pull out, and it's against the law when on a four-lane highway unless it is an emergency. Take the exit, and follow the road that leads back to the monument. It feels much more adventurous this way, anyhow!

As I was taking pictures of this old monument, I heard someone honk their horn. A gal who was coming down the narrow road didn't want to go around my truck. I moved my truck over so she wouldn't have to leave the pavement. We chatted a while. She told me there was an old cemetery at the top of the road we were on. She shared with me that she drove a school bus, and was 75 years old, and still drives even after breaking her hip earlier this year! "God bless you," I said!

I finished capturing the monument, then drove up to the top of the hill. She was sure right—it was the Clarkson Cemetery. I didn't go in, as daylight was getting sparse, and I had many more sights to visit. I did capture a few shots, though.

Next Stop: Shingle Springs/Duroc House

From Highway 50, we took the Cameron Park Exit. Made a right and followed Durrock Road. We found the marker was placed just alongside the road. I pulled over to capture the markings on it, and the surrounding area. No remnants here, either. The marker mentioned that the Duroc House was 175 feet due south from this monument. That would put it on the other side of the road.

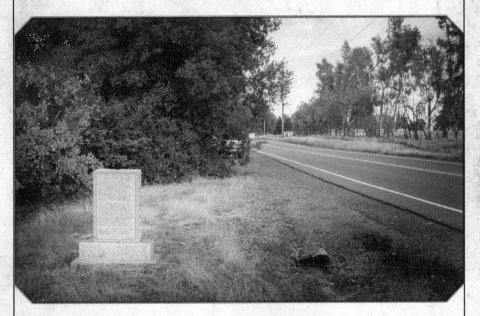

Next Stop: El Dorado/Mud Springs

We drove Durrock Road to South Shingle Road, where we paused for fuel. From South Shingle road we turned east on Mother Load Drive, heading to the town of El Dorado.

Just before we came to a fork in the road, there was a *National Historic Trails* sign pointing to the right. At the fork, there was a highway sign: arrow pointing toward the left, Placerville—7 miles...arrow pointing toward the right,

El Dorado—1 mile; Diamond Springs—3 miles. We turned right onto Pleasant Valley Road.

Only a short distance down this new road, there was a *Pony Express Trail Original Route* sign. We continued for another mile, where I spotted the monument off to our right and in front of the El Dorado Fire Station No. 46.

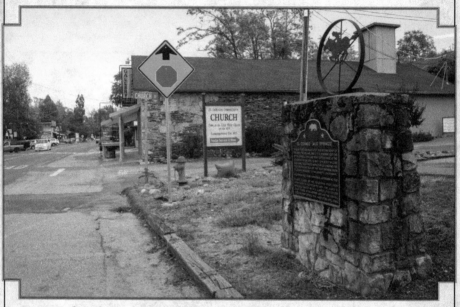

I took a few photos of the monument and the town. There were no ruins here.

Next Stop: Diamond Springs

Upon leaving the town of El Dorado, Pleasant Valley Road soon turned into Highway 49. The terrain through this area was rolling hills covered with oak trees. These towns are all small, but they are quickly growing together.

We arrived in Diamond Springs in short time, as it was only a couple of miles. This makes me question, "Why would they need stations so close together here?" That doesn't make any sense to me. The terrain, as I said, is

rolling hills; it is also at a low elevation, so not in a heavy snow area...Hmm?

On the left-hand side pulling into town we could see a large rock monument, once again in front of a fire station—Station No. 49. Also, there was a cannon monument right next to it.

The cannon's plaque read:

> This historic cannon was bought in the 1850's by the residents of Diamond Springs and used on all public occasions.
> It is displayed courtesy of the International Order of Odd Fellows Lodge #9 Diamond Springs and the Diamond Springs Volunteer Fire Department.
> Funds for this monument donated by friends of Elaida Smith.

The plaque on the large rock monument revealed information about the town, and just below it there was the round plaque of the *Pony Express Centennial Association Trail Marker*. There was no other information about this being a Pony Express station site.

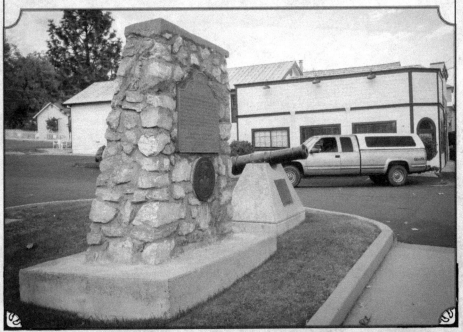

The fire station that these markers were in front of was one of the most appealing stations I have ever seen.

From this southern route, the XP riders would have continued on to Placerville, then Sportsman's Hall. I have already been to both of these sites and did not stop at either of them today.

Next Stop: Websters/Silverfork/Sugarloaf
This stop is in front of yet another fire station! I pulled into the parking lot next to the Kyburz Fire Station. I had driven right past it last time. I missed it, because I read the directions backwards (*the author of the guidebook I was referencing was heading westbound, and I was heading east...*)

This location has a large rock monument with a Centennial plaque describing the station. This area is beautiful, heavily populated with tall pine trees. The elevation is now reaching snow levels.

Next stop for the riders would have been the Strawberry Valley Station.

Last go-around I stopped at the monument. Tonight, I stopped at the store near that monument to use the facilities! Whew! Haha. Then I asked the clerk if she knew how much it was to stay at the Strawberry Lodge, across the street. She was kind enough to call them for me. It was $79; remember, today is Sunday, so not sure if that would be a weekend price. She hung up before I could ask her if they allowed dogs. She called back; it would be $89 with Rider. I thanked her and said I need to think about it. By this time (6:15 p.m.), it was very close to nightfall. I hadn't taken into consideration that I would be in the mountains, and how the sun slips away much quicker in them than in the valley. I thought I would have light 'til 7:00. Nope.

Sitting in my truck, I looked on *Google Maps,* trying to decipher what to do. I was leaning towards staying at Woodfords, where the next XP station was for those first few weeks of the Pony. I knew it was a winding road...Well, I called them and they put me on hold for a while. I hung up, as I knew they were supposed to be a bit spendy—I had read that in the guidebook. When I looked on *Google,* it showed a few motels, so I called the closest one heading toward Lake Tahoe: Apex Inn. From the pictures I saw, it appeared to be an older lodge, where you could pull right up to the door. I like these kinds best. They just feel homier to me. It was only $50 plus tax. Dogs were okay, and didn't cost any extra! We drove the short 14 miles.

Great room—has microwave, fridge, coffee pot (*YAY!*), TV, desk. It is an older lodge, but VERY clean, and the bed is a dream. So, good night! More to do tomorrow.

October 24, 2016
Lake Tahoe to Friday's Station to Luther Pass to Hope Valley/Sorenson's Station to Woodfords Station to Kingsbury Grade to Genoa to Sparks

Was a pretty restful night's sleep for being on the road. First time I have been in a motel in quite a while. As you know, I am typically in my own bed in my 5th wheel. Rider did well, too. He only barked once at passer-byers, so it was a good night all in all for both of us. I worked a bit on the computer this morning, before hitting the road.

Next Stop: Friday's Station Monument
 On our last trip through Lake Tahoe, I hadn't realized there was an In Search of the Pony Express monument across the street from Friday's Pony Express site. With the new GPS coordinates, found on the waymarking's website, we went right to it. Well, sort of, as I had to park

across the street in the Wells Fargo parking lot. There was no side-of-the-road parking. I had to be quick, as the parking lot had signs everywhere that they would tow unauthorized vehicles. I had just barely spotted the XP marker while turning the corner to park at the Wells Fargo. It was set back in a grove of aspen trees, behind the large "EDGEWOOD" sign. The gorgeous Edgewood golf course was just behind it.

Rider and I ran across the street. Just as we were surveying how to capture our photos, a gentleman walked by pushing a bicycle. He had a cardboard sign taped to it that read, "Entertainer for Hire." He stopped to ask if I would like for him to take a photo of me and my pup. I hesitated at first. But after chatting with him for a few minutes, I obliged and told him I would appreciate it very much. We walked over to the front of the XP marker, then my new friend said, "I would like to share a song with you." He explained that it was a song about the fellas who rode out West through the desert, and he believed it would be very fitting for my adventure: "Cool Water," by the Sons of the Pioneers.

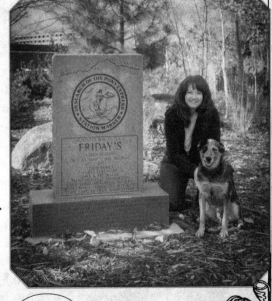

Before I could answer, he was singing away. I knelt down by Rider, as he was just a bit nervous about our new friend serenading us. We enjoyed the song, which was done very well, I may add. Then we got into position for our photos. I haven't reviewed them yet, but I hope they came out well.

I then asked him if I could take his picture by the Pony Express marker. He said, " Sure!" Our new friend's name was Larry, and his stage name: "Amador Kid." He told me his brother was an entertainer as well, and a writer. Larry's next journey, as of this coming Tuesday, is to fly south for warmer climate. He gave me his number in case I ever make it down that way to give him a call and say hi.

Larry headed back to his bike, and I hurriedly looked through my pocket for cash. I gave him some money for his time and the wonderful serenade, while expressing how thankful we were to have met him.

Meeting folks on my journeys is such a blessing. It reminds me of sharing a campfire and a cup of joe with a fellow traveler, like they did back in the days of yesteryear.

Back to the truck we went. Fortunately, the truck was still there—and no ticket. It had only been about a half hour.

Next Stop: Luther Pass
I entered the GPS coordinates into *Google Maps* for the Hope Valley Station. We headed back through South Lake Tahoe, then past Myers/Yanks Station, where we soon made a left onto Highway 89 heading south. The drive from there and down into the Hope Valley was gorgeous. We followed the Carson River most of the way. I pulled over to capture some of the views.

One of the locations where I pulled over, was to photograph a large grass valley surrounded by tall trees.

After I pulled over, I discovered there was a historical marker. It read:

LUTHER PASS TRAIL - CAME TO GRASS LAKE; "Passed over the summit of the first range and came to [grass] lake situated nearly on the summit of the mountain...we began our descent down the mountain over as rough a road as we came up, into Lake Valley." - Luman A. Scott, Sep. 8, 1859
This historical marker is dated 2013.
(Guidebook, available Trails West, Inc., P.O. Box 12045, Reno, NV 89510.)

Down below the rectangular plaque is the triangular sticker stating "California Trail," with the oxen yoke pictured. Then, below that, is the "JOIN US AT"... has the scannable symbol. Below that is written: www.emigranttrailswest.org

Next Stop: Hope Valley/Sorenson's Station

We continued toward the intersection of Hwy 88 and Hwy 89. While coming down into this valley, we could see a fenced-off area with a large boulder inside. It is just off to the left before you get to the stop sign at the intersection. Once we got to the stop sign, I could see that there was a fenced alleyway leading to that large boulder from the highway.

I turned the corner and parked off to the right-hand side of the highway. Wow! This is one of the most stunning locations I have seen! There are a multitude of large boulders rising from the grass-covered valley floor, decorated by a few pine trees here and there.

I walked across the street and immediately started photographing the cool-looking split wood fence surrounding our monument. Once I got to it, I was bummed to find that the brass marker with the station information was missing, as so many have been. I don't know much about this location, so it would have been nice to at least have had that marker.

I captured a lot of photos here. Poor Rider was told to "lay down" and "stay" a lot...as I shot from every angle possible. He was patient with me though. I wonder what he

HOPE VALLEY

STATION MONUMENT

thinks I am doing with that black thing. As he watches me put it up to my face, then point and click, then look down at the back of it and say, "I like it!" or "Oh, no! Delete!" LOL...

Across the highway from the XP sign location was a parking area with a sign that had "Hope Valley" written on it. Looked to be a trailhead. My guess is that Sorenson's and Hope Valley would have been the same station.

After we took off from here, not far down the road there was another parking pullout area. At that one, folks had their horses and were getting ready to go on a ride. This would be an awesome place to go for a ride and enjoy the Sierra Mountains.

Next Stop: Woodfords Station

I had GPS coordinates that were supposed to be the location of Cary's Barn, which is where the XP station would have been. At the end of my Google map drive, I found myself at Woodfords Inn, a hotel. There was nothing here that I could see; I thought maybe the marker or something may have been left somewhere nearby, so I went in and talked to the owner of the hotel. He said the only markers he knew of were across the highway and at the Woodfords Store. I asked permission to walk around a bit to see if the GPS was maybe just off the property or something. He said sure. I told him the GPS is what brought me to his place. He said that would be great to find that Cary's Barn had been there, but he had never heard of the barn or its name before. We talked about how much he charged for a room; he said $79 a night, every night of the week. He said he didn't want to have to remember what day it was to charge extra on the weekends...We laughed, and I told him that was a great plan! We exchanged information, and I said I would let him know when the book comes out; he said please do, as he would like to get a copy.

I walked around some more outside, but never found any signs of any kind. Maybe the GPS was mistaken and the person meant to state that they were for the hotel and not the XP station. Perhaps I entered it wrong...don't be surprised! It could happen...Haha! Believe it or not, I have been known to make a mistake or two. ;-)

Back in the truck, we drove over to Woodfords Store, hoping to get information and buy

some lunch. Sad to say, they are closed on Mondays. I left a card on the door. Just across the road from the store were the XP markers. I took a few photographs of them, then we

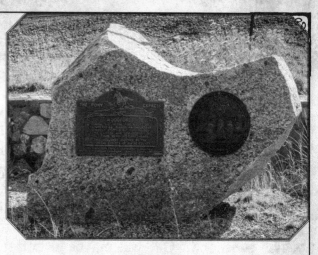

headed back down the hill toward Minden, Nevada.

Another beautiful drive down the mountain and into the Carson Valley.

Next Stop: Kingsbury Grade Historical Marker

This Nevada marker is located where the road had come out at the time of the Pony Express. The valley that ran up through the mountains looked narrow and to have been quite a tight area for a road that allowed wagons.

The historical marker read:

KINGSBURY GRADE
 Originally named Georgetown Trail, the Dagget Pass Trail and Pass was named after Charles Dagget, who acquired the land at the base of the road in 1854. In 1859 - 1860, David Kingsbury and John McDonald received a franchise from the Utah Territory to operate the toll road. At the time, the area was part of the Utah Territory.
 The men spent about $70,000 to construct a wagon road to meet the demand for a more direct route from California to the Washoe mines and to shorten the distance between Sacramento and Virginia City by ten miles. The new 16 foot wide road, supported in some places by granite retaining walls on both sides, made the passage easier for travelers on this main route from California. Merchants and teamsters frequently traveled this road, moving goods and people in and out of Nevada.
 In 1863, some of the tolls were 50 cents for a man and horse and $2.00 for a horse and buggy. That year, the estimated tolls collected were $75,000.
STATE HISTORICAL MARKER NO. 117
STATE HISTORIC PRESERVATION OFFICE

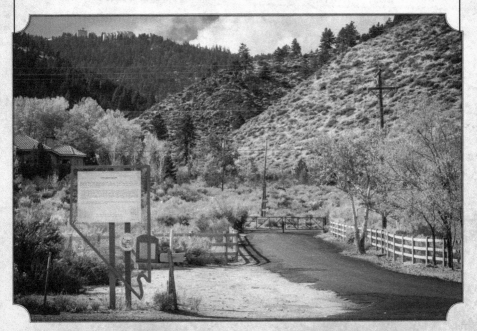

There was an XP marker
I had never noticed
on the corner of Main
Street; it was mentioned on a website. I have forgotten
which one. I wanted to get a photo of it. It reads;

> Near this spot stood the Genoa or "Mormon"
> Station of the Pony Express. 1860-1861. St.
> Joseph, Missouri to Sacramento, California.
> Dedicated on June 9, 1934, by citizens of Nevada.
> Under leadership Minden Rotary Club.

 Also, their small town park is a wonderful place to
stretch your legs and use the facilities. After capturing a
few shots of the marker, back in the truck we went.

Next stop...*Family* in Sparks. I sure have missed my sister
and her family.

Wow, what a journey this has been the last two years! Thank you all for your love, mental support and prayers for our safety...and for riding shotgun in spirit!

We will be back on the road again soon, for more adventures...as there are more Pony Express station locations to find and capture!*

Now, as we end this part of our journey together...Let us reminisce on how Roy Rogers and Dale Evans would sing, to bid us farewell:

"Happy Trails...
 to you...
 Until...
 we meet...
 again!"

See ya soon in *Rider on the Pony Express Trail – Volume 2*

Love, Carla and Rider (woof!)

If you have enjoyed this Journal, please, let us know! Make sure to let others know! Rider and I would be honored!

In order to keep up-to-date on our travels, find great resources, Western art and free gifts, please visit:
<u>www.CarlaEPhotography.com</u>

GLOSSARY

Acronyms and Abbreviations

AAA American Automobile Association. *An automobile service that offers roadside assistance such as towing, changing flat tires, replacing batteries, etc., as well as other member aids such as maps, travel discounts, etc.*
A/C Air conditioner.
BLM Bureau of Land Management.
Blvd. Boulevard. *A wide street, often lined by trees or other forms of landscaping.*
CCC Civilian Conservation Corps. *A program that provided work related to natural resources/conservation on government owned land for unemployed, unmarried men during the Great Depression in the United States from 1933 to 1942.*
FB Facebook.
GPS Global Positioning System. *A navigation system that provides the user with exact location, time, and speed anywhere, any time.*
LOL Laugh Out Loud. (*may also be written* lol)
NPEA National Pony Express Association.
Rd. Road.
RV Recreational Vehicle. *A vehicle equipped with home-like facilities, such as beds, kitchen, bathroom, etc., either with its own motor or pulled as a trailer.*
TV Television.
UPS United Parcel Service.
XP Pony Express.

BIBLIOGRAPHY

Benson, J. (1995). *Traveler's Guide to the Pony Express Trail*. Helena, Montana: Falcon, 1st Edition. Historic Trail Guide Series.

Godfrey, Anthony, Ph.D. (1994). *Pony Express National Historic Trail*. U.S. Dept. of the Interior, National Park Service.

Hardesty, Donald L. (1979). *The Pony Express in central Nevada: archaeological and documentary perspectives*. Reno, Nevada: Nevada State Office, Bureau of Land Management.

Hearty, P. A., & Hatch, J. (2012). *The Pony express stations in Utah*. Salt Lake City, UT: P. Hearty.

Nevada Bureau of Land Management. (1976). *The Pony Express in Nevada*. Reno, NV: Nevada State Office, Bureau of Land Management.

Townley, J. M. (1984). *The Pony Express guidebook: across Nevada with the Pony Express and Overland stage line*. Reno, Nevada: Jamison Station Press for the Great Basin Studies Center.

Visscher, William Lightfoot. (1908). *A Thrilling and Truthful History of the Pony Express: Or, Blazing the Westward Way, and Other Sketches and Incidents of Those Stirring Times*. Chicago: Rand, McNally & Co. Printers and Engravers.

RESOURCES

Austin RV Park. (n.d.). Retrieved October 15, 2015 from http://austinnevada.com/austin-rv-park/ Austin RV Park and Baptist Church – camping.

Bob Scott Campground. (n.d.). Retrieved October 21, 2015, from https://www.fs.usda.gov/recarea/htnf/recreation/recarea/?recid=65248&actid=

Free Campsites. Finding free camping locations is easy! (n.d.). Retrieved October 01, 2016, from http://www.freecampsites.net/ Free Campsites!!! Saves a ton of money when you are on the road for a long time.

Connally White, Donna (May 5, 2006). Rusty's Rainbow. Xulon Press. https://www.amazon.com/Rustys-Rainbow-Donna-Connally-White/dp/1600340423/ref=sr_1_2?ie=UTF8&qid=1515106176&sr=8-2&keywords=books%2C+Rusty's+Rainbow

Google Maps. (n.d.). https://www.google.com/maps Google Maps - Website and APP for Android. Used for multiple directions.

Grimes Point/Hidden Cave Archaeological Site. (n.d.). Retrieved October 19, 2015, from https://www.blm.gov/visit/grimes-point-hidden-cave-site

Hickison Petroglyph Recreation Area, NV. (n.d.). Retrieved October 19, 2015, from https://www.recreation.gov/recreationalAreaDetails.do?contractCode=NRSO&recAreaId=2026

National Pony Express Association. (n.d.). Retrieved April 9, 2017, from https://nationalponyexpress.org

Nevada Department of Transportation. (n.d.). Retrieved December 01, 2017, from http://www.nevadadot.com/

Nevada Northern Railway. Train Rides - Ely, NV (n.d.). National Historic Landmark. Retrieved October 23, 2015, from http://nnry.com

Old Sacramento. "Special Events." (n.d.). Retrieved December 01, 2017, from http://oldsacramento.com/

ParkAdvisor - Android Apps on Google Play. (n.d.). Retrieved September 20,2015, from https://play.google.com/store/apps/developer?id=ParkAdvisor&hl=en

Partnership for the National Trails System. (n.d.). Retrieved March 30, 2016, from http://pnts.org/new/

~~Pony Express Home Station.~~ (n.d.). Retrieved July 15, 2015, from ~~http://www.xphomestation.com/~~ This site is no longer available. See, "National Pony Express Association," as they have informed me that they now have the content available there.

Prospector Hotel & Gambling Hall. ELY'S HIDDEN TREASURE. (n.d.). Retrieved October 23, 2015, from http://www.prospectorhotel.us/

Raine, L. (n.d.). Raine's Market, Eureka Nevada Grocery Store. Retrieved June 21, 2017, from http://www.rainesmarket.com/

RV Parky - Android Apps on Google Play. (n.d.). Retrieved September 17, 2016, from https://play.google.com/store/apps/details?id=com.rvparky.android2&hl=en

Spencer Hot Springs. (n.d.). Retrieved March 29, 2016, from http://austinnevada.com/wide-open-spaces-austin-nevada/hot-springs/

The Historical Marker Database. (n.d.). Retrieved December 01, 2016, from http://www.hmdb.org/

Tooele Transcript Bulletin. (n.d.). Retrieved December 01, 2017, from http://tooeleonline.com
Stories Clint Downs, of Ibapah, Utah, told us about.

West Desert RV. Downs, Clint and Winna. (n.d.). Ibapah, UT. 435-234-1134. Camping.

PERSONAL NOTES FROM THE AUTHOR

I would like to end this *Journal* with some personal notes to you, my dear Reader:

When I started this project, I knew very little about the Pony Express. It has been a "labor of love" doing research, visiting, and reading all of the stories about these sites. There is so much information and misinformation out there! The Pony was running across this country a long time ago; there have been many changes that have happened over this last 150+ years...At times, it has felt overwhelming, but with God's help, He has assisted my persistence. While learning more and more with every research book, website and interview...the process became more and more enjoyable.

My hope for the *Journal's, Remnants of the Pony Express, and the mapping of the Pony Express Trail* is that my research...the sum of the research...that has come from all the historians and record keepers who come before me, that has contributed to my compilation of works...will benefit YOU...You, on your journey of following the famous Pony Express Trail! Whether from your armchair, or from behind the wheel, or on the back of a horse...

You are the reason I paid so much attention in sharing small details, as I want to share with you everything I have lived through and learned, including the times I have been challenged by weather, or tire blowouts, or my body's physical limitations from the Lyme disease (*which I tried not to mention often, as there were days that were very tough*)...even the mundane day-to-day, as that was all part of this experience as well.

With persistence, prayer and supplication, God has given me this labor of love to learn, grow, and gain strength from. I refuse to quit living a meaningful life, though my body suffers with a painful disease. I am truly honored and grateful for each of you that have taken the time to read this far...

Having you to share my stories with means a lot to me, and my prayer is that you will find YOUR passion and pursue it, with your whole heart, and not let life pass you by. Even for those of you who may have a body that is ailing, like mine, or worse.

While running a therapeutic horseback riding center, we would express to our students—students who had physical and/or mental disabilities, some so severe they had to lie down on the horse in order to ride:

> "Here, at this ranch, we focus NOT
> on what your limitations are, or
> what you think you *can't* do...
> NO, we focus on what you
> *CAN DO*, and we *DO* that!"

So, my dear friends...What can YOU do? What is it that will give you a heart full of joy? Even if it is simple, do it! Go for a drive, visit a museum, stop and read that roadside monument—you know, the one that you have driven past every day, and wondered what it says! Perhaps give one hour of your time a week volunteering. How about a fifteen-minute phone call to "?" Mail a card to a soldier. Capture photos of something you love. Draw. Paint. Sing. Play the piano for a local retirement home. Read to a child. Hug someone. There is life worth living all around us! My prayer is that you enjoy it. You don't have to go far; just go. If you can't drive, ask someone to take you, and they will be blessed from it, too. If you are able to travel, and can afford it, near or far, where do you want to go? What is holding you back? Time will keep ticking regardless, so start planning today!

I have heard this and believe it to be true; there are 3 things we need to be happy (*I am paraphrasing here to my interpretation of these 3 things*):

1) *Something to do.* This can be any size project or job; something to work on every day. (*If you are retired and feeling bored, you can still have meaningful projects.*)

2) *Something to look forward to.* This could be a trip, near or far; maybe a movie, or concert, or dinner, or weekly walks in the park, or (*you fill in the blank*). It can be anything you are *planning* on doing in the future.

3) *Someone to love.* This can be a significant other, of course, but not limited to. As in my case at this present time, it is my family and friends. My son, my sister, my nephew, my great-nephew—who can light up any bad day in seconds with his energy and love, my dad and his wife, my dear friends near and far, those on social media whom I have never met in person, but talk to often. There is always someone to love...and someone who loves you. When I am alone, for me, it is my number one love...my love for the Lord Jesus Christ, who loved me so much, He gave up his life for my sins...what greater love is there than this?! He is with me always...oh—and yes, my dog, Rider...what unselfish love he gives!

Be blessed, my friends...You are loved! God Loves YOU and so do I! I am grateful for you...as you see, because of YOU— yes, YOU—and you reading this...you have blessed me in allowing me to share my stories with you in my journals!

Thank you! Thank you! Thank You!

CPSIA information can be obtained
at www.ICGtesting.com
Printed in the USA
LVHW06s1551130618
580595LV00010B/242/P

9 781732 263802